Isuma

Inuit Video Art

MICHAEL ROBERT EVANS

McGill-Queen's University Press
Montreal & Kingston • London • Ithaca

ISBN 978-0-7735-3369-1 (cloth)
ISBN 978-0-7735-3378-3 (paper)

Legal deposit second quarter 2008
Bibliothèque nationale du Québec

Printed in Canada on acid-free paper that is 100% ancient forest
free (100% post-consumer recycled), processed chlorine free

This book has been published with the help of a grant from the
Canadian Federation for the Humanities and Social Sciences,
through the Aid to Scholarly Publications Programme, using funds
provided by the Social Sciences and Humanities Research Council
of Canada. Funding has also been received from the International
Council for Canadian Studies through its publishing fund.

McGill-Queen's University Press acknowledges the support of the
Canada Council for the Arts for our publishing program. We also
acknowledge the financial support of the Government of Canada
through the Book Publishing Industry Development Program
(BPIDP) for our publishing activities.

Library and Archives Canada Cataloguing in Publication

Evans, Michael Robert, 1959–
Isuma : Inuit video art / Michael Robert Evans.

Includes bibliographical references and index.
ISBN 978-0-7735-3369-1 (bnd)
ISBN 978-0-7735-3378-3 (pbk)

1. Igloolik Isuma Productions. 2. Video art – Canada, Northern.
3. Inuit art. 4. Inuit – Folklore. 5. Oral tradition – Canada,
Northern. 6. Inuit – Nunavut – Igloolik. I. Title.

PN1993.5.C3N86 2008 778.5909719 C2007-906907-X

Typeset by Jay Tee Graphics Ltd. in 10.5/13 Baskerville

To the loving memory of my mother,
Carolyn Ruth Robinson Evans,
and to Joanna, Miles, and Dylan Evans,
with all my love and gratitude

Contents

Acknowledgments

Little in this world is ever accomplished through isolated, insulated effort. This book came about only with the generous help and guidance of many people.

I would like to thank Zacharias Kunuk, Paulossie Qulitalik, Norman Cohn, and Pacome Qulaut – all members of Igloolik Isuma Productions – for their tireless explanations and endless patience. You all made me feel welcome, and I appreciate your help.

I would also like to thank Julie Ivalu, Jake Kadluk, Ruben "Bobby" Alorut, and Anthony Ittusardjuat at the Inuit Broadcasting Corporation in Igloolik. I am grateful for your willingness to let me tag along and watch you do your work. Each of you taught me a great deal.

This project was greatly assisted by John MacDonald, director of the Igloolik Research Centre, by his wife, Carolyn, and by their daughter, Lucy. You helped me in many ways, and your warmth, generosity, and guidance made my stay in Igloolik both enjoyable and fruitful.

Leah Otak, who was the operations manager for the Igloolik Research Centre, provided valuable insights and cheerful friendship. She is now serving Nunavut well in important governmental roles.

The Fulbright Commission provided the bulk of the support that I needed to accomplish my research, and this project would not exist without its assistance. I am particularly indebted to Denise

Yap, who served as my primary contact with the Fulbright group. Susan Carty provided invaluable assistance during the grant-writing process at Indiana University.

And many members of my family provided vital support and encouragement. I have mentioned Joanna, Dylan, and Miles in the dedication; while I was toiling on the tundra, they were maintaining a stable and loving home down south. Mary Parker has been steadfast in her support, and I am deeply grateful for it. Sibyl Masquelier and Mike Parker provided assistance in myriad ways, as did my father, Richard Evans.

I was guided in this project by a committee of professors who exceeded the routine demands of attention and care. Dr Henry Glassie, my mentor, has provided intellectual insights, moral frameworks, and warm friendship since my first days at Indiana University. I am forever in his debt.

Dr Sandra Dolby taught me volumes about folklore when I took her graduate courses and when I served as an associate instructor in her undergraduate course on American Folklore. She is also a friend. Dr Greg Schrempp added his always impressive thoughts on this project, and Dr Christine Ogan pointed me in several beneficial directions.

And I would be remiss if I failed to acknowledge my indebtedness to Paul Apak, the visionary videographer of Igloolik. Paul died during my stay in the North, but his impact on Inuit video will persist for generations.

SPELLING, TERMINOLOGY, AND USAGE

Inuit names and words, when converted to the Roman alphabet, can be spelled in many different ways. The word for non-Inuit people, for example, is "Qallunaat" (pronounced KHAD-loon-at), but it has been represented in a variety of different spellings, including "Kabloona" and "Qadlunaat." I have attempted to use the most common spellings in this book, but quoted material might contain variations.

A common confusion arises regarding the terms "Inuit" and "Eskimos." The word "Eskimo" comes from an Indian term meaning "eater of raw meat," and it was intended as a derogatory label. Given this origin, "Inuit" is generally preferred today; it is the term

used by the people themselves, and its translation means "people." (Technically, it means "those possessed by a soul.")

A movement is under way to use "Eskimo" as an umbrella term that would encompass the various non-Indian Arctic and sub-Arctic groups, but this book does not employ this approach.

Several of the legends and oral histories that appear in this book were collected as part of the oral-history project being conducted by the Inullariit Society in Igloolik; the society is a group of elders who are working with the Igloolik Research Centre to record Inuit oral folklore. This project has resulted in the collection of more than four hundred interviews. The original interviews are on audio cassettes and are kept, along with the transcripts and translations, in the archives of the Inullariit Society, Igloolik Research Centre, Igloolik, Nunavut, Canada. Copies have been deposited at the Northwest Territories Archives, Prince of Wales Northern Heritage Centre, Yellowknife, Northwest Territories.

When quoting from translated material – either the oral histories mentioned above or subtitles from videos – I have allowed myself to correct some obvious errors in grammar and spelling. I took this step on the assumption that the errors were the translator's, not the speaker's, who would have been speaking in Inuktitut and have had ample command over the language. At any rate, because nearly all the material that I examine in this book was translated from Inuktitut, I am not conducting an analysis at the sentence level anyway.

The use of shorthand terms to mean "dominant forces shaping Inuit life from outside" is confusing. The Inuit simply use the word "Qallunaat." The conventions of my own tradition would call these outside political forces "Western," with a capital "W," harkening back to the days long ago when Europe, and then the United States, were to the west, more or less, of such other powers as Russia, China, Turkey, and the Middle East. But from an Arctic perspective, of course, all these powers are Southern. In this book, I use "Western" and "Southern" as simplified terms meaning, generally, non-Inuit Canada, the United States, and Europe. And I use "Northern" as their counterpart.

I use the term "American" to refer to people, places, and things associated with the United States. While I acknowledge the argument that the term could – and perhaps should – be applicable to the entire Western Hemisphere, common usage nevertheless sug-

gests that "American" is unambiguous. And while "America" has a worthwhile and more accurate substitute in "United States," "American" has no decent substitute at all.

With the exception of "Inuit," which is plural for "Inuk" (meaning "person"), I use English methods of pluralizing words that are in Inuktitut. I have chosen to do this out of a sense of simplicity and ease for the readers. For example, in Inuktitut, the word *inuksuk* refers to a stone cairn that is roughly shaped like a person. The proper Inuktitut pluralization would be *inuksuit*; just as the "k" of "Inuk" is dropped and "-it" added to form the plural "Inuit," the ending of *inuksuk* is changed to form *inuksuit*. But in this book, in keeping with English rules, the plural is expressed as *inuksuks*. This is incorrect in both languages, I suppose, but it will make the words easier for readers to follow.

COPYRIGHTS

ISUMA

1

Reflections in the Ice

Just as Inuit art should take its place among the great arts of the world, Inuit videography should take its place among the great Inuit arts.

The history of Inuit art is well known among scholars interested in the Arctic.[1] The short version begins at the first of two critical junctures: the nexus between the Inuit and the natural world. For thousands of years the Inuit and their predecessors have been mastering the challenges of drawing sustenance and life from the harsh northern environment, and they have used these challenges as opportunities for artistic expression. A woman sewed a caribou parka, for example, to serve the basic role of keeping someone warm. But as is the case the world over, the garment did much more. "Clothes possessed symbolic as well as practical importance," revealing and negotiating social standing, connecting the creator and the wearer to the animals from which the materials came, and at times indicating the wearer's sex, age, occupation, home community, and childbearing status (Hessel 1998, 171). The wife made the parka, and the wearer donned it both as protection from the frigid air and as a statement, on multiple levels, to the world.

Similarly, tools and other implements were often given forms or images that went beyond physical necessity. Dorset-culture hunters, for example, sometimes snared seals with harpoon heads that had been carefully carved for decoration (Hessel 1998, 14–15).[2] In addi-

tion, carvings might have had magico-religious and ritual purposes (Swinton 1972, 116; Taylor and Swinton 1967; Hessel 1998, 14).

For centuries the Inuit were intermittently nomadic, following circuits that provided optimum hunting and fishing opportunities.[3] A life of regular travel meant that belongings had to be kept to a minimum, so the idea of merely decorative works of art – art that had no purpose other than to be looked at – was preposterous.[4] Art works, then, did not stand alone as items separate from life's routines but instead were viewed as fundamental aspects of the daily world; the design of the igloo, the toggle of the harpoon, the butt of the dog whip, the arc of the *ulu* – myriad tools of everyday life were created not merely with the grim determination of survival but also with the impassioned determination of celebrated existence. "It would be a mistake to assume that their art was 'merely' utilitarian, decorative, and secular" (Hessel 1998, 16).

Dorothy Eber has noted that "the whalers were the start of change" in the Arctic (1989, xvii); their arrival certainly ushered in an era of increasingly rapid change for Inuit art – the second nexus, involving interaction between the Inuit and other societies. Starting around 1770, contact with whalers and missionaries began to commodify Inuit art and shift it from the internally meaningful toward the commercial (Hessel 1998, 21). Inuit carvers found that they could trade small sculptures of polar bears and other images for guns, pots, and other items, so they began to create carvings intended only to be traded.

The relocation efforts of the 1940s, '50s, and '60s brought great upheaval for the Inuit. Many families were forced to end their semi-nomadic life and pressured by the Canadian government to move into permanent settlements (Tester and Kulchyski 1994). This move destroyed a traditional livelihood based on hunting, fishing, and gathering, and in its place came a dependence on a cash-based economy in a region virtually devoid of paying jobs. In the settlements the Inuit had little choice but to rely on government assistance for survival.

This dependence on welfare provided at least one impetus for the emerging Inuit art movement. In the 1920s the Canadian Handicrafts Guild in Montreal became interested in marketing "Eskimo handicrafts" and staged an exhibition in 1930 (Hessel 1998, 27). In 1949 the Canadian Guild of Crafts and the Hudson's Bay Company began to buy carvings from Inuit artists and market

them in southern Canada and beyond. "The production of art quickly became an integral part of the new cash economy, and by the early 1960s, Inuit-owned co-operatives had been formed in most northern communities to assist with economic development in arts and crafts" (9).

Within a few decades, in part due to the efforts of James Houston (1995a), Inuit prints also became prized by art collectors in Europe, Asia, and North America (Houston 1995b), and the settlements of Cape Dorset and Pangnirtung became known for their talented printmakers. Inuit sculpture also began to fetch hundreds and even thousands of dollars in New York, Berlin, and Tokyo. As Ingo Hessel put it: "Few contemporary art forms can claim such wide acceptance" (1998, 186).

The still-emerging realm of Inuit video has thrust Inuit art into a broader political realm. In the early days of broadcasting and even filmmaking, Canadians became concerned that much of the programming flickering before Canadian eyes came from outside – primarily the United States (Raboy 1990). People were concerned that Canadian identity would be eroded by the constant presence of non-Canadian materials on the big and small screens.

Steps were taken to counteract this assault; Marc Raboy's book *Missed Opportunities: The Story of Canada's Broadcasting Policy* does a good job of tracking them (1990). From a Native perspective, however, these steps merely moved the problem northward. Just as Canada attempted to resist American cultural imperialism by encouraging Canadian programs with Canadian content, the subsequent output of both American and southern-Canadian programming presented a similar challenge to the Inuit. As Arctic communities gained the ability to receive television signals from the South, concerns arose about the effects of non-Native programming on Inuit culture and language. In short, many Inuit communities and organizations expressed the same concern about Canada that Canadians were expressing about the United States.

Efforts to offer the Inuit a modicum of exposure in the media initially fell short. The Inuit Broadcasting Corporation (IBC), however, was central in the effort to make Native broadcasting an integral part of the public system, not just an appendage of the Canadian Broadcasting Corporation's (CBC) northern service (Raboy 1990, 310). This effort, coupled with the arrival of video technology and fractures among Inuit groups regarding the role of

Inuit programming led to the formation, ultimately, of Igloolik
Isuma Productions.

<div align="center">VIDEO</div>

Changes in technology have always had an impact on art. Rifles
made caribou easier to hunt, which provided more hides for the
creation of parkas. Power tools have softened the resistant face of
stone. And since the early 1980s the portable video camera has
been allowing storytelling to blossom in new and interesting direc-
tions throughout the world.[5] In many parts of the world, people
have formed small, grassroots video organizations that strive to col-
lect and record facets of their heritage in an attempt at cultural
preservation.[6] In some areas, including Australia, people have
formed video groups of a more professional nature, attempting to
express their culture through polished works intended for viewing
on television or in theatres.[7] In Igloolik, a small settlement of about
1,200 people on an island just northwest of Hudson Bay, three
video groups are active: Igloolik Isuma Productions, the independ-
ent organization upon which this book is focused; a production
centre of the Inuit Broadcasting Corporation; and a community
video group called the Tariagsuk Video Centre. The video artistry
of these organizations underscores an important point often over-
looked by southerners musing about the Arctic. The formula for
survival is delicate in the North, but for more than four thousand
years the Inuit and their predecessors have done more than merely
eke out a desperate survival from one generation to another.
Rather, they have lived – and live today – with the same depth of
culture, social relationships, and human interactions that can be
found anywhere in the world. Their art, as mentioned previously, is
collected enthusiastically throughout the globe. Their music, from
the traditional throat singing and *ajaja* songs to the more current
sounds of electric guitars and pop lyrics, can be heard on the radio
and purchased in CD shops; Susan Aglukark, Lucie Idlout, the pop
group Taima, and others form the core of a highly successful Inuit
pop-music movement, and their recordings and concert appear-
ances are welcomed by enthusiastic audiences. Inuit literature is
also gaining a devoted following, expanding interest in the poetic
elements of the Inuktitut language.[8]

Since the early success with printmaking and sculpture in the North, other efforts have been made to introduce additional Inuit arts – particularly pottery and works in precious metals – with varying results (Neale 1999a, 1999b; Sutherland 1994). Since the 1980s videography also has emerged and is becoming, on the one hand, an important part of the effort to record, preserve, maintain, express, and enhance Inuit culture. As John Palattella has noted:

> With inexpensive video equipment now available worldwide, some of it carted to remote corners of the globe by anthropologists, many of the indigenous people who were once examined by an ethnographer's camera are now looking at their own cultures through a viewfinder. From the Arctic tundra to the Amazon basin to the Australian outback, indigenous people are producing videos that are screened in local community centers, on regional and national television stations, and occasionally at international film and video festivals. (1998, 50)

On the other hand, videography is a rich and potent avenue of expression through which Inuit video artists are attempting to work with available models and tools to create a communicative connection across the void that separates people, times, and ideas. Inuit videography is linked to a larger system of art that transcends slippery divisions of folk versus high, sophisticated versus naive, schooled versus instinctive, or any of the other partitions that serve to elevate one culture's art over another. Inuit videography is no less Inuit because it is created with electronic machinery. It is no less art because it is shown on television. It is art, and it is important, because it represents a sincere human effort to communicate that goes beyond surface messages to embrace deeper and more profound truths.

THE LIVED ACTIVITY OF VIDEO

Folklore and other fields frequently argue against the tendency to view cultural expression as merely a collection of objects: houses, sculptures, tools, clothing, books, stories. The objects are the result of cultural expression, and studying them can reveal profound insights into the nature of the culture itself, but the objects are

equivalent neither to the expression nor to the culture. Cultural expression is a lived activity, an interchange among people carried out in a real setting and guided and shaped by social understandings. Seen this way, folklore is a way to communicate. It is the dynamic interplay among the artist, the audience, the social milieu, and the text (Bauman 1986).

Gaining an understanding of complex relationships, intricate situations, and subtle messages requires approaches to research that go beyond the broad and superficial. Ethnography, long practised in the Arctic by anthropologists, folklorists, and other researchers, lends itself well to the demands of cultural projects in the North. The personal, face-to-face approach, reinforced by long stretches of time in which the researcher works and lives side-by-side with the people whose activities and outlooks are being studied, stands a much greater chance of success in Inuit communities than does anything involving official documents, long-distance communication, short-term interaction, or conspicuous power differentials. Challenges such as power disparities and cultural miscommunications – both during the study and especially afterward, when researchers publish findings that gain some degree of authority by virtue of the researcher's position, academic credentials, and publication record – are always present in any ethnographic study, but the passage of time and the partial erosion of barriers through mutual action can help to mitigate some of these concerns (Evans 2004).

Responding to the desirability of ethnographic approaches in the Arctic, I spent nine months in Igloolik – the Arctic community most actively involved in video production – and conducted fieldwork research with the videographers there. In addition to direct observation of their work, I interviewed each producer in depth, over time, in formal tape-recorded sessions, in informal chats in town, and in shouted conversations over the din of outboard engines. The interviews served several purposes. The first was to provide the essential context necessary to an understanding of the goals, limits, and social and cultural milieu that affect the producers' work; rather than restricting my research to production work as though it were done in a vacuum, I sought to learn about the world in which these producers operate. The second purpose of the interviews was to teach me about the processes through which the producers did their work. I knew very little about videography

when this research began, a lack that proved to be more of a help than a hindrance. By asking the videographers of Igloolik sincere questions about their craft, their machinery, their art, and their operations, I was able to learn both the fundamentals of videography as they conduct it and the views and perspectives with which each producer approaches his or her work. Additionally, the interviews allowed me a greater grasp of the politics, aesthetics, and other principles that infuse Inuit videography today.

The interviews also carried a less direct motive: they allowed me to centre the project on people. The video programs serve as my texts, but the heart of this project lies with the people who make them.

In addition to extensive interviews with the video producers, I also spent time viewing, examining, and analyzing the videotapes themselves. I watched nearly every videotape created by Isuma, omitting only those no longer readily available in Igloolik. Beyond a simple viewing of each video, I also developed close descriptions of each and in many cases watched videos again in the company of their producers, which enabled me to ask questions about specific segments or images and generally to understand the videos more thoroughly.

And I augmented the interviews and viewings with long-term observation of each of the video groups. I spent many of my days at the building that houses Igloolik Isuma and the Tariagsuk Video Centre. I carried Inuit Broadcasting Corporation equipment to the beach with Jake Kadluk and helped him to shoot footage. I rode snowmobiles with director Zacharias Kunuk to the site of the taping of his first feature-length film, *Atanarjuat: The Fast Runner,* and watched him direct the movie's rehearsals. I sat in the studio and watched Neevee Irngaut host the local television news and information program, and I helped Norman Cohn moderate one of the program's call-in shows. This observation, with a small degree of participation,[9] was essential to my understanding of how these groups go about their business. I watched them make important decisions about future projects. I watched them comb through archival footage, searching for just the right image to fill a particular scene. I watched them rail against rival groups and chat amicably with those same rivals at the Northern Store. Through patient, constant contact, I was able to learn about the Inuit, the videographers of Igloolik, and the politics of Native issues.

These approaches, taken together, gave me the raw material that became this book. I also read books written by Knud Rasmussen, Franz Boas, Charles Francis Hall, and other Arctic travellers, and their comments shed additional light on the topic at hand. But it was my quiet presence in Igloolik for nine months that allowed me to grasp, and I hope convey, the essence of videography in the Arctic today. At the heart of this project lie several basic research questions: How do the Isuma videographers use, negotiate, and manipulate cultural symbols in their effort to tell Inuit stories from a particular perspective? How do they merge the realms of visual art, narrative, material culture, and folk life as they create their videos? How do they go about their work in harmony with the many facets of modern Inuit culture? And how do their videos contribute to the ongoing dialogue about Inuit culture and its role in the Arctic, in Canada, and in the world?

The study of video, like the study of other art, offers a dual opportunity for the enhancement of knowledge. Researchers have long explored culture through the creations of a people. We examine sculptures, houses, stories, place names, songs, tombstones, rituals, and countless other expressions in an effort to learn about the cultures that people hold. Once an artist chooses to express him or herself through a particular medium, researchers should count themselves fortunate; we have yet another way to enhance our understanding of that person's culture. Sometimes the media have been in use for a long time. Sometimes the media were embraced just recently. Either way, the more explorations that are done, the better. When Igloolik Isuma makes a video about caribou hunting, for example, the video presents researchers with multiple opportunities: we can study Inuit caribou hunting, and we can study Inuit perceptions of Inuit caribou hunting. We can also study Isuma's perceptions of Inuit caribou hunting, and we can study the particular videographer's perceptions as well. Aboriginal video does not thwart research; aboriginal video enhances it.

Inuit access to the mass media is important, and the governmental and financial organizations in Canada that support Inuit video should be urged to redouble their efforts to strengthen and extend aboriginal videography. It should be remembered, however, that the inclusion of Inuit perspectives in the body of research about the Inuit enhances the material offered by Qallunaat (non-Inuit) researchers – but does not replace it. As in any multivocal

enterprise, a greater number of voices only makes the enterprise more vigorous.

THE HAND ON THE CAMERA

Ever since Sol Worth put movie cameras in the hands of the Navajo, some scholars have wondered what would happen as Native populations gained increasing access to film/video equipment and increasing expertise in its use (Worth and Adair 1972; Palattella 1998). In some ways, this study is a continuation of the quest spurred by this question, although my research approaches the issue of aboriginal videography from a slightly different perspective from that taken by Worth and Adair. Worth and Adair gave cameras to the Navajo and taught them how to use the equipment to make movies – something the Navajo had not done before – and then they analyzed the process and products that resulted. My study differs in three important ways. First, I did not give the cameras to the Inuit. The Inuit gained video access and expertise through their own efforts, which will be described in coming chapters. This distinction is significant; in Worth's case, the equipment was introduced to the Navajo because he wanted to conduct a kind of field experiment. In the case of the Inuit, they decided on their own to get the equipment and learn how to use it. The motives and goals inherent in the former approach are quite different from those of the latter.

To the Navajo, Worth's cameras were unusual, alien, and even amusing. Brought from the outside, they were devices with which those on the inside had no previous experience. They were not requested by the Navajo out of a need to express their culture in film; rather, they were introduced by a non-Navajo out of a desire to answer a particular question: "What would happen if someone with a culture that makes and uses motion pictures taught people who had never made or used motion pictures to do so for the first time?" (Worth and Adair 1972, 3).

The Inuit videographers who appear in these pages, however, came about their work more naturally. For some, videography offered an opportunity to explore and express aspects of Inuit culture and history in a more complete fashion than was available through other media. For others, videography was a way to capture important information and perspectives, preserving them for

future generations. And for others still, it was a job, a decent means to earn a living that offered distinct advantages over driving the town's sewage truck. But all of them came to videography of their own volition, picking up cameras because they wanted to – not because someone asked them to in an effort to answer a research question.

Another difference centres on the question of training. Worth gave cameras to the Navajo and trained them in at least the basics of film techniques. He tried to offer as little training as possible in order to keep the data relatively unsullied, but he acknowledged that the training he gave ultimately affected the process that he was trying to observe. (And of course, he had no other choice.) For this book, however, the training was distinct from my research. The Igloolik videographers pursued their own training in a variety of ways; these ways led to controversy among the groups, but they nevertheless had nothing to do with my presence or research objectives.

And a third difference, related to the first two, centres on what the people being studied were asked to do. In Worth's case, he told the Navajo what he was doing and why he was doing it, and once again he acknowledged that the things he asked them to do could well have affected the final outcome. In my case, the Inuit were making videos already, having begun almost two decades before my arrival. I did not ask them to make videos for my benefit; my goal was to learn how they went about their tasks. All I sought was permission to observe the activities, interview the videographers, and watch the videos.

My approach is no more "pure" than was Worth's, and Worth's research laid a fascinating foundation for future research efforts. But given that natural parallels might be drawn between Inuit videography and the Navajo filmmaking described in *Through Navajo Eyes*, the differences need to be clearly stated. This book attempts to embrace the overarching project undertaken by Sol Worth, who sought to go beyond film as merely a record of culture by viewing filmmaking as an example of culture, an instance of the expression of culture through the creative process itself (1981, 6).[10] Worth, an admirer of Dell Hymes, wanted to discover what filmmaking would reveal about how the Navajo see and structure their lives and the world around them (4–5). He understood that observing a Native filmmaker would allow him to follow Bronislaw

Malinowski's suggestion that ethnographers should try to understand the Native's point of view and his vision of the world. It is interesting to note, going beyond Worth's injunction, that this is precisely what the Native videographer does as well. When Zacharias Kunuk makes a video about some aspect of Inuit culture, he is attempting to grasp more fully the Inuit way of understanding. It is this spiral of meaning that makes aboriginal video such a rich source of cultural expression.

INUIT AND THE MEDIA

One of the ways that video has been used by the Inuit relates to the "old traditional way of life," to borrow Warren Roberts's phrase (Walls and Schoemaker 1989). Video offers an excellent example of the use of a relatively new technology to maintain and revive relatively old facets of culture. But Inuit video must not be seen out of its historic context. The Inuit have a long tradition of storytelling, and this storytelling often took on highly visual and dramatic forms of expression. Storytelling lends itself naturally to video, and vice versa, and in many parts of the world, video is where storytelling has gone. Video should not be seen as a threat to a tradition of oral narrative; rather, it should be seen as the logical next step in an evolving process.

Relatively few scholars have taken a close look at Inuit video, although this is beginning to change. One outstanding scholar who has explored Inuit video is Lorna Roth, the author of several pivotal works about First People's media in general and Inuit media in particular. The history of First People's media efforts in Canada does not need to be recounted here because Roth has published an exceptionally detailed and thoroughly researched treatise on the subject (2005). Among Roth's contributions is an article that offers a useful breakdown of this history into logical stages, culminating in the creation of the Aboriginal Peoples Television Network:

1. Pre-Northern TV Context, in which media produced in the South ignored, misrepresented, or stereotyped the Inuit and other First Peoples.
2. (de)Romancing the North, in which First Peoples began to represent themselves in the media.

3. Policy-ing the North, in which studies were conducted to support legislation regarding aboriginal broadcasting.
4. Consolidation and Expansion of Broadcasting Infrastructure, in which inter-regional media strengthened connections across the North, aboriginal producers sold programs to southern broadcasters, and Television Northern Canada was established.
5. Crossing Cultural, Racial, and Territorial Borderlines, in which Native programming was created and distributed across broader, often informal, networks in multiple directions, and in which the Aboriginal Peoples Television Network was licensed.
6. An International Turn (present and future). APTN joined the airwaves on Sept. 1, 1999, and possibilities for international networking are explored. (Roth 2000, 254)[11]

The creation of the Aboriginal Peoples Television Network (APTN) and its position as a mandatory part of basic cable packages throughout Canada stands as a triumph for the Inuit and other Native groups. APTN is the first full-fledged Native network in the world, and it offers viewers in Winnipeg, Halifax, Vancouver, and elsewhere in Canada the opportunity to see the world through an aboriginal lens.[12] Roth points out that the impact of this network remains to be seen: on the one hand, APTN "provides an opportunity to share imagery, histories, to build bridges of understanding, to bridge cultural borders"; on the other hand, it could underscore and reinforce damaging stereotypes (2000, 267). To date, no comprehensive audience study has been conducted to determine who watches APTN and why.

The emergence of technologies and policies that opened and continue to open the door to Native programming, as Roth describes, presents both challenges and opportunities for Native producers. On the one hand, Native producers have access to audiences, funding, equipment, and other necessities that make their work and its appreciation possible. The IBC is a direct outgrowth of the movements that Roth discusses, and Isuma itself emerged as a separate entity from the IBC. On the other hand, this access to audiences and technologies presents hurdles that Native producers must address, sometimes on a continual basis. The critical reaction to Zacharias Kunuk's second feature-length film, *The Journals of*

Knud Rasmussen, described briefly in this book, serves as an indication of the kind of communicative gulf that must be negotiated when videos reach beyond a purely local compass.

Roth is particularly sensitive to the racial and power implications inherent in Native broadcasting. She argues that diversity is a key component in Canadian society, noting that "implicit in the idea of multiculturalism is the assumption that members of different ethnic and racial groups should (ideally) be able to communicate effectively with each other within a context of legal, social, and political equality" (1998, 488). At the same time, she points out that diversity and harmony are elusive goals that can slip through the grasp of even well-intentioned people and leaders.[13]

Roth focuses her attention on broadcast issues in particular, so as a video production organization, Isuma falls somewhat outside her sphere. However, she thoroughly describes the social and political context within which Isuma was formed and continues to grow. Isuma is the beneficiary of a great deal of patient, savvy political positioning that began almost a half-century ago and continues to this day – although some of the results of this effort have become the target of Isuma's frustration.

Gail Valaskakis, another scholar who has explored the Inuit mediascape, views the development of aboriginal media outlets and efforts as a form of resistance to cultural fragmentation and imperialism (1992, 77). She argues, quite rightly, that while Canada has taken some steps to put its interest in Native culture into practice – steps that are sometimes misplaced, halting, or fiercely contested, I might add, but still better than the record mounted in the United States – it must be noted that "the development of native communications ... is in equal measure the result of the insight and determination of aboriginal peoples themselves" (63).[14]

Noting that some peoples take control of communication technologies and communicative spaces to ground communication in local values, Valaskakis argues that "aboriginal people are listening to and watching native broadcasting and that aboriginal languages are a vital but not exclusive feature of native programs" (1992, 77). In other words, Native programs offer more than merely language preservation. They offer opportunities for cultural negotiation, expressions of identity, and the achievement of positions of respect in the global dialogue. Quoting George Henry's claim that "media consumption without the ability to answer back is the most colo-

nized situation possible," she notes that now, "there can be little doubt about the increased tendency of native people to answer back" (77). Valaskakis's work meshes well with Roth's findings, and both point to the use of media as a means to preserve facets of culture as well as a way to enhance status among the world's peoples.

Marc Raboy takes a position similar to Roth's and Valaskaskis's, arguing that broadcasting in Canada has been both a means to communicate and an object of struggle, a contested terrain (1992, 156). In his review of Canadian broadcasting policies from the 1920s through the Meech Lake Accords of 1987, a review that focuses on the English-French divide in Canada rather than addressing specific questions of indigenous broadcasting, Raboy traces the shift from the idea that there is only one broadcast audience in Canada made up of two language groups – English and French – through the debates over broadcasting's contribution to Canadian unity. He emphasizes the financial aspect of Canadian support for public broadcasting, noting the erosion of budget support for the CBC, the privatization of television production, and the introduction of new cable services (163). Ultimately, the trajectories of dwindling financial support and debates over Canadian unity versus "special status" or other delimiters resulted in the idea that Canadian broadcasting "is a microcosm of Canadian society, and of the quintessential Canadian dilemma of how to accommodate divergent socio-cultural demands within a 'national' framework when the question of 'nationhood' remains unresolved" (170).

This is the context, addressed by these scholars and others, including Faye Ginsburg (1991, 1994) and Stephen Riggins (1992), in which indigenous broadcasting in Canada was born and in which it has grown over the last several decades.

2

Igloolik Isuma

In 2001, at the renowned Cannes Film Festival, the Camera d'Or award was presented to the director/producer of *Atanarjuat: The Fast Runner.* Zacharias Kunuk stood at the podium in a crisp black tuxedo and gave his acceptance speech entirely in the Inuktitut language.

Inuktitut is the language of the Inuit, the circumpolar Arctic peoples from Canada and other Northern nations. Kunuk's speech reflected the vision behind *Atanarjuat,* the world's first feature-length film written, produced, acted, and directed by Inuit. The film is in Inuktitut, a complex but highly regular tongue that echoes with only dialectical differences from Greenland to Alaska. The film offers English or French subtitles to aid the Qallunaat.

While arguably the most famous and influential, *Atanarjuat* is just one part of the deep and rich oeuvre developed by Kunuk's videography company, Igloolik Isuma Productions.[1] Launched in 1981 by Kunuk and three others, Isuma has created a wide range of videos about Inuit life, culture, and worldviews.

IGLOOLIK

Igloolik, the home base for Isuma, is a hamlet and an island. The island separates Fury and Hecla Strait from Hooper Inlet, north of Melville Peninsula, in the run of frigid water between mainland Canada and Baffin Island. The outline of Igloolik Island resembles

the profile of an open clamshell, with Turton Bay forming the gaping mouth. It is an island of rock, mostly limestone, in which can be found fossils of ancient sea sponges and chambered nautili before they curled into their snail-like spirals. Tiny shrimp swim in the pools near the beaches, and diminutive char populate the shallow waters of the only lake on the island large enough to support them. There are no trees; such gaudy growth is reserved for warmer climates. The low areas are covered with damp tundra, stubborn ground plants, and the tiny twigs of a willow that dares not adventure more than an inch into the wind. The high areas are not high; the most prominent feature of the island is the ridge, about 150 feet above the sea, that is used as the cemetery. The ridge's rim is checked with stone-covered graves, most marked with small wooden crosses, some adorned with plastic flowers or colourful pieces of cloth.

The hamlet of Igloolik officially fills the island, but the homes crowd a small cusp on the western shore of Turton Bay. About twelve hundred people live there, nearly all of them occupying small, wood-frame houses painted in gentle, solid colours with little exterior decoration. Physically, the settlement is a thin strip that parallels the shore, rarely extending more than ten or fifteen houses away from the water. Socially, it is a pair of overlapping circles; the centre of one is the Saint Matthias Anglican Church, near the bay and west of the Northern Store, and the centre of the other is the Saint Stephen Catholic Church, near the bay and east of the store. The emotional edges of these circles, never bitter but always palpable, are gradually relaxing, and the introduction of a Pentecostal Church is aiding in this erosion.

Conceptually, the town is a hemisphere, with the radii converging on the Northern Store. Located across a dirt road from the rocky beach, the store provides supermarket-type food and goods that vary in quantity and quality, depending on how recently the annual supply ship has disgorged its containers of groceries and household supplies from the South. Also open for business is the Co-Op, which offers similar fare. Planes arrive regularly with produce and other goods for the shelves, but little is terribly fresh.

The town is governed by a mayor and a hamlet council, and the Hunters and Trappers Association and other groups regulate community life as well. A small branch of the Royal Canadian Mounted Police keeps watch, and an elementary school and a high school

endeavour to keep students enrolled and active – although not always with success.

Few wage-based jobs are available in Igloolik; most of the population receive support cheques from the government. But many of the Iglulingmiut, the people of Igloolik, are hunters, especially the men. Hunting brings in a significant portion of a family's food supply, augmenting the expensive and largely prepackaged foods available in the stores. Seal, caribou, walrus (fermented underground into a delicacy called *igunaaq*), ptarmigan, *muktuk* (whale fat and skin), and the occasional polar bear add fresh protein, minerals, and vitamins to the typical, modern Northern diet. Hunting is considered so important – both nutritionally and culturally – that students are excused from school when their families go out on the land.

Clothing in the North is vehemently casual, with jeans, sweat-shirts, and sweatpants dominating the landscape. Most of the jackets, shirts, and pants come from the Northern Store or the Co-Op, and despite occasional flashes of up-to-date fashion, most have the appearance of basic, economical, department-store wares. Sneakers, hiking boots, winter boots, and rubber "wellies" cover people's feet, although some Inuit wear the more traditional *kamiks* (skin boots lined with felt duffel). Many of the women wear colourful *amautis* (the large-hooded garment traditional to the Inuit); babies are carried in the hoods, where they peer out and cling to their mothers' hair or necks.

In the summer the water in Turton Bay and the straits shimmers with beams of the sun, which gyres overhead in an oval that never touches the horizon. Temperatures reach into the teens (Celsius), and for a few weeks mosquitoes and blackflies thicken the air with wings and whines, swarming and biting with the forced enthusiasm of a short season. The tundra becomes marshy, tugging at boots with greedy suction. And boats cut wakes through the waves as people head off to catch Arctic char and walrus. Children ride bicycles and play tag outside throughout the night, unworried by the opinions of clocks. Trucks scuttle back and forth, hauling water from the reservoir in the west and hauling sewage to the lagoons in the east.

As summer wanes, the sun's oval tilts in the sky, until at last the circuit is broken by the horizon to the north. Then, as it seems from the ground, the earth passes through the oval, forcing the sun to spend ever greater arcs of the night on the other side of the planet. The autumn is cool and pleasant; the bugs are gone, and

the snow has yet to arrive. With the return of the school year, some of the children spend nights at home, while those who remain outside past the ten o'clock curfew siren taunt the bylaw officer whose job it is to shoo them indoors. By mid-November, the sun strains to break the southern horizon, converting midday into a unified swath of sunrise and sunset. Then, around 26 November, the sun succumbs to the swing of the earth and ceases to bring direct light to this part of the world at all. Sunlight remains absent until mid-January.

Winter is cold, routinely reaching fifty degrees below zero, sometimes going down to seventy below. Snowfall covers the land and the ice, but not to any great depth – normal for this part of the polar desert. Daylight returns swiftly, and toward the end of February the sun creates shadows eight hours a day.

On 1 April 1999 Igloolik ceased to be part of the Northwest Territories. The territory split on this day, giving Canada a total of three: the Yukon, the Northwest Territories, and Nunavut. Nunavut, which means "our land" in Inuktitut, is the large portion to the east, and the "Northwest Territories" name remains attached to the smaller western portion.[2] Nunavut is occupied predominantly by the Inuit, who are in a position to govern themselves, with a certain degree of autonomy, for the first time since Canada notified them of their new citizenship back in the 1800s. The official language of the Nunavut government is Inuktitut, and those who aspire to hold government positions face pressure to brush up on their language skills.

ISUMA

Isuma means "thought," but the word has deeper implications than simple cognitive activity. It refers to the currents of the personal soul, and it carries intonations of wisdom, insight, and history. Zacharias Kunuk writes: "Our building in the centre of Igloolik has a big sign on the front that says **Isuma**. *Think*. Young and old work together to keep our ancestors' knowledge alive. We create traditional artifacts, digital multimedia and desperately needed jobs in the same activity. Our productions give an artist's view for all to see where we came from: what Inuit were able to do then and what we are able to do now" (Igloolik Isuma Productions 2005, 9, original emphasis).

Igloolik Isuma Productions was officially incorporated in 1990, and it occupies the second floor of a pleasant building across the street from the town's focal beach. To the west is the Northern Store, and to the east is the Saint Stephen Catholic Church. The building is broader on the first floor than on the second, and scars on the ground reveal the oversized stone igloo that used to occupy this lot. The igloo, which was used as a museum of Inuit artefacts, fell into disrepair and was abandoned. It was vacant for several years. Finally, the town decided to tear it down – a child was killed playing in the rubble – and proposals were accepted for buildings that could be constructed in its place. Isuma's plan was approved, and Isuma secured the funding to have the structure built.

Downstairs in the Isuma building several rooms are rented out to various small companies and government offices; one room is occupied by an Isuma-related initiative to use drama and video to counter the horrific teenage-suicide rate in town. Opposite these rooms is the Tariagsuk Video Centre office and the shared video-editing studio. The studio is rigged for efficiency. A large double set of shelves, hand-made of heavy wood, is filled with equipment: VHS player, Hi8 player, Beta player, three-quarter player, three-quarter recorder, and assorted other pieces of high-tech machinery. A bank of cable jacks spans one shelf, and a diagram below indicates the pattern of cables-in and cables-out that makes the gear work in harmony. In one corner is a console at which the editing takes place. Two monitors, one larger than the other, indicate what is being played and what is being recorded. A centre panel controls the video, and a large box covered with slide-switches to the right handles the audio. Other surfaces are covered with various videotapes that provide the images, sounds, and voices needed for the video that is being created.

Up the stairs directly ahead is the headquarters of Igloolik Isuma. Other small rooms upstairs house Kunuk's office, the Isuma tape archive, and a conference-type room with a long table squeezed against one wall. The main office carries the hurried clutter of any busy space. A long table is piled high with papers that threaten to bury the always-blinking answering machine. A fax machine on a small table across the room churns out messages every day. Norman Cohn sits at the large centre table for hours at a

time, peering into his laptop computer in an effort to find yet
another way to attract much-needed funding. A coffee maker trick-
les nearby, providing caffeine for everyone in the office.

Structurally, Isuma is a small core of dedicated artists surrounded
by part-time actors, designers, costumers, and others who join
active projects and then return to their normal lives once the
action dies down. On some of the days that stretched slowly
between projects, the Isuma offices were quiet. Pacome Qulaut
might be in the editing studio, pulling together clips for a new
short feature. Cohn might be in the main office, working through
the ceaseless puzzle of independent finance. Kunuk might be out
at Ham Bay, sprawled across the snow, getting footage of a boat as it
braves the icy waters shortly before freeze-up.

ISUMA'S VIDEOS

The first video created by Kunuk was *From Inuk Point of View.* Taped
in 1985 – technically before the creation of Igloolik Isuma Produc-
tions – the video was the first project that brought together the
four men who would found the company. Kunuk directed the
video, and Paul Apak was the editor. Pauloosie Qulitalik was the
cultural narrator, and Norman Cohn was the cameraman. The
video offers perspectives on changes in the Arctic in recent years.

In 1989 Kunuk visited Alert Bay in British Columbia. He created
another video from this trip showing his reflections on the Native
people he found there.

Then, shifting from direct commentary to descriptive depictions
of Inuit life, Kunuk and the others at Isuma created three videos
set in the 1930s. The first was *Qaggiq*, taped in 1989. Set at a winter
camp in the 1930s, the video shows four families building a large
communal igloo so that they can gather together and celebrate the
coming of spring. This video has something of a plot running
through it: a young man seeks a bride, but her family is divided
about the appropriateness of the union.

Qaggiq was followed in 1991 by *Nunaqpa*, also set in the 1930s.
The video follows two families as they hunt for caribou to cache for
the winter. The elders remain in the base camp and pass the time
telling stories, while the hunting party stalks caribou and over-
comes the difficulties of hunting on the tundra.

And in 1993 Kunuk and Isuma created *Saputi*, which follows three families as they build a fish trap. However, the capriciousness of nature creates problems; the fish do not come.

The experience, reputation, and success that these videos brought to Isuma lay the groundwork for the Nunavut series. This series of thirteen videos features facets of traditional Inuit life as it follows five Igloolik families in 1945 and 1946.

After the Nunavut series Isuma turned its attention to the creation of documentaries that show various facets of Inuit culture and society. The first was *Saninguati*, which focuses on the sculptors of Igloolik. Kunuk is an accomplished carver himself, and this video shows Jake Kadluk (of the Inuit Broadcasting Corporation) and other carvers in the community. *Saninguati* was created in 1995.

In 1998 Isuma responded to the illegal hunting of a bowhead whale in the Igloolik area. The hunt was conducted to honour the wishes of a dying elder, and it ultimately led to the legalization of a single bowhead hunt every two years. *Arvik!*, the video about the illegal hunt and the subsequent court case, includes a history of whale hunting presented from an Inuit perspective.

And in 1999 – the year that the creation of Nunavut became official – Isuma released *Nipi* (*Voice*). This video examines the shift in power, wealth, and information systems brought on by the rapid changes taking place in the Arctic. "*Nipi* examines fundamental questions of democracy, power and change in Nunavut and indirectly in Canada itself: in education, religion, gender, lifestyle, the distribution of economic development and the make-up and inner structure of the new leadership class" (Igloolik Isuma Productions 2005, 43).

During a funding-induced hiatus in the production of *Atanarjuat*, only a few people poked around the office, pulling together clips for *Nipi*, which was funded by Telefilm Canada and allowed Isuma to bring in some money during the *Atanarjuat* lull.

The "new leaders" topic is pertinent in Inuit society. One of the leadership challenges in the Arctic lies in social disapproval. In traditional Inuit life, people were dissuaded from standing out. Special talents were kept hidden; unique abilities were masked. The goal was to fit into the community, to subordinate the individual to the group. Leaders were recognized by virtue of their age and experience, not their brashness. This philosophy made sense when

harmony within the community was essential to survival, but today's demands are different. Today, the emphasis is on youth, education, and bureaucratic savvy. *Nipi* focuses on these and other issues surrounding Inuit leadership.

Isuma, of course, continues to produce videos of various kinds. Recently, the Isuma producers released *Kunuk Family Reunion*, which aired on the History Channel in Canada, and at the time of this writing *Qallunajatut* (*Urban Inuk*) and other projects are steaming ahead.

Isuma's second major feature, *The Journals of Knud Rasmussen*, was released in the fall of 2006. The movie explores the moment when the Christian world of the West came into collision with the traditional world of the Inuit. Set in the early 1920s, it tracks the arrival of Danish explorer Knud Rasmussen in the Igloolik region, and it chronicles the destruction of Inuit beliefs in the face of Christian overtures. Like *Atanarjuat, Journals* uses mostly local talent; unlike *Atanarjuat*, it presents not a story arc but a collage of images and ideas that represents Inuit views at the time.

The movie was named one of the top ten Canadian films of 2006 by the Toronto International Film Festival Group, which opened its annual film festival by showing *Journals* to an acclaimed audience of international film stars and producers.

"Once we saw Norm and Zach's film, we knew that one of the most important films from and about Canada had crossed our paths," explained festival co-director Noah Cowan ... "Zacharias Kunuk and Norman Cohn have created a truly visionary work of art," said Cowan, in a statement Wednesday. "They have again redefined the scope and visual palette of Canadian film, while telling a profound and moving story. We are proud to present the world premiere of the film, and to support the efforts of these exceptional filmmakers in their presentation of this film to indigenous communities" (Hernandez 2006).

Journals was also shown at the Native American Film and Video Festival in New York in November 2006. "Elizabeth Wetherford, head of the National Museum of the American Indian's Film and Video Center, which is organizing the festival, said that [a] quest for spiritual authenticity helped to qualify the movie as 'one of the most outstanding achievements this past year in native film'" (Alioff 2006).

The film received mixed reviews from critics. Many of the critics who reviewed the film were highly positive:

- "Fans of the Kunuk-Cohn style won't be disappointed with their follow-up, The Journals of Knud Rasmussen." (Hays 2006)
- "A poetic, elliptical account of the first contact between European explorers and the Inuit ... not only a startling work of art but a cultural and historical event ... otherworldly and gorgeous." (Pigott 2006)
- "The film ... is more a collage of image and sound than it is a traditional narrative feature, and is a challenge well worth audience perseverance." (Fischer 2006)
- "Brilliantly sustained ... impressive photography." (Uhlich 2006)
- "Journals is a moving experience about sharing cultures for the sake of preservation, even when it can't be rationalized." (Hillis 2006)

Others, however, found the movie's pace and narrative flow too slow and difficult. Vanessa Farquharson, writing for the *National Post*, gave the film a "¾-closed eyelid" rating, noting that "at least two people at an advance screening had reached REM sleep by the midway point ... Not even a triple-shot of espresso can make up for subtitles disappearing at random or scene after scene of people chilling out in an igloo, not really saying enough to merit subtitles anyway" (2006). Bruce Kirkland of Sun Media wrote that "the story meanders, taking too long to get to its point ... Unfortunately, *The Journals of Knud Rasmussen* pales in comparison to the epic *Atanarjuat*. Oddly, it even feels longer, although it runs shorter, because the flow is choppy and the viewer is less likely to be caught in the current" (2006).

Perhaps the harshest treatment came from Leslie Felperin, writing for *Variety*, who called the film "glacially paced and structurally lumpy." She continued:

Although this Arctic-set Canuck-Danish co-production offers some compelling scenes, spectacular scenery and picks up toward the end, the tale of a 1922 encounter between Inuit people and European explorers lacks the verve and universal accessibility that made "Atanarjuat" such an arthouse pleaser. Beyond Canada and the fest circuit, where the pic is likely to be

more admired than enjoyed, "Rasmussen" looks likely to gener-
ate about as much commercial interest as walrus meat ... On
paper, the plot might sound like it offers a rich mix of ideas,
encompassing the collision of cultures, religions, genders and
the material and spiritual worlds. What a shame then that the
telling is often so flat, especially in the early reels when too
much time is devoted to long takes of Avva and his brood sing-
ing and dancing in their igloos, amid chunks of oral history
from subsidiary characters that slow the narrative. (Felperin
2006)

What Felperin and many of the other critics seem to miss, how-
ever, is that *Journals* is very much a part of Isuma's larger oeuvre.
Most of Isuma's videos have relied on the beauty of the landscape,
the earnestness of the characters, the directness of the action, and
the deliberate avoidance of Hollywood techniques to bring out the
majesty and awe of the Arctic and the Inuit. Kunuk and Cohn are
not trying to take Southern cinematic tropes and recast them in
the North. Instead, they are showing the world a different way of
seeing – a way that has been honed over centuries through the
patience, persistence, innovation, and mental depth that have
allowed the Inuit to thrive in the Arctic.

KNOWLEDGE

Throughout Isuma's oeuvre several themes run with clarity: the
beauty of the Arctic, the value of Inuit perspectives to the rest of
the world, the right of the Inuit to speak for themselves. One recur-
ring theme involves respect for traditional Inuit knowledge. Kunuk
explains what is at stake:

Can Inuit bring storytelling into the new millennium? Can we
listen to our elders before they all pass away? Can we save our
youth from killing themselves at ten times the national rate?
Can producing community TV in Igloolik make our community,
region, and country stronger? Is there room in Canadian
filmmaking for our way of seeing ourselves?
 To try to answer these questions, we want to show how our
ancestors survived by the strength of their community and their
wits, and how new ways of storytelling today can help our

community survive another thousand years. (Igloolik Isuma Productions 2005, 9)

This perspective casts an interesting light on *Qaggiq, Nunaqpa*, and the other Isuma videos. On one level, these videos can be seen as entertainment. On another, they are cultural salvage work – efforts to record how igloos were built and how caribou were hunted before this knowledge is lost forever. But the Isuma videomakers see them as something else. They see these videos as a chance to show people – southerners, perhaps, but young Inuit in particular – how difficult life used to be in the Arctic and how intelligent, resourceful, and creative the Inuit had to be to survive there. This respect is not limited to ancestors long dead. The old people in Igloolik – people who can be seen shopping at the Co-op, checking their mail, walking along the streets – have this knowledge. They are that intelligent. They have had to be that resourceful. They possess this creativity. Kunuk and Cohn hope that viewers of their videos will look at these people differently and will understand that true wisdom about the ways of the North lies not in young, school-educated minds but in these land-tested veterans of the Arctic.

"Some forty year olds are running this community," Kunuk says. "The eldest who have all this knowledge are just sitting because, because of new politics. We have to have a grade 12 ... To get a good paying job, you need education ... So they [elders] lay low. They're just dying off. So that's one of the reasons why I went into video. I mean to capture it before they go. That was my idea, capture it before they go. And learn from it."

And the process of making the videos – even beyond the existence of the videos themselves – is intended to reinforce this message. "We had a scene that needed a sealskin tent," Kunuk says. "Few know how to make them anymore. So we turned to Rachael [an Igloolik elder]. She knows how to do it."

"And there's not a prop guy anywhere in the South who knows how to do it," Cohn adds. "The lab [the Igloolik Research Centre] archives knowledge – it doesn't perpetuate it. If Rachael makes a tent and her three daughters learn how by watching her, then the knowledge is not archived. It is active and perpetuated."

Another theme running throughout Isuma's work is the idea that the Inuit deserve a place among the world's leaders. With

more than four thousand years of history in one of the world's most difficult places to live, the Inuit and their ancestors have developed myriad techniques for solving intricate social, environmental, and political challenges. The videos made by Igloolik Isuma show time and again that the Inuit have much to offer the rest of the world.

NEW APPROACHES

In the world of independent art, there is a scarcity of full-time, permanent, salaried positions. In exchange for the freedom to tackle the projects that interest them, the people of Isuma have given up the security of the steady paycheque that they could earn at the Inuit Broadcasting Corporation (IBC). No one at Isuma can depend with confidence on a salary; rather, the pay – along with the job descriptions, the responsibilities, and the time demands – fluctuates according to the project at hand. When between projects, many of them collect government-subsidy cheques like the majority of Arctic residents. During the filming of *Atanarjuat*, scores of people earned part-time salaries.

Kunuk, Cohn, and the rest of Isuma, living as they do from project to project, must always have an idea of what they are going to do next. As one video moved forward, the Isuma producers had several grant applications out for other projects. They planned to do a video about shamanism, for example, and they worked to secure funding for it. They also applied for grant support for a video about the challenges of being an aboriginal video producer in modern Canada. Specifically, the video would focus on the struggle to secure grant support for *Atanarjuat* and would focus on what Isuma sees as a racially biased, unfair system of funding. Cohn smiled slightly when he talked about this project. "We want to see if they're willing to finance a video that will expose the very people doing the financing," he said. "This will be interesting." (The funding application was ultimately declined.)

For the Isuma producers, the uncertainty of independent video is more than offset by the freedom. Kunuk, Paulossie Qulitalik, and Paul Apak, all working for the Inuit Broadcasting Corporation, became disenchanted with the IBC's bureaucracy and what they perceived as a Southern-centred and Southern-directed organization. In 1990, joined by independent videographer Norman Cohn,

they formed Igloolik Isuma Productions Incorporated, an enterprise that would create videos about the North from an Inuit perspective, without the strings and red tape that formal affiliation with the government can bring.

Isuma's core embraces videography as a political tool. Even while earning awards as an IBC producer, Kunuk had been working on independent video projects for several years, and he was beginning to gain an international reputation; one of his projects, *Qaggiq*, was shown at festivals and exhibits in several countries. Throughout this time, Apak was busy making independent videos as well. In 1990 he produced *Umiaq*, which tracks a trip he made to northern Russia to videotape the making of a walrus-skin boat. Apak left the IBC shortly after completion of this project, and Kunuk followed suit in 1991. The final straw came, Kunuk says, when he filed a requisition for a four-wheel all-terrain vehicle (ATV). At the time, each station in the IBC network had to submit a "wish list" for equipment to the central office in Ottawa. Kunuk found this process demeaning; the requisition of professional equipment to do a professional job, he felt, should not be degraded to a "wish list." (Norman Cohn commented later that presenting a "wish list" is something children do at Christmastime, hardly an appropriate requirement for professionals requesting necessary equipment.) Despite his feelings about the process, Kunuk submitted a wish list that included the ATV, and then he began the negotiation process. He insisted that the machine was needed so that the producers could haul gear to the locations where they planned to shoot, and he pointed out that producers in other communities already had vehicles, while his producers had to drive their own machines or lug the equipment by hand. He sacrificed other items on the wish list in favour of the ATV, and he pressed his request down to the wire.

In the end, the request was denied. Kunuk, already concerned about the Southern control over IBC, the minimal freedom he felt was given to producers, and the constant battle over budgets and supplies, left the IBC a short time later and devoted his full energies to Igloolik Isuma Productions. At Isuma he could pursue the projects that seemed most important to him, and he would answer only to the local people involved in the enterprise. The move, however, cost him a great deal of security; he shifted from a government-supported, steady production facility to a grant-supported, intermittent business that would at times employ scores of people

and at times lay off nearly every one of them. Still, Isuma suited his temperament and his vision, and he made the move permanent.

The Isuma producers position their organization as a resistance cell, and the power structure that they are resisting is colonial Canada – and through Canada, the colonializing powers of England, France, America, and the rest of the South. The story is familiar: Canada, in an effort to strengthen its sovereignty over the northern reaches of North America, sent Royal Canadian Mounted Police patrols into the Arctic to set up small posts and to make regular contact with the Inuit. The political threat was real (or so it seemed to the Canadian government); Norway and Denmark had sent several explorers into the region, in essence extending their influence over the Pole, and into the not-so-distant reaches of the North American Arctic archipelago.[3] As the Mounties made regular contact with the Inuit, stories were relayed southward about the conditions that the Inuit faced every day: the threat of starvation, the lack of formal education, the absence of health care, and so on. Ottawa responded by "encouraging" – often backed by intimidation, threats, and false promises – the Inuit to move to artificial settlements, where schools, clinics, and other facilities could be placed (Tester and Kulchyski 1994).

The result was disastrous. Families were split. Groups of skilled caribou hunters were moved to regions devoid of the animals, and the hunters were given fishing gear and told to provide for themselves. Promised support – jobs, food, and so on – failed to materialize, and several Inuit starved to death in the new settlements or on the arduous march back toward their original homes.

As part of this "bring the Inuit into the modern world" movement, the Canadian government forced children to leave their homes and enter boarding schools, where they were forbidden, often under penalty of severe beatings, to speak their native language. For many adults today, the memories of their time in the boarding schools remain bitter.

Isuma stands against the colonial impulse that drove Canada to conquer the Arctic not with armies but with schools, settlements, and the Mounted Police. Isuma advances its position by holding up Inuit life and culture, both past and present, as models for the rest of the world.

3

Inuit Video as Folklore

Then out there beyond puny human efforts to control little bits of the universe looms amused the larger force that some describe by scientific mechanics and others name divine will, a force that escapes creativity but toward which a project gestures ... Gathering the individual into its creation, arriving as a communication among people, referring beyond to the all, a project claims the power we have built into the word art.

Henry Glassie (1992), 270

Zacharias Kunuk's first video, *From Inuk Point of View*, carries a telling title. In the Inuktitut language, *inuk* is a singular noun meaning "person." (Literally, it means "one who is possessed by a soul" – with an interesting line of ownership. The soul possesses the person, not the other way around.) *Inuit* is the plural form, created in typical Inuktitut fashion by dropping the ending "k" and adding "-it."[1]

So *From Inuk Point of View* expressly does not attempt to offer "the Inuit perspective" on anything; Kunuk understands the enormous variety of attitudes, opinions, thoughts, approaches, and worldviews that thrive among the Inuit. The video is a personal expression, not a collective one. Borrowing Henry Glassie's words, it is the product of "the intending consciousness of an actor" (1989, 34). Kunuk applies his own perspective, his own creativity, and his own unique expertise to the task. Starting with the choice of subject, he gives his videos a unique imprint – an imprint that often emphasizes the inventiveness and wisdom, creativity, adaptability, and sophistication of his ancestors:

I try to videotape things that fascinate me. Whoever invented the dog team must have been a genius. Whoever invented the igloo must have been a genius. The harpoon. All these tools.

Some – how did they figure it? Somebody had to figure it out.
Where did they come from? Before, our ancestors – every thing
was done shamanistically. They had to get the information.
Maybe it came from them. I wouldn't be surprised. Because the
art of the igloos – you can't do it any other way, probably build
it square. The shape of the igloo, and when it's perfect, it's
beautiful. The dog team, somebody figured it out. Tying a line
to these animals and commanding them – command them to
left, turn left, to turn to right, to stop, to go. That fascinated
me. Also navigating – navigating was really fascinating, to see
how people navigate. Because you could be out there in the
blizzard, just have to know your way around. But how? It's really
very neat. You have to be out there. You have to know the land.
You have to know what kind of rock is out there. You have to be
out there a lot in order to know what you're doing. Same with
finding different types of snow, snow covering on the floe edge.
You have to be out there in order to know what you're doing, a
lot. You have to be out there a lot. Just standing on the seal
hole, and when the seal comes up for air, it's a great feeling.
Makes you jump, everything. You also have to know if it's an old
aglu or if it's a fresh *aglu*.[2] Or is the seal near here? You have to
know all these things in order to see it. "Yeah this one is fresh,
so we are near." And then somebody walks around, trying to
scare the seal to that person who is standing there. That's a
unique teamwork, teamwork, really teamwork. People walking
around, or skidooing around, or dog-teaming around. The idea
is try to get seal to that person, whoever is standing on the seal
hole. It's there, right under your feet, breathing. Then the per-
son who is standing there now has to know where to harpoon
or shoot. Because the seal is in the water, there are currents
going, there's a tide going. Is it high tide? You must know if it's
up. You have to know the *aglu* water. The seal could be in, the
seal could be out there. The seal could be out there. The per-
son who is standing on top has to know where the wind is com-
ing from. Has to know what, how's the tide. Know the current.
Know where to aim. I've missed a couple of times, the hunt, I
have, I have got it. It's easy once in awhile. Just, I mean, some-
body just walks up to a seal hole and stands there and he just
thinks that's hard. First of all, that's easy. But once you're there,
you have to know where the seal is. You have to know which

direction the wind is coming from. Where you have your feet. And the currents especially. And the wind. And the seal would be facing the wind, or facing which way the direction of the current is coming. Then in the pie, that piece of pie is the seal. You have to know that. What you call it? Scientific? Experience. I love it. Sometimes it's so easy, sometimes it's so hard. Sometimes you just stand – in one or two minutes the seal is there. Sometimes you're there, sometimes the wind is too strong and you don't hear it or listen to it. Some days you get nothing at all. You start to wonder what's wrong with you – and this guy sitting there gets a lucky strike every time. Sometimes it looks as if it all depends on the mood. [Laughs.] Same as caribou hunting, same as any other hunting. You just have to know what you are doing.

Kunuk, impelled by his passion for the wisdom of Inuit elders and his personal vision of the facets of Inuit life, created *From Inuk Point of View* and other videos to give expression to this vision. The creation of videos is a personal performance that strives to educate, inform, and motivate viewers in service to social and even spiritual ideals.

But while it is apparent that Kunuk – like all video artists – goes to great lengths to project his own views into his videos, it is just as apparent that no artist works with total freedom. Like folklore, art is the act of creation with attention to culture, a means to bring "into dynamic association the ideas of individual creativity and collective order" (Glassie 1989, 24). The creation could be the telling of a legend, or the carving of a sculpture, or the dancing of a dance – or the taping and shaping of a video. Essential to this process, from a folkloristic standpoint, is the sincere and enthusiastic involvement of the artist in the culture that he is trying to express (Glassie 1999, 17). The culture, of course, could be any of the myriad cultures that an individual embraces: religious, social, communal, familial, and so on.

Involvement in culture means understanding and working with the genres and other systems that the group imposes on the individual. Just as it is difficult to imagine someone carving an image out of stone and sincerely declaring it an opera, it is difficult to imagine a videographer working completely outside the bounds of cultural norms and categories. Something carved out of stone is

going to be evaluated and understood as a sculpture, even if the artist insists that it is something else. And if it is evaluated as an opera, it is likely to be deemed a poor example despite the artist's intentions. Similarly, a video will be critiqued against cultural expectations and generally understood genres.

This tension between the personal and the social is a fundamental aspect of cultural communication, and those interested in studying culture often find it a fruitful realm for exploration and analysis. Folklorists – as well as anthropologists, cultural studies scholars, and others – will be interested in specific facets of indigenous video as well. For example, folklorists might be interested in videos because of the folklore contained within them; videos record and present elements of the society being taped (Dégh 1994). In Igloolik this society consists of the Inuit of this small community, and together the IBC, Isuma, and the Tariagsuk Video Centre have made hundreds of videos that show aspects of the culture that is prevalent here. Isuma's *Nunaqpa*, for example, shows caribou-skinning techniques that reflect the kind of history and awareness that Kunuk describes. *Qulangisi* shows the logic, skill, and patience required to hunt seals. *Qaggiq* shows an approach to igloo building (and the dance of relationships). Videos showing storytelling, *qulliq* (stone lamp) tending, the sewing of skin clothing, the making of *kamotiqs* (sledges), and so on – all are of interest to folklorists for the information that they provide about Inuit culture.

But the *process* of videography is perhaps of even greater interest to folklorists and other scholars (Bauman 1975, 291).[3] Indigenous media producers often "stress the activities of the production and reception of indigenous media" (Ginsburg 1993, 575), and the different ways that Isuma's producers go about their work shed a great deal of light on the cultures of the Inuit and of the producers themselves. In particular, they reveal the goals that each artist holds for humanity, goals that cannot possibly be reached through the tiny efforts of an individual person but that loom ever closer as we march toward them together.

CULTURAL NEGOTIATION

Folklorists' embrace of video – and of the mass media in general – has been tentative at best. Part of the problem is that video is intended for large audiences. Strict adherence to definitions of

folklore resembling Ben-Amos's view that it constitutes "artistic communication in small groups" requires the rejection of any media intended for large crowds (1972, 13). But this notion of folklore as occurring in small groups belies some fundamental assumptions. First, holding a storytelling model or a ballad-singing model in mind, it assumes that the audience is a single group: the people on hand when the story was told or when the ballad was sung. But the study of material culture, to take one example, shatters this assumption. The "audience" for an Inuit carving could be just the buyer and his or her immediate family, or it could be the throngs of people who file through an exhibit at the Metropolitan Museum of Art. Similarly, a chair built by an Appalachian woodworker might be seen by just a handful of visitors to his or her living room, or it might be seen by thousands of people who watch a long-running play for which the chair was purchased as a prop. In both cases, the audience comprises more than just the initial group of admirers; depending on what happens to the object in question, the audience can grow over time to encompass legions of people. Jake Kadluk of the IBC created a video of a walrus hunt; the program was aired on Television Northern Canada, which broadcasts to thousands of homes throughout the Arctic. In the summers, the video is shown again in rerun. It also might be repackaged in special programs produced in the future, and clips from it might be worked into additional shows. In all, the audience for this piece could comprise thousands of people who watched it the first time, thousands more who watched it in rerun, and thousands yet again when it was rereleased in other forms. Kadluk, like many artists, indeed hopes that a lot of people will see his work; he wants people to learn about one particular hunter and about walrus hunting in general by watching his video. Ultimately, the audience might be quite large – even if the initial audience was small.

The folkloric nature of Kadluk's work is not altered by the number of airings or the size of the audience that eventually appreciates it. The audience, however large, is viewing the product of Kadluk's folklore, not the more important process. It is the group involved with the process, the act of creation, that can be used to distinguish folklore from other forms of expression. The audience that eventually watches Kadluk's video might be huge, but at the moment of creation the group involved would be the four employees of the IBC – Julie Ivalu, Jake Kadluk, Ruben "Bobby" Alorut,

and Anthony Ittusardjuat – perhaps some bystanders, and the hunter and the others being taped. These people – a small group of them – came together to make a piece of art, a program. They interacted, they communicated, and they followed patterns and fulfilled expectations, and in the process they made a program that stands as an artistic achievement. That tens of thousands of people are eventually going to view the tape is irrelevant. The scope of the eventual audience cannot determine whether something is folklore; it is the "small group" present at the moment of creation that matters.

Nevertheless, there is for some a certain discomfort with the consideration of "mass" media as folklore. In addition, there is discomfort with the presence of electronic mediation in folklore, a preference for the direct and personal over the electronically manipulated. Both issues have been addressed by respected folklorists; Dell Hymes has considered the first, while Linda Dégh has discussed the second.

Dell Hymes points out, quite nicely, that there is no such thing as "the masses," and he is exactly right; "there are no masses, only ways of regarding people as masses" (Hymes 1975, 8). Hymes's view of people – and his view of the ethnographer's proper perspective – are worthy of support; I daresay few ethnographers would argue in favour of treating large groups of people as homogenous collections of mindless mannequins. It is important, however, to distinguish between the "masses" and the "mass" of "mass communications" or "mass media." The term "mass communications" is useful as a means to distinguish media that operate on a few-to-many relationship beyond the scope of a single storyteller, say, sharing a tale with a few dozen, or even a few hundred, listeners. And not only does the term have value, but it also does not inflict the slight to which Hymes refers. It seems to me that the "mass" in "mass communications" or "mass media" refers not to the people who will eventually receive the communication or media but to the ultimate quantity of examples of this mode of communication or media that are created. The "mass," in my lexicon, refers not to people but to the number of copies of the newspaper or magazine issued or to the number of radios or television sets that could be tuned to receive a particular broadcast. There is a "mass" to such instances of communication, and this mass has nothing to do with people. If a magazine printed a hundred thousand copies

of its first issue, for example, and absolutely nobody bought or read one, it would still be an example of mass media. So I will use the term "mass media" to refer, in my case, to videos that are either broadcast on television or made available for viewing in some other way, and I do so without intending any comment on the people who view them. That said, we are free to consider the relationship between folklore and the mass media without the fear of unintentional slight.

Linda Dégh offers a persuasive argument against limiting folklore to the non-electronic. In *American Folklore and the Mass Media* she notes that electronically reproduced folklore "retains all the criteria by which we judge what is folklore and what is not: it is socially relevant, based on tradition, and applied to current needs." She points out that the mass media bring folklore to audiences in ways necessary in the modern world, and she encourages folklorists to wade into "the slippery marshland of the new, mass-mediated cultural universe" (1994, 1–2).

The above argument is intended to usher in video as a possible folkloristic act. But the objection is easily seen: if an Inuit video is folklore, why not *Law and Order* or *All My Children* or *Saturday Night Live?*[4]

The most important difference falls back to the "small groups" idea, with the emphasis this time on "group" rather than "small." Alan Dundes has given us the notion that a folk group is any two people who share at least one common trait (1965). While economical, this definition fails to rule out much, making it somewhat less than helpful. But by adding a new layer to it, as Roger Abrahams did, it becomes more cogent: a folk group is any group of people who are aware of their own "groupness" (1983, 345). The team at the National Broadcasting Corporation (NBC) that puts together *Law and Order* – the scriptwriters, the actors, the producer, the director, the lighting technicians, the makeup artists, the hairstylists, the set crew, and so on – all work on the same show, and they all are aware of a common purpose, but it would be difficult to argue that they all feel part of the same "group." The makeup artists probably don't see the scriptwriters very often during a routine day, and the lighting technicians most likely have little to do with the hairstylists. And other affiliations often take precedence; the set crew may feel greater allegiance to its union than to the rest of the team putting together *Law and Order*. But at

the IBC and Isuma people have a very strong sense not only of being part of their particular video team but also of being part of Igloolik, Nunavut, and the Inuit in general. There is a strong sense of group identity that is lacking in a studio at which everyone goes separate ways at five o'clock and doesn't see the others until nine the next morning. Even with *Atanajuat,* a large-scale Isuma production, the people who worked on the movie were much more part of a group than are the people in the major Hollywood or New York studios. The *Atanajuat* artists go to church together. They play "pass the penny" and "nail the board" with each other in the Community Hall. They visit each other's houses. And when they were working on the production, they were all there, bustling about in a kind of dynamic equilibrium. They are much more distinctly part of a group – and much more aware of being part of a group – than are sound crews and costumers in New York who work on multiple shows in differing configurations of personnel.

SOCIAL EXPECTATIONS

Kunuk and his fellow videographers face a difficult problem. An oral storyteller has the advantage of watching the audience as the story is told, and he or she can make adjustments as needed. If an audience laughs cheerfully at the silly nature of one particular character, for example, the storyteller might "play up" this character a bit, further exaggerating mannerisms and speech. If the audience is impassive in response to a character who was supposed to be funny, however, the storyteller might diminish the character's role in the story or even drop it altogether. Albert Lord describes one immediate audience effect on performance this way:

> The essential element of the occasion of singing that influences the form of the poetry is the variability and instability of the audience ... The singer begins to tell his tale. If he is fortunate, he may find it possible to sing until he is tired without interruption from the audience. After a rest he will continue, if his audience still wishes. This may last until he finishes the song, and if his listeners are propitious and his mood heightened by their interest, he may lengthen his tale, savoring each descriptive passage. It is more likely that, instead of having this ideal occasion the singer will realize shortly after beginning that his audience

is not receptive, and hence he will shorten his song so that it may be finished within the limit of time for which he feels the audience may be counted on ... One can say that the length of the song depends upon the audience. (1971, 16–17)

The audience's reactions are important in performance because they suggest to the teller the patterns and expectations that he or she may draw upon in the telling. "During communication, in the interplay of coherent intention and coherent response, creator and group become a unity shaped by the creative act" (Glassie 1989, 34). The teller often will know much about the audience before beginning, but the shifting nuances affected by mood, recent events, distractions, and other factors – in short, the facets of the narrative event – require the teller to adjust as the story goes on.

When Kunuk makes a video about hunting caribou or building a sod house, however, his audience is far removed in both time and space. He can't hear his viewers comment on particular passages. He can't see them nod or scowl when certain images appear on the screen. But the physical absence of the audience during the production event does not mean that it has no influence at all. Audience is very much on Kunuk's mind when he goes about his work.

Immediate feedback is luxurious. It allows a storyteller to adjust continually to accommodate the audience and to achieve the greatest effect. But the audience exerts another kind of influence as well, even when remote. When the teller initially chooses a story to tell, and a way to tell it, he or she takes into account an understanding of the audience members and their likely degree of appreciation for certain kinds of stories and certain ways of telling. In other words, the intended audience affects the story even before it is told. A teller would be unlikely to choose a bawdy story for an audience that would consider such material offensive – unless offence was the desired goal. Similarly, a teller would be unlikely to choose a staid, prim story for an audience in a rowdy bar. The nature of the intended audience affects the story selection because the teller tries to anticipate the kinds of stories and the manners of telling that will have the greatest desired impact. (See Dolby-Stahl 1985, 52–4.) As folklorist John Michael Vlach puts it, "Folk artists, by definition, submit to or are at least very aware of the demands and needs of their audience ... Should they deviate markedly from the usual criteria they run the risk of rejection" (quoted in Benedetti

1987, 4–5). Similarly, William Wilson notes that "if the story is to live, [the storytellers] cannot, in the telling of it, depart too far from the value center of the audience whose approval they seek" (1976, 46).

In addition, the audience continues to influence the artist after the story is done. If a story was well received, the teller might consider which of its aspects – selection, style, word choice, gestures, and so on – contributed to its success. If a story was badly received, the teller might consider which of its aspects contributed to its failure. Was the topic too painful? Was the delivery too boisterous? Were the words too difficult? Was the tone too flat? The teller who desires to do well in the future will consider the various aspects of the telling and make decisions about what to change, and what not to change, the next time he or she is called upon to relate a tale.

Obviously, a video cannot be adjusted to suit audience reactions during the process of performance.[5] But like the teller of oral narratives, Kunuk considers the needs and expectations of the intended audience and adjusts, in advance, such factors as the selection of the story or topic to be shown in the video, the way the video is made, the use or abandonment of certain special effects, and other facets of production. "I try to give the audience what they need," he explains. If the intended audience is the people of Igloolik, for example, then he can make certain assumptions and decisions based on his knowledge of this group. Usually, he regards the Inuit viewers who will see the video on the local cable channels as his primary audience and the Qallunaat audiences who might see the video at festivals, contests, and grant-application judgings as his secondary audience.

And like tellers of oral narratives, Kunuk considers the successes and shortcomings of his previous works when deciding what to do next – and how to do it. A successful video, like a successful tale, will encourage its creator to do more of the same. When Isuma released *Qaggiq*, it was widely heralded as a triumphant piece of Northern, aboriginal videomaking. Two years later came *Nunaqpa*, a video similar in many ways to *Qaggiq* but different in several key ways. Kunuk is not mass-producing clones of his early work – his oeuvre shows clear signs of growth, thought, and development – but instead has learned from his early experiences and has honed

his sense of the kinds of videos that are most likely to achieve the effects that he desires for them.

So the audience, although physically and temporally divorced from the performance process, nevertheless affects this process through the minds of videomakers. And the audience – or more accurately, the impression that the videomaker has of the intended audience and the understanding that the videomaker develops regarding past audiences – is part of the larger cultural context within which the performance takes place. Richard Bauman points out that performance is fundamentally social (1986, 8), but it is important to note that this social aspect does not demand the immediate presence of others. As Bauman also argues, the very act of creating a recording gives a storyteller a sense of a larger audience and so inspires a fuller telling of a tale than might otherwise be delivered (105). The presence of a camera, and special lights, and a microphone, and a director conspires to suggest an audience – and often a large audience – even if no one else is present at the time. Hymes notes that sharing a performance is essential but can be "real or imputed" (1975, 13). In other words, the performer must believe that the sharing will take place, but it does not necessarily have to take place at that moment. In the case of video, the performer helps to create a program that is intended to be seen, even if the viewing will take place at a later time and another place. The imputation of sharing is still in effect. The understanding that there will be an audience at the presentation event is sufficient to provide the social dynamic that is essential to the performative act.

Kunuk considers the often-conflicting demands of a particular situation and shapes his video performance accordingly, demonstrating competence (see Hymes 1975, 131; Worth 1981, 49).[6] His goals include personal satisfaction in the work, a clear delivery of certain values and images, an elevated opinion of Isuma within the community, the appreciation of the people involved in caribou hunting, and so on. (And his goals do not include many of those assumed by Southern audiences: the seamlessness of transitions, the impressive use of special effects, the swift changes believed to ensnare attention, and so forth.) The video segment is taped, edited, and aired. The degree to which the goals are met serves as a measure of Kunuk's competence – which involves both the selection of the goals and his ability to achieve them.

Nunaqpa follows two families across the land during their inward trek to hunt caribou, recording their natural activities as they go. In reality, the piece is more tightly controlled than it might first appear. The credits cite Zacharias Kunuk as the writer (in addition to director and producer), and the camera angles reveal that the group's activities were arranged and even loosely blocked in advance. Nevertheless, the video does not follow a conspicuous plotline. The hunt provides something of a structure for the piece, but as a narrative device it is essentially different from the impending wedding and conflict between the parents that form a more obvious plot in the earlier *Qaggiq*. In *Nunaqpa* the actors are free to do what they know how to do: set up tents, hunt for game, and entertain each other. There is no climax; even the shooting of the caribou is done casually (bang! bang! "We shot two!" – then on to the butchering). *Qaggiq*'s suspense has been replaced by *Nunaqpa*'s adherence to a more candid style, and the latter simply ends when the hunting party returns to the main camp.

This natural approach to videography presented Kunuk with some interesting challenges:

> In *Nunaqpa* it was different – the shoot – because we were running out on the land. We have to be a step ahead of these people all the time. Just to get the view. And we cannot just let them sit alone for hours and hours because the sun is moving. And the Caribou Union did not cooperate. The wildlife that we wanted to capture, these people hunting which – We have no control over the wildlife, so what we end up with – we just want to follow these people. Especially when they were on a hunt. We just followed them. We tried to keep up with them, 'cause it was quite an experience for me too. 'Cause I never ran so much with a beta cam on my shoulder in my life ... We just tried to show them living, them hunting, living, coming back, what's the view from the shore when they're coming back, 'cause I've heard so much about it and I was there and I saw it, and we captured it on video. That's how it was like. These old people were happy to see them coming with all this meat.

There are times – but fewer than in *Qaggiq* – in which the process of making the video becomes apparent. As the hunting party is hiking back to camp, a light drizzle begins to fall and droplets cling to

the camera lens. If Kunuk had been worried about the audience's awareness of the camera – the droplets remind viewers that they are looking through a lens – then the scene could have been shot anew and steps could have been taken to keep the lens dry. But Kunuk and the others at Isuma seem untroubled by such things. That the process might be rendered transparent is not important; what counts is the value of the content. The old people who camp along the shore and wait for the hunting party to return are portrayed by actors from Igloolik who lived there before the government settlement program and who remember going about these very same tasks. It is the appreciation of their memories that matters.

THE VARIANT AND THE VIDEO

The hunter aimed his rifle. Kunuk aimed his camera. The caribou was captured, on rocky hill and on videotape. Kunuk had recorded, for the limits of his technology's duration, the act of caribou hunting, by this hunter, at this time, near Igloolik. When the hunter went home that night, he told his family about the hunt; he wove a narrative about the stalking, the subterfuge, the choice of one brown-and-white body out of the many that grazed on the hill. He talked about the moment of decision, the careful aiming of the gun, the squeezing of the trigger that turned wildlife into sustenance. He described the act of butchering, the flavour of the meat.

Later, the hunter told the same story to his friends. The basic points of the narrative were the same, but the story itself, of course, was not an exact replica of the first version. It was a new variant of the tale, a fresh account of the hunt.

Kunuk's video also shows the facets of the capture. But when the video is shown and reshown; it does not change. The material on the tape is exactly the same from one showing to the next, without regard to audience, context, or timing.

Folklore's existence in variants is one of its hallmarks (Toelken 1996, 33–7).[7] Each telling of a story, each dancing of a dance, each enactment of a ritual is a variant – necessarily so because no two performances are identical.[8] "Neither tradition nor variability alone makes folklore. The key is their simultaneity, their interdependence" (Glassie 1989, 31). But with video, each playing of the tape is not a variant in the same sense because the content and pre-

sentation on the tape don't change at all in subsequent showings. The story shown and told on the tape holds constant – the actions, words, conflicts, and perspectives presented are the same for the hundredth showing as they were for the first.

So video demands a new way of thinking about variant. In oral storytelling the performance produces a new variant because the words are not (usually) exactly the same, and the intonation, gestures, facial expressions, pace, and other factors are new with each telling (Bauman 1975, 302–5).[9] As Lord puts it, the performer "is at once the tradition and an individual creator" (1971, 4). Also changing are the audience, the reason for the telling, the stories that were told before and after, the setting, and other rich elements of context. The hunter describes his hunt while sitting in his kitchen, enjoying caribou meat with his family. He tells of the hunt outside the Northern Store, chatting with friends he met there by chance. He talks about the capture with hunting partners going out for whales the next week.

Each telling brings new words, new emphases, new gestures and expressions. But each new telling also embraces new contexts, new audiences, new reasons for beginning the tale. When Kunuk's video is shown on successive occasions, the former set of factors does not change – but the latter set does. The video is offered as more than just an idea; it is the specific variant frozen on tape that the artist gives the world in the hopes of bringing it further down a chosen path. The audience, setting, reason for a showing, and other contextual, event-centred factors, all new with each showing of the video, in essence complete a new performance of the videography process and thus result in a new experiential variant. One day a showing of Kunuk's video might produce awe over the resourcefulness of the Inuit, blending the use of an old skill (stalking caribou) with a new technology (the rifle), which makes the hunt easier and more humane than it was when spears were used. The next showing of the same video might trigger an appreciation of the energy required by the hunt, as the hunters stalk, butcher, and haul the animals. A third showing might result in good-natured teasing about the hunter's role as a star of the small screen. Because the presentation of the video to an audience is an essential part of the video's performance – and because the nature of this presentation changes as the audiences, situations, and rationales change – each showing results in a new performance despite

the consistency of the other elements of the performance. And each performance, once complete, results in a new variant of the video, taken broadly to include the nature of the presentation and its reception.

TRANSMISSION OF CULTURAL INFORMATION

An anthropologist might look at Kunuk's video about caribou hunting as ammunition for a treatise about Inuit communication systems, a social product that fits in with other anthropological explorations into kinship, government, and other facets of culture and society not necessarily created by any individual person. An art historian might look at the project as an example of Kunuk's approach to videography, exploring his use of cutaways and sound and other techniques that give expression to his personal style as an artist. Folklorists are interested in the area in which these spheres overlap; "being neither art history nor anthropology, folklore finds a comfortable niche in the middle ground between its two senior siblings" (Cerny 1989). It is the ground between these poles, the particular creations of individual people within a social and cultural context, that is of interest to folklorists, so Kunuk's video about caribou hunting offers a way for folklorists to explore what it means to be an Inuit videographer within Inuit society. Kunuk's work means one thing to his peers at Isuma, quite another to his rivals at the IBC, another thing still to the people of Igloolik, and yet another to the hunter himself. As an artistic creation, Kunuk's video is bounded by the society and culture in which he works, and it stands as an example of his artistic views, talents, and perceptions within these bounds.

A possible tension between folklore and video, however, lies in the transmission of information. In the classic folklore model, skills and ideas are passed from parents to children, from masters to apprentices, from elders to youths. This education takes place, generally, in face-to-face encounters in which examples are offered, attempts are made, and responses are given. In some ways, video disrupts this process.[10] It is now possible, for example, for a person to learn how to tend a *qulliq* (stone lamp) by watching the *Qulliq* video. With video, a master can record an activity, and an apprentice can learn from it years later – perhaps even after the master's death. The master-to-apprentice relationship is changed in other

ways as well. Video allows for no monitored trial-and-error process; the apprentice, after learning as much as possible from the video, might try the activity and gauge his or her success without the edifying reactions of the master. And unless used as part of a larger pedagogical enterprise, video is unidirectional; the apprentice can learn only what the master shows on the tape, without any questions or false attempts that might lead the master to show something different or to show the same activity in a new way.

Given such disruptions, it is easy to think of video as the antithesis of folklore. It is unchanging. From creation to presentation, it is spatially and temporally disjointed. It is geared to a mass distribution devoid of personal interaction. But the *creation* of video, rather than the consumption, can embrace a cooperative impetus toward harmony. "We think of folklore not as a kind of material but as a kind of action" (Glassie 1989, 34).

In keeping with this idea, Isuma strives to make videos in what Cohn calls "a third way" – not entirely Inuit in approach, because videography itself is an outside endeavour brought to an Inuit sphere that previously had had nothing to do with it, but not entirely Quallunaat in approach either. The producers at Isuma approach videography in a way that is resonant with Inuit views of the world:

> For four millennia Inuit have refined cooperation as a medium of production and survival, valuing consensus and continuity over individuality and conflict. As a collective, Igloolik Isuma Productions arrives at the millennium practicing respectful cooperation as a formal element of our media art. We implant these values – our collective process – in our filmmaking practice; community support and participation are qualities of production we make visible on the screen. We extend these same values to cross-cultural collaboration. As artists bridging the past and future we practice a third way, different from either the Inuit way or the White way, both solitudes separated by centuries of fear and mistrust since Columbus and Frobisher "discovered" the New World. Inuit skills of working together join with southern ideas of community videomaking in a new model of professional production that can expand film and television in Canada and around the world. (Cohn 2002, 23)

Along these lines, Isuma often chooses loose outlines over tight scripts. In the grant application that Isuma submitted to Telefilm for the Nunavut series, the producers argued for an Inuit approach to video storytelling that did not necessarily fit Western notions:

> At Isuma, our 'Final Draft Scripts' are composed as story out-lines for each project which describe the Inuit idea of the pro-gram and generally what our actors will do. These Scripts are based on research with Elders who recount true stories orally from their own experience and knowledge of the past: how things were done, and how people behaved.
>
> Details of action and specific dialogue are then improvised during filming in an Inuit way, through discussion among cast and crew based on their own experience, responding to the weather, land and other conditions on location at the time. These conditions are always variable, and cannot be predicted – or "scripted" – in advance ...
>
> This approach is precise and professional based on realities of Inuit culture. Inuit hunters travel without maps, since condi-tions on the land are always variable and the road cannot be "scripted" in advance. Hunters arrive safely through knowledge and experience. This is the Inuit way, based on oral rather than written skills.
>
> We produce our television programs with the same skills used in hunting on the land ...
>
> Igloolik Inuit ... have survived 4000 years not through aggres-sive, emotional conflict but rather by living cooperatively in very close quarters. Perhaps for this reason Inuit have no word in their language for "war," consider aggressive conflict to be ridiculous or insane, and believe that only children express pas-sionate emotions openly.
>
> Cultural differences like these must necessarily change the idea of what makes a "story" ... Cooperation *is* the story, rather than conflict. (Published in Gale and Steele 1996, 69–71)

MATERIAL CULTURE

Video is more than a story, more than the telling of a story. It is also something that is made. A video is a material object, made through

the manipulation of other material objects and through the efforts
of the people being taped and of the editors, directors, and pro-
ducers who turn the raw footage into a finished presentation. As
such, it is physical art, just as tangible as an oil painting or a sculp-
ture; with video, as with other material art, nature is destroyed in
service to culture (Glassie 1999, 17). And as such, it is an intrusion
into the world, an intrusion created for deliberate purposes and
given form with these purposes in mind.

One difference between a video and a carving, of course, lies in
mediation. A carving of an Inuk raising a spear in search of a fish
can be appreciated immediately, without the intervention of any
additional mechanism. A video, however, must be played to be
appreciated; it is meaningless without mediation. But in this day of
"performance art," in which such nonmediated genre as sculpture
and painting are presented along with either live performances or
the playing of video or audio recordings, mediation has ceased to
be a limitation in art – if it ever was so. Art relies not on the unme-
diated apprehension of the artist's work but on the apprehension
itself.

Videos depend on cameras and VCRs in the same way that books
depend on presses. The only way to appreciate *Moby Dick* is to read
it, and the reading demands the printing. As a story, *Moby Dick*
existed in the mind of Herman Melville; our only access to it lies in
our ability to read words that Melville wrote and that someone else
printed as a book. But an interesting difference emerges between
books and videotapes. Books themselves are works of art; the bind-
ing, the typography, the illustrations, and even the choice of paper
and ink are options in the bookbinder's art, and the book that
emerges can stand as a work of art even if unread. To take but one
example: *Nunaqpa*, Kunuk's video about caribou hunting, remains
an intellectual property; the physical product is unimpressive and
machine-made. The art lies not with the physical tape but with the
images recorded on the tape, just as the art of the Boston Philhar-
monic lies with the music itself, not with the audiocassette that
allows us to hear the music remotely. The art – the effort to reshape
the world – is thrust into the world by an artist who chooses vehicles
useful in achieving the desired teleological end.

Also in contrast to books, the creation of a video requires the cre-
ation of other pieces of material art. While it is possible to video-
tape a scene candidly, with no warning and no preparation, most

videos presented as art are painstakingly created, beginning with some kind of script. Whether the script is a loose set of general instructions intended to give shape to an otherwise impromptu performance – as is the case with many of Isuma's productions – or whether it is a full, detailed explanation of lines to be spoken, gestures to be made, tones to be adopted, and actions to be undertaken, the script represents a piece of cultural and personal artistic expression in written form. It is one example of the material culture that goes into making a video. Other examples include the costumes, the sets, the props, the makeup, the hairstyling, and all the other objects and items created in service to the producer's vision. Each of these items represents material culture in its own right, and together they form part of the material art of the video.

These items also are the raw materials from which the videographer builds the final creation. Just as the carver wields a saw and a dremel, the videographer wields the camera and all that passes in front of it. Either directly or through oversight, he makes the sets, he places the props, he positions the people, and he controls all the details that will make up the scene that he intends to capture on tape. He manipulates physical objects to express a particular view. More than Melville pushing a pen, Kunuk shapes a scene, building it frame by frame until the desired effect is achieved. If something happens during the taping that detracts unacceptably from the scene, it can be performed and taped over again until the materials deliver the result that the videographer envisions.

VIDEO AS FOLKLIFE

In addition to functioning as both storytelling and material culture, video, at least as it is done in Igloolik, can also be seen as an essential element of the folklife of the community. Jan Harold Brunvand defines "folklife" as "the full traditional lore, behavior, and material culture of any folk group, with an emphasis on the customary and material categories" (1986, 329). In this section of the chapter, the emphasis is on the behavioural and customary. Video is not ritual, for the making of one video replicates the making of previous ones only in a broad sense. And it is not festival, for it usually lacks several of the key elements of festival, including any sense of the celebratory or sacred. But it is a form of folklife, for it shapes how people go about their everyday lives in and around the

community. This influence is not uniform, of course; some people in Igloolik watch the videographic efforts from a distance, content to view the final products when they are ready. But many of the Iglulingmiut take part in the larger projects, contributing their efforts both in the spirit of cooperative enterprise and as a way to bolster their incomes.

The first way that this shaping manifests itself, of course, is obvious: the actors would not be wearing their costumes or performing their actions if not for the video project that inspired and (sometimes) paid them. The costumers might make parkas at other times, but the garments would be intended for practical use and social show, not to function as costumes for a video. The actors might routinely get together for fun or socialization, but they wouldn't be performing the actions and saying the words asked of them by the director. All three video groups in Igloolik – Isuma, Tariagsuk, and the IBC – use people from the community to create their videos, and as a result life in Igloolik is different from that of any other Arctic town. Samuilie Ammaq describes his walrus hunting in an IBC video. Lucy Tulugarjuk plays the evil seductress in *Atanajuat*. Rosie Iqallijuq talks about the starvation of some travellers as cameras from the women's video group Arnait Ikajurtigiit roll. The creation of video, now more than three decades old in Igloolik, has had a direct effect on the way that people share their lives in this community. Few of them have been untouched by video production, and everyone knows that their activities might end up captured on tape.

The production of video in Igloolik affects the folklife there in other ways as well. Videography forces the people of Igloolik – especially those directly related to the development of videos – to consider the intricacies of their culture more directly than do most people. For example, the overarching conundrum in *Saputi* demonstrates a facet of Inuit culture that might otherwise have gone unarticulated. While its title suggests that it will be about fish traps, the traps are in fact subordinated to the daydream scenes in the program. This apparent feint points to a conceptual underpinning in Inuit culture. Nearly every aspect of traditional Inuit life – hunting, fishing, travelling, visiting, celebrating – is dependent on the fickle whims of nature. A hunter might declare that it is time to go out for caribou, but if a storm hits, these plans will have to be delayed to suit the environmental timetable. A group of families

may decide that a *qaggiq* (large igloo for communal gatherings) celebration is in order, but if the hunters are unsuccessful for several days in a row, there will be too little food for the gathering. As an old man says in the *Atanajuat* script, "Dreaming of ice won't make it freeze."

Video calls on participants – and to an extent, viewers – to confront facets of their cultures more deliberately and more fully than they otherwise might. The impact on the social life of the community can be both subtle and profound.

LAYERS OF UNDERSTANDING

When a story is told orally, the teller pieces together the words and images "on the fly," converting an abstract mental construct into a story while at the same time delivering the story to an audience. A videographer – Kunuk, for instance, making *Nunaqpa* – goes through a similar process of construction and presentation, offering both superficial meanings apparent in the video and deeper layers of meaning encoded in images, words, and juxtapositions.

When viewers watch *Nunaqpa*, they generally accept at face value the activities that they see on the screen. The man butchering a caribou stands for a man butchering a caribou; the image is an icon for an actual event. But this icon carries meanings below the surface as well, and Inuit audiences understand them.[11] The caribou can represent a substantial amount of food for a family, so the man butchering the animal is providing sustenance for his loved ones. (See Freuchen 1961; Rasmussen 1929; Stefansson 1927.) The skin becomes clothing – a warm coat, perhaps, or a few pairs of boots – so the man is not only feeding his loved ones but also keeping them warm. In addition, he is helping to secure his family's future because a man cannot hunt in the winter without a caribou coat to ward off the killing temperatures. Or the hide might be bedding, an added layer of comfort for the sleeping platform that spans the back of the igloo, *qarmaq* (semi-permanent shelter), or tent. It is on that platform that the entire family sleeps, side by side beneath the heavy skin blankets. So the man also might be tending to the family's unity by making warm the one place where he gathers with his wife and children at the end of the day.

The layers mount. The antlers represent tools, but they also gesture toward carvings; caribou-antler carvings have been popular

cash items ever since the Europeans began whaling and exploring
in the Arctic more than a century ago (Eber 1989; Swinton 1972).
The cash that a good carving brings can provide necessary com-
modities that must be purchased in a store: fabric, steel knives,
ammunition. (Not to mention, these days, Nintendo cartridges,
hockey gear, and the latest offering from Nike.) So butchering
a caribou can be seen as an entry into a cash-based system of
exchange that positions the Inuit and outside traders, usu-
ally Qallunaat, in a delicate balance of competing needs. It also
serves as a reminder of gender roles in traditional Inuit life; the
man kills and butchers the caribou, but the woman is responsible
for cooking the food, treating the skins, and sewing the clothing
(Wachowich 1999). The man will skin the animal in accordance
with the desired use of the hide – cutting one way if it is to be used
for clothing, another way if it is intended for bedding – but beyond
this, it is the woman's job to make use of the animal once it has
been delivered to the door.

Other layers: in *Nunaqpa* the hunter is not alone, and his pres-
ence with company engages certain understandings. Hunting is
almost always done in small groups because solitary travel in the
Arctic is dangerous, so a man's isolation would raise questions:
Does he have any friends? If not, why not? Has tragedy struck the
rest of his party? Or has he committed some taboo that resulted in
his ostracization? The hunter in *Nunaqpa*, travelling with others, is
obviously prudent, proper, and popular. The time of year would
engage additional meanings, as would the weather, the state of the
man's clothing, and other cues.

These meanings, which would be understood by Inuit audiences
watching the scene, give resonance to the icon on the screen: the
man butchering a caribou. As an icon, the image carries meaning,
and the cultural familiarity of the viewers conditions the nature of
the interpretation.

But the video works the other way around as well. Rather than
serving as an icon for a previous event, it is a mechanism by which
this event is constructed. In this view, the narrated event is not
logically prior to the narrative but depends on it – events are
abstractions from narrative (Bauman 1986, 5).[12] Seen from this
perspective, the man butchering the caribou on screen does not
stand for a man butchering a caribou in "real life," but rather the

image on the screen shapes and conditions our understanding of an event that we infer from the information provided by the video.

This perspective runs against the immediate sensation offered by video. Even in this age of special effects (most of which are left to Hollywood's big-budget filmmakers), there is a tendency to believe what is seen in documentary-style videos: the man butchering the caribou on the screen really did butcher this caribou in the manner and place depicted. In straightforward documentary videography, this assumption is usually intended. The videographer wants the audience to believe that the events on the screen reflect, with some degree of accuracy, the events that occurred.

So on the surface, videos invite the audience to accept that the video is an icon for the event. But the very nature of video presentation counter-intuitively supports the "event as abstraction" idea. Like oral storytellers, videographers use such techniques as flashbacks and beginning *in media res* to manipulate the formal properties of the narrative while at the same time keeping the underlying story intact. In addition, changing camera angles breaks apart the flow of the event as it would have been perceived at the time that it happened, but nevertheless the audience follows the underlying story, reassembling the parts to form a coherent whole. Videomakers also use the sound track variously to smooth over the breaks, as when the sound continues uninterrupted despite a change in camera angle, or to emphasize the seams, as when the sound and the camera angle change at the same time, or even to provide a sense of discontinuity in an otherwise steady scene, as when the sound changes – adding music, for example – even though the camera angle remains the same. Audience members receive these and other real pieces of a story and fit them together in their minds to form an abstraction that is then accepted as the real event on which the video is based.

And even if the camera never changed angles, even if the stream on the screen was wholly uninterrupted, the abstraction of the event itself would be necessary because of the information that is not presented in the video. A few years ago the IBC, for example, created a short piece on Nunavut Day, a celebration commemorating the signing of the agreement that would create the new territory. In Igloolik part of the celebration featured a young man performing a drum dance in the gym of the Ataguttaaluk High

School. The camera did change angles but not very often; instead, it remained fixed on the young man as he bent forward, dancing slowly and striking the rim of the drum with a thick stick. In the span of the camera's arc, only a small segment of the audience can be seen, people sitting on the floor or in small chairs, some dressed in traditional outfits and others in jeans and Toronto Maple Leafs jackets, chatting and watching and applauding from time to time. From this small segment, viewers of the video are expected to extrapolate the full crowd, which extended in both directions along the walls of the gym. Viewers do this with ease. They can fill in the rest of the setting, "seeing" the rest of the room and the people in it, even though these details were not shown on the screen. So the actual event, in the viewers' minds, is abstracted not only from the pieces presented in the video but also from their own experiences and understandings of what such scenes are usually like. It is possible that the videomaker asked the entire small audience to crowd into one section to appear in front of the camera, but the video's viewers will not consider this likely. Rather, in their minds they will fill in the rest of the scene with reasonable accuracy.

FOLKLORE AND VIDEO

Some folklorists shy away from video – or anything mediated through electronic machinery, or anything intended for mass consumption – out of a belief that a fundamental difference exists between folklore and video and that the boundaries should thus be defined and defended. But folklore is a multidisciplinary enterprise, a pursuit more comfortable where ideas flow together than where ideologies march apart. When an artist goes about the task of creation, he grapples with modes and models offered to him by society, working through them to create a personal expression of the larger concerns, issues, and beliefs that impel him forward. Videographers – especially those of Isuma and other indigenous video collectives – work in small groups to create forms of cultural expression in ways that reflect their heritage and their worldviews.

Once created, a video stands as a frozen variant, allowing the performance of video to be completed time and again when the video is watched in various settings and for various reasons. Rich with embedded and encoded meanings, the video serves as a communication from the videographer to the world, stretching out

into time in ways that echo but do not mirror other forms of folk-
lore. It is a material work of art that can weave together elements of
the community's folklife and offer tapestries of cultural informa-
tion to distant neighbours and future generations. Kunuk, Kadluk,
and the other videographers in Igloolik work through this process
routinely, pressing the personal against the social to achieve the
eternal.

4

Isuma's Artists

Isuma is a flexible collective that expands and contracts depending on the work at hand and the availability of performers and crew. Deliberately rejecting the hierarchical structures, rigid schedules, and coercive leadership techniques that Zacharias Kunuk and the others see as indicative of a misguided, neocolonial approach to organizational management, Isuma instead follows an approach that its members find more natural and more in keeping with Inuit ideals. The producers operate with a high degree of freedom, joining projects or developing their own in keeping with their vision and energy. Deadlines are subordinate to weather, hunting opportunities, and other factors that have long influenced Inuit lives.

At the core, in the beginning, were Zacharias Kunuk, Paul Apak Angilirq, Pauloosie Qulitalik, and Norman Cohn.

Paul Apak died in 1998, after launching the effort that would result in *Atanarjuat: The Fast Runner.* In recent years, following the success of *Atanarjuat,* the Isuma office has added several staff members. But Kunuk, Cohn, and Qulitalik remain at the heart of Isuma, supported by other talented people. This chapter tells the stories of the central characters.

ZACHARIAS KUNUK

The history of Isuma is inextricably linked to Zacharias Kunuk's journey from the old ways of Inuit life to the world of independent

videography. He was born in a sod house at an outpost camp near Igloolik on 27 November 1957. He recalls being carried in the hood of his mother's *amauti* (parka); "then I remember I used to crawl under my mother's *amauti*, under her to get in front so I could get my milk." He also remembers that life on the land was hard, especially for him and his family. His father had sided with a shaman in a local feud. When the shaman died, Kunuk's father was afraid that he would be next, so the family moved away from the camp. They were treated like outcasts in many ways, Kunuk said. The only time they got news from the outside world was when somebody in the family grew ill. Then they would be visited by others who would try to help – and who would bring information and gossip with them. "We would get the news that somebody died, or something bad happened, or plenty of things over there."

Kunuk recalls the time, when he was a boy, that his mother went into labour:

My mother gave childbirth alone in the springtime, in the tents. I woke up. She had made herself a bed with curtains, skins low beside her, in a tent in the springtime. She was there in pain when I woke up, and I noticed that I was alone [with her]. What she did was, she sent my brothers and sisters out of the tent because she was in labour. And I was sleeping – that's why I got left behind. I woke up and she was moaning, and what I noticed she had prepared something in front of her, and one of the objects I remember was a nice glass jar, really clean. Empty. Just straight glass. And she still, I didn't know she was in labour. She wanted me to hand her the jar, so I gave it to her, and she puts it into her mouth and blows, she was blowing air into it. So on that I freaked out, and I got out of the tent and I just stood outside. And a few minutes later, I heard the baby cry. She did it. She did all of us. So I never forgot that.

As Kunuk was growing up, he was raised in many ways as a girl, because his namesakes – Atagutaluk, Kigutikajuk, Tagaaq, Kuatuk, and another Kigutikajuk (this one was his father's mother) – were all women. "My hair was long and it was braided, like I was being brought up like a girl, because of my name," he said. "That's why I try to take my hat off every time I eat, for my namesake. If I am not outside."

He explains further:

I carry five namesakes. All of them used to be women. So tradi-
tionally ... To my father, to my mother, and to other existing
people in the age group – 'cause my father's like sixty-eight
years old now – he still calls me "mother." So in Inuit culture
you go by the rank, by your age. When you're the youngest, you
do the most shitty work. When you're the oldest, you com-
mand, tell people what to do. Because my namesakes, they were
all – They call me "mother," they call me "the old lady." And
every time I speak, they sort of feel, have to listen. Because it's
me, Zacharias, speaking, but my namesake – that's what they
are aware of. That's how it goes, and we just live normal today.
But some people just call me "mom." Old people just call me
"mom," or nicknames ... I've heard a lot about my name from
my mother, because my mother tells me that when she
[Kigutikajuk] was going to die, she wanted to be a man on her
next life. Because she didn't like having to wait for the hunters
to come home, and wait for food to come in. What she wanted
to do was be out there hunting the food. That's just my name-
sake. So, every time I eat I take my hat off, or somebody tells me
you're forgetting your name. That's just a superstition we have.
Respect your namesake.

Kunuk remembers a little bit about his grandmother Kigutikajuk,
primarily from stories that he has been told. One story that he tells
shows the woman's courage:

I think it was two years ago this elder was telling me about my
namesake, and he was talking about death. She knew – that's my
namesake – that the undertaker is coming. I only knew "under-
taker" in the WWF, in that whole wrestling, the wrestler.[1] The
undertaker that can sort of, they call it that, when they cut the
wheat? [I suggest "scythe."] Yeah, regarding that. But anyway, he
was telling me that she saw the undertaker coming into the
camp, only she knew that the business of the undertaker is to
take somebody. Somebody's going to kick the bucket. She
thought the undertaker was coming for her, to take her away –
and she was not ready to go. It's not time. Not yet. So she pointed

at the undertaker to stop, to stop it. But the undertaker wasn't coming for her. The undertaker was coming for somebody else.

Growing up in the outpost camp, Kunuk lived for many years before he saw his first non-Inuk. "There was a Roman-Catholic Priest, Father Tony, somehow maybe I was sick or there was no doctors or nurses in this area. I went to his wooden house and he stuck a needle in my elbow. Some sort of vaccine that everybody was getting, and it was my turn. First Qallunaat I see, and he sticks a needle in me. Ouch. My parents they would discipline us – 'behave or that Qallunaat is going to get you.' So we were brought up scared of the Qallunaat." One of the reasons that the Qallunaat made effective bogeymen, Kunuk thinks, is because of the timing of his youth. "The Qallunaat, they were coming around up here in the last World War, and the Inuit knew that they kill other people. They kill themselves. I remember that's why they were so afraid that we might get killed also."

When Kunuk was nine years old, a government worker told the family that the children must be sent to school – or the family-allowance cheques would stop coming. So Kunuk's parents sent their children to school in Igloolik. Kunuk went to school through grade 8, the highest available at the time. He found that he liked school a great deal.

School was fun. I mean, I loved mathematics, but reading and spelling were not my – I tried to master them. But math, no matter how many numbers you have, you always have the result. If in fractions, or any way you tried, you'd always get what you're looking for. I loved math. And art, I loved art. I was drawing in school, and I just had it – and somehow I just had it, drawing. Then I started carving because I wanted to go to movies. The movies in the seventies, you had to be – There was like a matinee for kids, and adult movies. You had to be sixteen to get into the adult movies. Not "adult," like maybe it's Walt Disney and real movies. So I was under sixteen and was carving. By the age of twelve I started carving, trying to sell my carvings to the teachers so I could go to the movies. Sometimes I was small, sometimes I was short, I even cried for a quarter to my parents, which they didn't have. Sometimes they had it, and that's why I

started carving. I was carving for big bucks, 'til I got my camera in 1981. Then I started recording. It's fun, it's fun.

The link between carving and movies took deep hold. Kunuk so loved movies that when he heard that a private individual could own a video camera and make movies of his own, he wasted no time. He was a highly regarded carver by this time, in 1981, so he made several carvings and flew to Montreal to sell them. He had seen television whenever he had gone out of town, and he knew what he wanted to do.

What I did was I bought a video camera – a portable video camera – twenty-six-inch TV, and a VCR, so I could view my shootings. When we went to buy my camera, a guy at the counter showed me – "this is how you charge your batteries," "this is how you put your camera on," "this is how you put the tape." I don't know how many tapes I brought back because I started to record over it and over it, which I shouldn't have. But I kept one tape which I wanted to save so much – my son just learned, crawling on the floor. I just made home videos of my family and I kept that. I am glad I kept it, because he's now seventeen years old, and I can just throw on the tape and show him how he was crawling on the floor.

Kunuk was living in a tiny "matchbox" house in Igloolik at the time, yet the living room was dominated by a big television set. "I would put on my tapes, and kids going by outside – they would be glued to my window. Trying to watch the TV through the window."
Armed with this setup, Kunuk began to teach himself how to make movies. He filmed family events. He filmed goings-on around town. He filmed anything he could think of, and he continually learned how to convert ideas in his mind into images and sounds on videotape. Broadcast television had not yet arrived in Igloolik, so Kunuk was developing his skills, and his eye, with minimal shaping from outside broadcast models. As his skill increased, he found video a supple medium: "Through the carving you have to work and work to express what you are trying to show. If it breaks, you have to change your mind a little and fix it. Not what you planned at first. But video, you don't have to do anything, just

show it and it speaks for itself. That was the difference. Video just speaks for itself."

When the Inuit Broadcasting Corporation (IBC) opened a production centre in Igloolik in 1982, Kunuk applied for a job. Video skills were rare in Igloolik, of course, and he was hired. He worked as a producer for the IBC for eight years, eventually earning promotion to the rank of executive producer. The executive producer is in charge of the entire production centre, handling all the budget and personnel matters as well as overseeing the video-production work. Kunuk was grateful for the chance to further document the wisdom and cleverness of the Inuit for a broad audience: "That's why I make video, to talk about the old things, so maybe just to really see it, how it went. There's a lot of things that we still just know that have to be recorded. The danger of floe edge – people sometimes die, drift off. When they try to get back on the safe ice, but they – how to do it? So we have to record it on video. If an ice broke off, me, and I am drifting out to sea, how do I survive? They knew how to do it."

In 1985 the IBC hired Montreal-based video artist Norman Cohn to hold a two-week workshop in Iqaluit to teach video techniques that went beyond the standard broadcast model. Kunuk was interested in the workshop because it offered an antidote to the conventional training that, he felt, threatened to turn IBC programming into fledgling, ineffective echoes of national-network news shows and other major Southern programs.[2] Kunuk and Apak had not been through the typical Southern-oriented training sessions and so continued to present material in a unique style. Cohn had seen their work and liked it, and he was happy to learn that Kunuk was being flown to Iqaluit to take part in his training session. And Kunuk was eager to learn how to use his camera to greater advantage:

I never had real formal training in camera. I learned it all by myself. At the start when I had my own video camera, at the start, it was a colour camera. But I couldn't get the camera to work the colour. It was just the white balance, or a switch, or daylight, or overcast – which I didn't get at the start, and I couldn't work it out. It took me maybe a year before I knew how to get the colour right. Here I was working for IBC a

number of years just learning off Paul Apak, show me a little
how to work the camera. I never had any training ... Maybe I am
off, maybe I am on, maybe there are new tricks I could learn.
So I came down to a workshop, I think it was a one-week work-
shop where a whole bunch of us had to start, sat down with our
trainer and we would learn to do camera training. But every-
body was so busy, you know how – they're doing the network,
they had to package shows. Everybody went to work, and left
me there. I am here to learn. I am just wasting away. So I said to
Norman, "We have to do something. I came all the way down
here to learn what you can teach me. Let's do something." I
mean I was tired of waiting. There was this other guy who was
interested in learning, a good buddy of mine. He and I ended
up the only people of Norman's. We went out there. First time,
I train using the camera, and he was telling us that the camera
– we had the whole floor. That was the subject. So one of the
training things, we went into a church, where the camera has to
be anywhere we want, where it should be. So what it was, we
were walking with the camera, but in church we usually sit
down. But now I was with the camera. I have to get some shots
of people visiting. I have to walk right up to the minister, who is
talking, right up in front of him, right side, right behind him.
Just to get the video, the best video possible. And I had never
done that before. And we sort of felt odd at the start. But
nobody minded, nobody cared, nobody even knew I was there.
I mean everybody ignored me. Then our next training was,
we're in the high-rise, in the restaurant where everybody goes
to eat, on their lunch hour. We wanted to videotape what kind
of people could eat up there, so I went up there. I have the
whole floor, I can move around, I can videotape people eating.
But it was even more odd because it turned out to be very
Qallunaat, the people who go there were back then, '85, I think
it was. Winter of '85. People who go to eat there, they're all
Qallunaat, no Inuit. And here I was taking the camera to their
faces, and it must have been odd with people eating soup with
the camera right beside them. It was a situation where some-
body could just throw that soup at me. But nobody did. Again,
everybody ignored me.

So I got it. I got rid of my fears, how to have the whole floor.
Or that image, you want to capture an image now while it's

there, you cannot catch it, or you can catch it maybe in a different way. But you want it now. That's the message I got. You have the whole floor, you can move around and because inside IBC they weren't doing that. I wouldn't be surprised if they're still not doing that. They would just stand there, tripod and get everything from that one position. But the trick is to have the whole floor, take different angles. But Norman's training was fun. But still, that was a church service and a lunch break, a lunch hour. But then we moved on to events like a drum dance, to everything, like square dances. It's really fun when you are all over the place with the camera. But before I thought, the idea of the length to capture an image, make it close from that distance, not every camera can do that. But the difference it makes to be really there, right beside somebody dancing or drum dancing who moves around, get the beat of the drum dancer. How it feels like to be drum dancing, that's what's more important for me to capture it than to sit at the corner with a tripod and capture it all that way. It's different. It looks more real. So that was my training.

As part of the workshop, Cohn and Kunuk made a video together. It was a portrait of Iqaluit titled *Two Strangers in Frobisher Bay.*[3] (Neither Kunuk nor Cohn are from this town.) After the workshop, even while Kunuk continued to work at the IBC, he set about making videos on his own. His first independent production, completed in 1986, was *From Inuk Point of View,* a twenty-nine-minute documentary that shows various aspects of the syncretic life in the North.

From Inuk Point of View is not a movie or a documentary. It is a video collage, showing images that, in their relationships with each other, sketch out the compass of Inuit life in Igloolik in the mid-1980s. Viewers see a pit of white bones in the waving grasses, dog teams pulling *kamotiqs* (sledges) across the snow, walruses belching on the ice, children dressed up for Halloween, the bustle of the annual sealift, the settlement of Igloolik lying still and stubborn against the harsh winter.[4] "I just followed my parents, and I made a video tape of my parents hunting up there. I worked on other Inuit issues – what people are thinking, what elders are thinking, how Inuit used to live. Trying to hammer their methods to everybody's head, that this community is unique. It's four thousand

years old. Wake up! We have that evidence. We showed some two-thousand-year-old carvings that somebody had found."

From Inuk Point of View shows that life in Igloolik today is a forced mix of practices, beliefs, and attitudes from both North and South. The message lies not only in the images, which are rich and provocative, but also in their juxtaposition. The relationship between images is a powerful tool in Inuit art: "The concepts of transformation, spirits and shamanism ... allow artists the creative freedom to play with unusual juxtapositions of subject matter, composition, materials and even colours" (Hessel 1998, 43). A common approach to Inuit sculpture involves the use of several images: not just Sedna, for example, but Sedna and a walrus and a seal and a drum dancer, together forming a web of relationships. Sedna is the mother of the seal, which is a transformation of the smallest joints of her fingers. She is also the mother of the walrus, a transformation of the largest joints. The drum dancer evokes thoughts of journeys beyond the material world. Shamans use the drum as a vehicle with which to travel to the spirit world, and once there, they endeavour to appease Sedna so that the seals and walruses and other marine mammals will be available once again for hunting. It is through the juxtaposition of these images that relationships are anchored and stories are told. Sedna as mother. Sedna as keeper of the food. Shaman as supplicant. Shaman as procurer. Walrus and seals as children. Walrus and seals as nourishment.

In a similar vein, struggling against the limits of a deep but linear medium, *From Inuk Point of View* offers an argument against those who live in the South and have formed their opinions of the North through movies, books, and slide shows that have ulterior motives, showing the Arctic as dark and dangerous, the Inuit as exotic and ever-smiling. Kunuk, on his trips south to film festivals and art shows, is asked the same questions again and again: "Do you know how to build an igloo?" (Yes – he uses them for props in his videos and as shelter when he hunts.) "Do you live in an igloo?" (No – his house is made of wood and drywall, with a furnace, plumbing, and cable television, just like the others in Igloolik.) "Do the Inuit still use dogsleds?" (Yes – but only to take sport hunters from the South on polar bear hunts. The law requires those hunts to be conducted with dog teams. The rest of the time, hunters use snowmobiles, all-terrain vehicles, and boats.) *From Inuk Point of View* is an attempt to answer many of these questions at once, showing life in the Arc-

tic not as strange, glorious, or anachronistic but as everyday reality. Halloween is an odd transplant, but it is celebrated every year. Life is more than eking out a grim survival; there are celebrations and parties and silliness. And a lot of people hunt; it is uneconomical to do otherwise.

Yet as much as *From Inuk Point of View* is a response to Southern misconceptions, Kunuk says that it is aimed primarily at a Northern audience: "That's why we never really subtitled it in English. As I was saying, I wanted to hammer that information to everybody's head. Where we are and where we go. I had shown it through TVNC [Television Northern Canada]; they had it on a couple of times. More than a couple of times. We made that especially to the Inuit audience. To hammer in to their head where we are, what's happened to us. It was fun – the elders were speaking out."

Video Stream

Kunuk intends his work to capture, preserve, and perpetuate Inuit culture and language, and his second independent video, *Qaggiq*, reveals some of his strategy for achieving this goal. He is not content to make videos that are aimed at people who fondly remember the old ways. He wants his audience to include young people in the North – and most people in the rest of the world – who know little about Inuit traditions. His decision to subtitle the video in English, for example, shows something of his perception of his audience. The spoken language throughout the video is Inuktitut, and no dubbing interferes with the audience's ability to follow the dialogue. But the subtitles serve to broaden the audience by incorporating those who understand English but not Inuktitut spoken at normal conversational speeds. The video is an effort to communicate Inuit culture outward, to new audiences, not merely to reflect it inward to those already familiar with it.

That the video is scripted, albeit loosely, offers more evidence along these lines. Kunuk wanted to shape a story for his viewers rather than simply capturing and showing igloo-making skills, for example. This is not strictly a documentary; it documents much about remembered Inuit life, but it goes beyond this as well, striving to engage the audience with character development, a plot about an impending marriage, a climax as several outcomes become possible, and a resolution. Video is the tool that Kunuk

uses to remind people of how Inuit ancestors triumphed over difficult challenges: "We see it, it brings back memories of how they used to live. This is how we used to live. How great it was. I remember, people remember. It's been a long time. People are forgetting. People are really forgetting. Our job is to capture it now. Not tomorrow."

Kunuk gradually grew disillusioned with the IBC and its Southern-controlled budgeting system, so in 1990 he joined with Paul Apak, Paulossie Qulitalik, and Norman Cohn to formally incorporate Igloolik Isuma Productions. A year later, he left the IBC completely and began working exclusively with Isuma.

NORMAN COHN

As mentioned above, Isuma began to emerge as a coherent concept when Kunuk got together with Norman Cohn in Iqaluit. Cohn, a Qallunaat who maintains homes in Igloolik and Montreal, considers himself one of the "original, first generation, video freaks." When low-cost, portable video technology was first developed by Sony in the late 1960s and early 1970s, an early generation of nascent videographers jumped into the field:

> It was mostly a sort of radical, left-wing, sixties-related gang – people who saw low-cost film or television production as a sort of grassroots, radical opportunity to crack what was otherwise a very exclusively controlled corporate system. And so you had basically sixties-type left-wing groups springing up in different parts of the states mostly. Mostly New York and California at first. With names, you know like Video Freaks. There was another group called Ant Farm. The first journal published was called *Radical Software*. And video was referred to within this crowd basically as guerrilla TV.

In 1970 Cohn was in Chicago working on an experimental film project about young children, a "sort of pre-Sesame Street, aimed at poor, young preschoolers." As a result of his involvement in this project, he was invited to participate in the 1970 White House Conference on Children and Youth. Working with "heavy-duty professors and a twenty-one-year-old pitcher from Chicago," Cohn's committee met about six times during 1970 in preparation for the

conference, which was to be held in December. One idea that emerged from these meetings was the creation of a film about early childhood identity that would be shown at the conference as a way of stimulating discussion. "It was one of the few areas that I could participate in, in these meetings," Cohn says. "So I say, 'Well, you know I don't know much about early childhood education, but I know enough about filmmaking to know that we don't have a budget to make a film. Film is too expensive.' And everybody was disappointed. And then I said, for a reason that I could never identify afterward, 'Well, let's do it in video.' And everybody said, 'Well, what's video?'"

Cohn explained to the group that video was an inexpensive form of film, more or less, and that it was available immediately. The conference gave him a US$3,000 budget to make this video, and Cohn then tried to figure out what to do next:

I called up a video-equipment manufacturer that no longer exists. At the time, it was called Concord – it was probably bought out by Panasonic or somebody. And Concord was one of the competitors of Sony at the time, and they had video equipment. And I called them up and I said, "I am Norman Cohn from the White House Conference on Children." You know, I sort of implied I was assistant secretary of state. Anyway, I explained what we wanted to do, and they actually agreed to loan me equipment. Not only loan me equipment but loan me a lot of equipment ... With that machine I got this really brilliant idea – I mean it remains brilliant twenty-eight years later. Which is, I realized that the thing about video that – what it's great at is just looking at things. And that if you looked at children – just looked at them and didn't turn it on and off the way films are made, just let it run – you got amazing information. So I started filming. I had two small children at the time, so I, when I took this machine home I had to teach myself how to use it, I practised by filming my kids. I looked at the stuff that I shot and I thought, "Wow!" So finally what, the project I did was, I picked eight different children at different age intervals, from zero to four years old ... And I decided that I would film each child for a solid half hour, cause that's how long the tape lasted. Each reel of tape was a half hour. So I would make one whole tape, unbroken, real time of each child, where the

camera just watched the child. Like if the parent talked to the
child I wouldn't film the parent – I just watched the child. So
it's like staring at an infant for thirty minutes. And to give those
tapes a sort of a, some sort of common relationship to each
other I decided that each one would start when the child was
eating, at an eating time. So, and then just continue for thirty
minutes. So some kids would eat for thirty minutes, some kids
would eat for two minutes and then play or do something else.
Some kids would eat for one minute and throw their food on
the floor. It didn't matter. But each one started when the child
was being fed. So I had these eight thirty-minute tapes, and the
idea I had was to play them back simultaneously. I got Concord
to lend us eight playback units, eight machines, and eight mon-
itors. And in Washington in 1970, we had a room set up where
these eight machines were in sort of a large horseshoe. You
could walk in the room and sort of walk in to this realm of eight
monitors. And the tapes were played by being started simulta-
neously and they would play for half an hour. They would all
finish. There would be a ten-minute break, and then they
would be played again. So they would be played maybe ten
times a day for the course of the conference. And what you got,
is you walked in to this horseshoe and by scanning the eight
screens you literally saw child development. You saw the emer-
gence of identity. It was like time-lapse photography only it was
eight different children – but it didn't matter that it was eight
different children, 'cause on one screen, the six month old was
playing with his spoon. The nine month old had just picked up
the spoon. The one year old was just getting the spoon into his
cheek. But the eighteen month old got the spoon into his
mouth, and the two year old was eating more smoothly. By the
time you got to the four year old, it was a knife and a fork. And
you could see these things, you could see the changes. Like you
could see what was invisible. You could see the gaps between
the monitors by doing it like that. So it turned out to be actu-
ally a brilliant display. Sort of totally by accident – I had no idea
what I was doing. I mean I was just inventing it. I started, I
taught my – you know, it's like taking home an electric train set
and figuring out how it works and then fooling around with it
in the basement and then setting it up in a certain kind of way,
and it turns out that the way you set it up is incredible. And it

was incredible.. And we had, there were delegates to the White
House Conference who spent the entire week in that room
taking notes. There was a woman who wrote a book based on
watching those tapes. So after that, I decided that video was a
lot more interesting than film.

Inspired by the power of video, Cohn moved to New Haven, Con-
necticut, and launched a career as a freelance videographer. It was
a difficult path; "it's not like there was a lot of money available to ·
pay people to do video freak stuff." He drew on his expertise from
the White House Conference and billed himself as an early-child-
hood videographer, and before long he had landed a freelance
assignment for a New England Head Start training program. He
travelled to Head Start programs and filmed the teachers in the
classrooms; then he would play back the tapes so that the teachers
could see how to improve their skills. He also established a video-
access centre in New Haven, the first of its sort in New England.
"The video freaks of this first generation in the early seventies were
generally banded together around some piece of equipment or
facility where people were sharing equipment," Cohn explains.
"First it was just Port-a-Packs, where a group of people would buy a
piece of equipment together. After a while, when editing equip-
ment first emerged, people would get editing equipment." From
there, these access centres would get grant money to purchase
additional gear and to train people in its use: "The issue was access
to television, access to production equipment, access for nonprivi-
leged people and nonprivileged groups. So access centres were
facilities where individuals or, you know, the local community
health clinic could decide that they would send somebody to get
trained – who could then borrow the video equipment, you know,
once a week to make a video in the health clinic to show poor
mothers how to breastfeed their kids. That was the kind of uses that
this sort of guerrilla-television movement had in mind."

At about this time, Cohn says, other groups were trying out
different uses for video. One group called TVTV (Top Value Tele-
vision) went to the 1972 political conventions and covered the
media that were covering the conventions. A husband-and-wife
team did an early form of the Fox *COPS* show; they spent a month
travelling around with the New York City police and recording
their activities.

This history provides a backdrop for the evolution of video in Igloolik, beginning with Kunuk and Paul Apak, who was a leader in the Inukshuk Project, which helped to bring broadcasting to the North. Both the Igloolik work and Cohn's work in the South focused on increasing public access to television production and broadcasting. Cohn moved to Prince Edward Island, in the Canadian Maritimes, in the mid-1970s, largely because much of the public-access funding was drying up in the United States. He established the Center for Television Studies on Prince Edward Island, and the focus was similar to the work of the community-access centre that he launched in New Haven. Cohn held workshops, trained people – including people from the Fair Haven Community Health Clinic – in the use of video technology, and produced videos of his own on a freelance basis.

He also noticed that the original generation of videographers, faced with vanishing funding, was turning in two different directions. One was to filmmaking, which meant going to Hollywood and making major movies for major money. The other was to the art world, which involved using video as a performance medium. In Canada the latter direction predominated, so Cohn found himself billed as a video artist. He spent increasing amounts of time on his own projects, trying to bring in money as the funding dwindled in Canada as well. But video held on as a tool for social change in Montreal, where an organization called Vidéographe launched a video-access movement connected with the Quebec separation movement: "Vidéographe became a kind of – I mean it was the video wing of the FLQ/PQ [Front de Libération du Québec/Parti Québécois], the guys who were involved in looking for Quebec self-representation or eventually independence, whatever. So it was the one place where video sort of caught on and stayed caught on as a radical tool. In the rest of Canada it became an art tool."

Back on Prince Edward Island, in the early 1980s, Cohn devoted greater amounts of time to producing his own works. He created video portraits of disenfranchised people: children in hospitals, the elderly in nursing homes, and so on. He had an increasingly difficult time showing his videos as social-movement material, but he did find openings into the video-art world. "So I started showing them in the art world," he says. "I started getting Canada Council grants. My work was shown in art festivals ... So I became a video art-

ist because it was one of the only venues where my video had anywhere to be shown."

As his popularity grew in video-art circles, Cohn began to sell more and more of his videotapes. Eventually, the work load became too great because he had to distribute the videos himself. (His work was "too unconventional for a conventional distributor to sell," he says.) So he stopped distributing his work, he left Prince Edward Island, and he became "an itinerant video artist." He staged a show of his work in 1983 at the Art Gallery of Ontario, and he travelled to several other museums: the National Gallery of Canada in Ottawa; the Vancouver Art Gallery in British Columbia; the 49th Parallel Centre for Contemporary Canadian Art in New York; the Musée d'art Contemporain in Montreal; the Dalhousie University Art Gallery in Halifax, Nova Scotia; the Memorial University Art Gallery in St John's, Newfoundland; the London Regional Art Gallery in London, Ontario; and the Mendel Art Gallery in Saskatoon, Saskatchewan. "Sort of the first one-man show of video art in Canada. And it was these portraits of sick kids and old people and these – you know. But the show, I mean the show was portraits. That was me before I came – that was when we came to Igloolik."

Cohn, in some ways, was tiring of the art world, a realm of "very narrow festivals and venues where the other people who are being shown in those places were completely thinking about completely different things from me – where I had less in common with them than I would have had in common with some street lawyer in Winnipeg or a heroin addict in Winnipeg. I was with the wrong gang, with one or two exceptions."

Concluding that the video-art world was a dead-end, Cohn began to search for a new direction: "I was looking for a place to take what I knew, which I had been doing for fifteen years, and keep doing it. And I was very strongly not wanting to keep doing it as an artist, or as an artist only." He knew a French videographer who had done some work with the IBC, and it was through this connection that Cohn first saw the work being done by Kunuk and Apak at the IBC centre in Igloolik:

And when I saw their tapes – their tapes looked like mine! And I thought to myself, "That's very interesting." I go to video festivals and I never see anybody's tapes that look like mine. I turn

on the television and I never see anybody's tapes that look like
mine. I go in to museums and I never see anybody's tapes that
look like mine. And here, there are tapes where these guys look
like they're interested in the same things I am interested in. So
I sort of set out to meet them. I contacted Inuit Broadcasting
Corporation and proposed that – At that point in the mid-
eighties, IBC was doing a year-long training program in some of
its centres, where they would bring in a trainer for a year. And
they were also doing two-week visiting training workshops on
particular topics – so that a trainer in place in Cambridge Bay,
for example, might be an ex-CBC [Canadian Broadcasting
Corporation] retired person. Who would take a one-year con-
tract the way any white guy will take a one-year contract in any
field to come into a community like this, to teach a course. And
then they would bring in other people during the course of
that year to do sort of two-week seminars in some specialized
idea. So I sold the IBC Ottawa management to contract with me
to do two two-week training seminars. One in Iqaluit, where
they had a training program, and one in Cambridge Bay, where
they had a training program ... So I proposed a curriculum that
I called something like Alternate Camera Techniques for
Non-Conventional Documentaries. And managed to convince
the Ottawa guys, who were very conventional – sort of main-
stream, second-rate video-type people – to hire me to do that.
And so in March of 1985 they brought me in to Iqaluit for two
weeks, and then Cambridge Bay for two weeks, to do these two
seminars with the two training groups that they had. They had
never run a training program in Iqaluit. And as a result of that
Zak [Kunuk] and Paul [Apak] had been, had the good fortune
of being essentially very undertrained, so they were self-taught.
That's why their work looked like mine. Nobody else's at IBC
looked like mine; only Zak and Paul's looked like mine because
those guys hadn't been trained. Everybody else was trained to
make their work look like bad CBC. So fortunately when they
brought me in to Iqaluit, they flew Zak, who had never had any
training except through Paul. And through his own self-train-
ing. They flew Zak to take my workshop in Iqaluit, which was
fabulous because that had been – that was my reason for being
there in the first place.

Kunuk and Cohn became friends quickly, and they made the *Two Strangers in Frobisher Bay* video mentioned earlier. Then Cohn went on to Cambridge Bay to conduct his workshop there, and then he convinced the IBC to keep him on for another week to work with Kunuk and Apak covering the biannual elders' conference, which was being held in Hall Beach. He billed the opportunity as a kind of "advanced course" in camera techniques, and the IBC agreed. When the project was done, Cohn faced an important decision. He could look for work in Montreal – his work with the IBC was over – or he could go to Igloolik with Apak and Kunuk. He decided to go to Igloolik, and he has made the settlement his home ever since.

Cohn divides his time between Igloolik and Montreal, where his partner, Marie-Hélèn Cousineau, and their son, Sam, live when they are not also in Igloolik. (Cohn's previous two children, now adults, live in Boston.) While Cohn is in the South, he does studio-production work on Isuma videos – work that cannot be done easily at the facilities in Igloolik. But whether he is in Igloolik or Montreal, he keeps his focus on what he considers the broader issues of the role of media in society:

When you start to realize that the process of how things are made is an important part of how they impact on audiences, then the war over process is not a small thing – and that's what we're doing here. We are fighting a guerrilla battle over a process of production that we think is politically much more progressive than the conventional process of production. Either in conventional filmmaking, which is extremely hard – as military as the military – or conventional television, which is as corporate-controlled as is Wall Street, or the pharmaceutical or the chemical industry. So our "process competitors" are essentially the military and the oil and gas industry. We see ourselves as a third process alternative for how film and television can actually be made, and it happens to be a quirk of fate that this is occurring in an Inuit community. Because those issues are completely independent of what particular group has managed to survive into 1998 and remain active. It's as if in the last thirty years there were all kinds of cells of people working on these issues, any one of which could have been the one in 1998 who managed to survive. But *Radical Software* did not survive. The

Video Freaks did not survive. Ant Farm did not survive. TVTV did not survive. I mean – my video access centre in New Haven, Connecticut, did not survive. So what happened to survive is this right here. And we are carrying a flag for something that's been going on for a long time and that represents a much larger constituency than just Inuit.

The presence of a non-Inuk at the heart of Isuma raises questions of authenticity. With Cohn participating so centrally, is Isuma an Inuit organization? Cohn offers an interesting and cogent argument on this point. Being Inuit, he insisted, has nothing to do with the ancestry of your parents. It has nothing to do with how you look, or where you live, or what you wear or eat. It has to do with your name. At birth, Inuit children are given the name of someone from the community who has died recently, and the child takes on the social status of his or her namesake. In this way, the child is woven fully and permanently into the fabric of Inuit life and culture. Similarly, when a person immerses him or herself in Inuit life in the North, at some point he or she will be given an Inuit name. This granting of an Inuit name carries with it more than just the recognition of fondness or inclusion. It welcomes the newcomer *as an Inuk*, and Cohn argues that this consideration, reflecting as it does a rite of passage into the Inuit community, carries with it far greater significance than does any happenstance of Inuit genealogy or physical traits.

Cohn, of course, has an Inuit name.

PAULOSSIE QULITALIK

Paulossie Qulitalik, an elder and the chairman of Igloolik's Community Education Committee, also works with Isuma, often as an actor. In many ways, he is the voice of wisdom in Isuma, adding harmony to Kunuk's love of art and Cohn's thirst for political justice. Qulitalik was born in 1939 in Argo Bay and was adopted by his grandmother, who was living in the Igloolik area at the time.

Qulitalik was living in Iqaluit when a film company began production there on *White Dawn*, a film adaptation of a James Houston novel. (It is interesting to note that the impact of James Houston on Inuit art extends even as far as videography.) He signed on to be

an actor and to build igloos for the set, and his interest in video and film work grew throughout the production process.

When he moved back to Igloolik, he did some work for the IBC and joined Isuma on the *Qaggiq* video, acting in the production as well. He is a cofounder of Isuma and has been involved with every video that Isuma has created, acting in every production and winning a Canada Council grant in 1992 to produce *Saputi*.

"I know about Inuit culture," he said, with Kunuk translating during a break in the preparation work for the restart of *Atanajuat*. We were sitting in the low *qarmaq* (semi-permanent shelter) that would be used as a set, and Qulitalik had just finished building an igloo outside. "I want the Inuit culture to be visible," he added. "That's why I joined Isuma."

"The Inuit have a different culture," he continued, "and we know about it. Using our culture, our ancestors were able to live in the Arctic. It's what we believe in, and we can use our heads – because we've been using our heads for years. I've seen people living in sod houses, people living in igloos. People hunting by dog team. I've seen it all. So, that's why I know about it. I remember when we used to have sealskin inner linings for our igloos. I remember when people were hungry and there was not enough oil burning in the *qulliqs* [stone lamps]. It was that hard. I want the outside world to realize that hard times do really come. But we learned how to handle them."

Atanarjuat: The Fast Runner

Atanarjuat: The Fast Runner is the first Inuit-made feature-length movie ever produced. It is based on an Inuit legend, an intricate narrative of disharmony, conflict, and ultimate healing that focuses on events surrounding two brothers: Atanarjuat and his older brother Amajuat.[1] Several variants of the legend are in circulation in the Igloolik area. One was told by Michel Kupaaq in an interview with Therese Ukaliannuk on 6 March 1990:

> I have seen two stones that used to be used as benches. One near Pingiqalik and one at Iksivautaujaak. I am not sure what it means; however, this I know – that in the winter time the walrus usually frequent around the area where the bench is situated at the place near Pingiqalik. And in addition, in a place where we usually refer to as Iksivautaujaak on this island, there used to be two stone benches, but the bench that the older brother Aamarjuaq used had now been knocked over. The bench that the younger brother Atanaarjuat used still had not been moved at this moment.
>
> One still can see the gravel that they used to make their walrus cache in around the grounds of the stone bench.[2] At that time they did not have shovels or anything like that, so they buried their cache using bones for a shovel. Higher up there are stone formations that are said to have contained seal skin blubber containers. Further up there are *qammat* [small shack] ruins.

It is believed that the two brothers used to keep a watch for their floats that had been used on a bowhead whales earlier in their hunts. So they would wait on their benches for the floats to show up around that area. These harpoon floats were made from a bearded seal skin. When the winds started to blow from the southerly direction, the harpoon floats would become visible out in the horizon. When the floats came into view they were usually attached to a bowhead whale. With the help of the currents and the wind, the floats would come into view. The main purpose for the floats was so that the carcass of the whale would not be missed when it passed through.

As the two brothers were successful hunters, the rest of the hunters felt jealous about their hunting ability. Both brothers had two wives with them. The other wife would be staying in another place while the other stayed in another one, more particularly one would be staying with the rest of the people that stayed at the old sod houses that are still visible at Igloolik Point.

Because the rest of the hunters were jealous of their ability and the fact that they could not outdo the brothers in any way, a plot to kill them was put into motion one spring. The rest of the hunters knew that once the ice had left that the two brothers would again practise their mastery of hunting skills to kill bowhead whales and wait for the floats to show up on the horizon while they waited on their stone benches. In the spring time while the two brothers were out hunting on the ice not far away from their camp, as a matter of fact the tents were still visible from the location where they hunted, they could see some activities going in the other camp. When the two brothers returned to their camp they asked their wives to go and check the other camp to see what might be going on in the other camp for they have seen some activities silhouetted against the sky. While the two wives still had not returned from the other camp both men went to sleep.

While the women were at the other camp they were given instruction to place their long stockings that had laces on the side of the tent where the men would be sleeping. So the women did what they were instructed to do so. While the brothers slept, the aggressors came to their tent and then their tent was promptly over took with men jumping on top of the tent while the occupants slept inside. This action was meant to finish

them off quickly. There was an old woman who did not wish to
see the two brothers killed and yelled out to the aggressors as if
she was warning them: "Atanaarjuap angajuata arpapaasi!"
("Atanaarjuat's older brother is running for you.") At that
moment Atanaarjuat got to his feet and fled the tent without
any clothing on. While the older brother Aamarjuaq could not
get rid of the aggressors for he was way outnumbered, so he got
up while he was being stabbed and walked with the tent with
everyone one on it down towards the beach, where he collapsed
and died.

Meanwhile, Atanaarjuat had gone to the ice without his cloth-
ing on with the men in pursuit but he kept going, outrunning
them easily. As this was in the spring the ground condition eas-
ily ate away the flesh on his sole for he did not have any type of
clothes on. So the flesh started to bleed and his footprints were
easy to follow. As the aggressors followed his footprints they
came across a lead that was too wide to cross, so that left them
no choice but to return back to their camp.

At that time there were two old couples staying at Siuraq with
their grandchild. They were there to hunt eider ducks using
snares, at the same time they were gathering eider eggs.
Atanaarjuat made it to Siuraq while the two elders were there –
his feet were bleeding badly so the footprints were visible. In
order to hide the footprints they were cut out and then turned
upside down. As he was not wearing any clothing at all, he was
given sealskin pants to wear that belong to the elderly man
along with the sealskin jacket. There were plenty of seaweed on
the beach as is usually the case in the spring time, so the old
couple hid him by covering him with the seaweed.

Shortly afterwards the people that were out to kill him
arrived to this place. Immediately the old couple were asked if
they had just recently been visited by someone, but they replied
that they had not seen or knew anything about a visitor
recently. The old woman cooked some ducks that they had
caught in a snare, and she cooked some with some dried sea
weeds known as iquuti using blubber as fuel. The old couple
fed them. As the old couple claimed not to have seen anybody,
the aggressors decided to return back to their camp. After they
had left, Atanaarjuat was brought out and started to live with
them while the old couple looked after him for his wounds.

They used an eider skin to bandage his feet for the skins had some fat that acted as an ointment to the raw flesh on his sole of the feet.

After some time the wounds healed so all of them travelled to the mainland towards Tasiujaq so they could spend their time right through to ice breakup where there were some caribou to hunt. Throughout the spring Atanaarjuat hunted in order to supply themselves for the winter months ahead. When the ice left he and the grandson went inland towards Tasiqjuaq where they made their camp near a lake that the caribou swam across. They stayed in the summer camp right up to the autumn at Tasiqjuaq. He made himself a warehouse to store some of the caribou that he had been catching. They stayed in that location for a period of time – even they built themselves an igloo. After they had built their igloo they watered the grounds surrounding the igloo from the lake.

At this time he wanted to see the people that had made an attempt on his life. First he went back to the old couple and their families in order to supply them with food provision and at the same time he had moved in closer to this area for he had decided to make the trip across as soon as the strait Ikiq had frozen over. He had a set of clothes made for his wife who was not involved in the betrayal.

When the strait had frozen over he started for Igloolik area back packing caribou skins. As he got closer to the place he was seen approaching. His wife, the one that he was carrying clothing for, shouted: "Atanaarjuatlu kisimi manusinarpajuva." As Atanaarjuat neared the camp, it was still day, his wife went out to meet him. The wife was still wearing the same clothing that she had worn all through the summer so he said to her: "Qangamikiauna taimannaaluk aturtinnakku." ("I do not know when I had allowed her to wear a clothing in this condition.") He immediately tore her clothing apart, and she stood naked in front of him. Then he gave her the clothing that he had brought with him. When she got dressed both went up to the camp together.

Apparently his other wife who was involved in the attempt on his life was now married with someone. She too went out to meet him so he too tore her clothing apart and left her naked. He gave her skins that she would be able to make her clothing

with and sent her on to her place – for he had no intentions of
returning her as his wife.

The hunters returned to find him in their camp. He knew
that there was no way that he was going to be killed while he
was awake. So he invited the hunters to go with him to his camp
so that they can get some meat provisions from his stock, as well
he wanted them to get some caribou skins so that they would be
able to get some for clothing material. So he left the place with
his wife back to his camp. After they had been there for a while
they all arrived all at once for they would not get to this place
with this man one by one. In addition they all needed each
other for protection from this man.

He had made himself crampons from caribou antlers ahead
of time that he would use as a traction against the slippery
ground surrounding his igloo. So he invited them to a feast and
fed them as much as he could by bringing more food whenever
they ran short of what they were eating. When the people could
no longer eat more for they were full, once again he went out-
door as he had been doing while he fed them, but when he
returned this time he had on his crampons and a lower section
of a caribou antler known as *narruniq* for a club. He started to
club the men that were in and killing them, while some fled
outside. He checked for the pulses of the ones that were uncon-
scious – if there were pulses he would club them. The others
who tried to flee away found the ground too slippery as he had
watered the area surrounding the igloo previously, so once he
caught up to them he would club them.

He killed all the men as this was his revenge for the attempt
they made on his life that preceding spring. After he had killed
them all, he returned back to the place where the women were.
Since he had killed most of the men, the women were now
helpless without them, so he had decided to look after their
needs himself. As for the sons that he had left fatherless, he had
them working to serve him as well. Some he gave the task to
harpoon, while others carried things for him, and some who
only had to pick up things. I have not heard how he finally died
or what happened to him later in his life. (Kupaaq 1990)

In an interview with Louis Tapardjuk a year later, Kupaaq answered
some questions about the legend:

Tapardjuk: What do you know about the legend connected to this place [Iksivautaujaak]?

Kupaaq: The namesake of Iksivautaujaak is actually connected to the legend where the stone was used as a seat (Iksivautaq). Legend has it that there were two brothers who each had a stone bench. Another is located on the left side of the point at Pingiqalik ... Both were used by two brothers – Atanaarjuat and his older brother Aamarjuaq – as benches. They used to have bearded-seal skin floats. They would both go out hunting in their *qajaq* so when they caught a bowhead whale so they would attach their float to the dead bowhead whale. In this place when the tide is coming in the tidal current also starts to move in, with the help of the wind the bowhead whale would come close to the shore. They both would sit in their bench waiting for the float to come into view on top of the waves. That is why it is called Iksivautaujaak.

Tapardjuk: In the legend of Aamarjuaq and Atanaarjuat, did they have their parents with them in any part of the legend?

Kupaaq: When I used to hear the legend told, I do not recall their parents mentioned. I used to hear that Atanaarjuat was the younger brother of Aamarjuaq. There is one thing that I can only speculate was the time when they were being attacked that an old woman had shouted to distract the attackers and warn the younger brother. "Atanaajuap angajuata aqpappaasi." "Atanaarjuat's older brother is running after you." Because of her warning Atanaarjuat was able to escape from beneath the tent when the attackers stood up. While the two brothers were sleeping in a skin tent the attackers had jumped them right on top of the tent – they were sleeping – and started to stab through. When the old woman mentioned that Atanaarjuat's brother was running after them they had momentarily stood up at which time the younger brother was able to escape the attackers. I believe it happened in this place as I have heard it mentioned, perhaps it might have been some place else.

As the legend goes he fled to the ice without any clothing on while the attackers were in pursuit. They could follow his trail of blood stain on the snow as his soles had blistered to the point where they bled. In the spring there is always an open lead that runs across to Siuraq which is wide. He managed to cross this lead which made the pursuers to turn back as they

could not cross this lead. I heard that he had landed at Siuraq.
In those days that island used to be swarming with eider ducks.
When he landed he came to a camp where an old couple were
staying with their daughter. They were snaring ducks when the
ducks had started to lay eggs.

In another version of this legend, I heard very recently on the
radio that this old couple were actually his parents. But I
personally have not heard that they were his parents. When
he started to live with them he was given seal skin jacket
(*nattik*) and the seal skin pants (*nattiquti*) before proper
clothing were made for him. When he first landed of course his
tracks were visible with the blood, so the couple cut out the
tracks and turned them upside down so that they were not
visible. At the end of the island the currents are much stronger
so there is usually a large build-up of reeds, so it was at this site
that he was buried under the reeds to hide him from his
attackers.

It was not long after that the attackers arrived. The elders
told them that they had not had any visitors lately, indeed they
asked them to stay for cooked ducks which the attackers did
and soon left to return. Later when his soles had healed they all
left for Tasiujaq. The old man had a *qajaq* [small boat] so with it
he was able to provide for them. Once he had supplied them
enough food for them to last, he then proceeded on to estab-
lish his summer camp inland to a lake called Tasijjuaq. This is a
place past Angmaluttuaaluk. Once he had established his sum-
mer camp with the daughter of the elderly, he set his camp at
the caribou crossing point at the lake. It was here that he
caught the winter requirement. Once Ikiq (Fury and Hecla
Strait) had frozen over so that one could travel on it, he made a
journey to Igloolik asking his former attackers to go and get
some caribou meat with him from his summer camp. It was at
Tasijjuaq that he killed all of the people that had attacked him
the preceding spring. As for the children of the men he had
killed he went back to the place here at Iglulik so that he could
look after them and bring them up so that they could properly
get their revenge once they have matured.

Tapardjuk: Was he married before he was attacked?

Kupaaq: Yes, he had two wives. As a matter of fact both he
and his older brother had two wives each where the other was

related to the families of the people that were planning to kill the two brothers. When the two brothers saw something that was silhouetted at the place possibly where there are old sod houses, there was certainly some activities going on so they send their wives to check as to what was going on in the other camp. They finally returned when the two brothers were already sleeping. So the woman removed their foot wear and place it outside on the side where the men were sleeping. These two women had taken side with the plotters to kill their husbands. It was on account of this mark that the attackers were able to jump the men right through the tent to stab the two brothers.

I have not heard if they might have had children.

The other wife who was involved in the scheme was already married to another when he returned at the time he invited the people to come and get food from his summer camp. When he arrived he was immediately recognized by his other wife who immediately went out to meet him even before he arrived. Upon his wife's arrival he immediately tore her clothing apart and gave her a brand new set of clothing that had been made before he left for this place. Then when he came to the village his other wife who was part of the plot to kill him also came down to meet him, so again he tore her clothing apart and gave her the raw material for her to make her own clothing.

Tapardjuk: I have heard that these stones that were used as benches were carried from the beach, have you heard anything about that?

Kupaaq: It is said so, one must also realize the fact that the beach was much closer to those rises than it is today.[3] If it was to have been carried from the current shore line it is just simply too far. I would have to guess that the shoreline would have been much closer to the place where those stone benches are currently placed. You can see that the raised beaches are continuously getting away from the water. As a matter of fact when I started to remember things that happened around me fish were trapped in a lagoon when the water receded at the low tide. Now you can see it only as raised beach where some tents are currently pitched, the lagoon is gone. I do not believe it was only a dream, indeed there is no more water where the lagoon was. During the spring tide you can see the dampness of the hole in between the raised beaches. (Kupaaq 1991)

A SECOND VARIANT

Another variant was collected in an interview with Hervé Paniaq, one of the writers of the original *Atanarjuat* script; the interview was conducted on 24 March 1990 by Louis Tapardjuk:

They use to live all around this vicinity. It was at Pingiqqalik that they resided at this particular incident. They had oppositions or enemies at the time. Their opposition were out walrus hunting without any luck. The two brothers went down to Ugliit to get their fuel supplies from their summer cache. While they were trying to get at the cache at Ugliit, their enemies also got there. Their dogs were taken from them and they left the two brothers behind. The men that took their dogs left for Pingiqqalik. Their dogs had been taken away from them in order to intimidate and just simply domineer them.

Atanaarjuat started to run after them, once he got past the dog team, Atanaarjuat being the younger, he blocked the team and started to scold the dogs. His older brother was known for his strength, he was following behind and caught up with them while the younger brother was stalling them. He just took the aggressors and them from their sled, he got on to the sled with Atanaarjuat and left for home leaving them behind.

They were successful walrus hunters, the two brothers had a dog team, whenever they caught walrus the others would come and get a share of their catch. Their father had been treated as an underdog before the birth of his two sons. He would be given only walrus ribs for his share of the catch, so his wife only had ribs for food so the strength of his two sons were connected to the diet she ate.[4] When the two brothers had grown up, they were able to provide for – This was about the time they had thrown the aggressors from their dog team sled.

One day the two brothers once again caught a walrus so using their dogs they pulled the carcass onto the ice and started for home without bothering to flense it, towing it whole. Their father started to fall behind so the older brother picked him up as one would with a child and placed him on top of the walrus carcass. The rest of the hunters just gave up on them. When the brothers got home they finally flensed the walrus.

All through that time they did not get along [with the other hunters]. After spending the winter they moved to Iksivautauyaak for the spring. Both had two wives with them. At this time the two brothers and the others did not get along. While the two brothers were hunting square flippers the wives paid a visit to their own relatives. This was the time it was decided that the two brothers must be killed. After the two brothers had hunted square flippers they returned home tired and sleepy.

The people that had planned to kill the two brothers had made arrangements to set the killing with the two wives. The plan was that the women would take their stockings outdoors and place them on the side of the tent where they would be sleeping. The stockings were to be placed where the stones were used as weights for the tent. When the two brothers returned from their hunt, they went to sleep. While they slept the enemies arrived at their camp – they went to the tent and got on top of it. The older brother Aamarjuaq carried the tent with men on top of it stabbing him but he was not able to fight them off and finally got killed. The two brothers had separate tents so the men were also trying to kill Atanaarjuat in the same manner as the older brother, someone yelled from the camp: "Atanaarjuap angayuata arpapasii" ("Atanaarjuat's older brother is running for you"). It was an old woman that yelled. While the men trying to kill Atanaarjuat were thrown off their concentration he slipped out of the tent naked. The old woman had thrown off their attention from him so he was able to escape them.

So he ran down to the ice without any clothes. He fled across to Siuqat without his clothes on. The enemies followed him for his tracks were now bloody. He had come across an open lead that was wide; somehow he managed to cross the lead. He made it to Siuqat to find two old couples living there with their grandchild. They were living on eider ducks by snaring them. He arrived without his clothes on so he was made to put on the elder's sealskin pants and his sealskin jacket and the stockings. He asked to be hidden in the seaweed on the shore. So he was buried underneath the seaweed. The men that were pursuing him showed up out in the distance. Soon after they arrived.

The two couples went to greet the newcomers. The newcomers asked if a man had arrived recently; they replied that they had not seen a man since the rest of the people that had stayed there moved away to their spring camp. They had not seen a man since. In the meantime Atanaarjuat was hidden under the seaweed on the beach. The elderly couple were told that Atanaarjuat had escaped them. The elderly were struck awed about this announcement and appeared to be frightened about the man on the loose. They claimed not to have seen anyone at all. When the elderly couple mentioned that no one had come their way, the men made preparation to return back where they came from. The wife was cooking ducks, so the man invited them to stay for the meal before they returned. During the time the ducks were cooking, the elderly couple kept mentioning the fact that Atanaarjuat stayed with them until the summer. In summer they moved to Tasirjuaq to hunt caribou where the caribou had a migration route that took them across the lake where they were hunted while they swam. While they were at the lake, they caught plenty of caribou. They secured plenty to clothe themselves. Atanaarjuat had a light thin furred jacket made known as *qaliruaq*.

When the ice had formed in the sea and the route through the strait was set, he flooded the surrounding of their igloo so it would be slippery. He made a pair of kamiks that had soles made so it was not slippery on the ice surface, possibly made from caribou antler. He also made a club from the lower section of the caribou antler (*naruniq*).

When the ice was strong enough to cross the strait they made a set of clothing for his second wife who was not involved in the set up. Taking these with him he started off crossing the strait to get his wife at the place of his enemies. As he crossed the strait he ran along side of his dogs. When he was getting closer to the camp his identity was still not recognizable however his wife started to say "Uiga surluuna, Atanaarjuat surluuna." ("Looks like my husband, looks like Atanaarjuat.") She would say these words until he arrived at the camp. She went over to meet him, and when she got to him, he tore off her old clothing and gave her the new ones to put on. His other wife also came down to greet him, the one who had set him up.

He too tore her clothes up and gave her skins for her to make
her own clothing.

After spending some time, he was planning to return. He said
to everyone that he had caught caribou at a lake that had a
caribou route, he had caught plenty while they crossed, anyone
wishing to come and eat some caribou back fat, they were
welcomed to come and eat some. He might have added that
they could come over and get a load to take home. The men
came to his camp, they arrived at his camp. He prepared for
them to eat so everyone had plenty of meat with caribou back
fat. When they had their fill, he started to clobber them with
the club he had made from a caribou antler. For those who
tried to flee he would go after them while they slipped on the
slippery surface and clubbed them to death.

Legend have it, that the stone at Iksivautauyaak was used by
Atanaarjuat. While he lived there whenever the south winds
started to blow, he would leave by his qayaq. He had a square
flipper for a harpoon float. Whenever he caught a bowhead
whale he would just leave his float attached to the whale
behind. When he got home he would just get to bed while the
south wind blew. He would tell everyone to keep an eye out for
the float. He knew that the harpoon float would be blown
towards them with a whale in tow. (Paniaq 1990)

A THIRD VARIANT

Another variant was told by Inugpasugjuk and collected by Knud
Rasmussen:[5]

Two brothers, Aumarzuat and Atanârzuat, lay sleeping one
night in their tent, when they were attacked by enemies.
Atanârzuat was killed, but Aumarzuat managed to escape and
made his way home to his parents' house. His parents hid him
under some seaweed, fearing lest his enemies should come in
search of him. And this they did, but his mother then set about
cooking some meat, so as to make it appear that she had no
knowledge of their errand. They sought about everywhere,
especially where the snow had melted away. They threw har-
poons in all directions, but were forced to return home without

having accomplished their purpose. Aumarzuat then lay for
some time to let his wounds heal, and when he was well again,
he kept to places far from the dwellings of men, and hunted
game for his parents.

Winter came, and his mother made him a fine tunic, all
embroidered with handsome white patterns. His tunics were
always made like that, and when Aumarzuat had got his new
tunic, he felt a great desire to set out and take vengeance for
the killing of his brother. His parents sought to dissuade him
but in vain, Aumarzuat held to his purpose, and since there was
no help for it, they at last agreed to let him go off and seek ven-
geance for his brother.

He then went alone toward the village of his enemies, and
when he came in sight, and people saw him, they said:

"It can be no other than Aumarzuat, for he is the only one
who wears tunics like that."

And true enough, it was Aumarzuat, they could all see for
themselves when he came nearer, and he came to the village
and cried:

"I should like to fight while I am awake. Last time I was
attacked while I slept. Let all my enemies come out if they dare."

They all came out, and the fight began, between that one
man and his enemies. But when Aumarzuat had killed two men,
and the others now saw the mighty strength of him, they ceased
to offer any resistance; they were now afraid of him. The fight
came to an end, since none would now strike in self-defense,
and Aumarzuat took the wives of the men he had killed, and
returned to his parents' house. Two men went with him on the
road; they meant no harm to him, but all the same, when they
were about to take leave of him, Aumarzuat killed one of them.
He had, as it were, got into the way of killing; and thus he
avenged the slaying of his brother. (1929, 298–9)

ATANARJUAT: THE SCREENPLAY

It was Paul Apak's idea to make a full-length movie based on the
Atanarjuat legend. A legend in Inuit videography in his own right,
he had tackled several major projects already. He knew the
Atanarjuat story and decided that it would make a good movie, so
he wrote a draft of the screenplay in Inuktitut.

The screenplay is entitled *Atanarjuat: The Fast Runner.* The final draft of the script was written by Apak, Norman Cohn, Zacharias Kunuk, Hervé Paniaq, and Paulossie Qulitalik, and it was completed on 29 March 1998. Two versions were made: one in English and the "official" version in Inuktitut. Six main characters carry the action:

- Atanarjuat (ah-tah-NAH-joo-aht). He is a young man when the story begins; he is strong, handsome, and well-dressed, obviously a skilled hunter.
- Amajuat (AH-mah-joo-aht), Atanarjuat's older brother. Stronger than Atanarjuat, he is described in the script as "a powerful, physical young man – a force of nature. He is neither mean-spirited nor kind." In the film, he is seen as a roughhousing, positive brother who understands duty and the difference between good and evil.
- Atuat (AH-tuat). She is a beautiful young woman, and she and Atanarjuat are thoroughly in love.
- Puja (POO-yah). A friend and rival of Atuat's, she is both sexy and dangerous.
- Sauri (SAOW-ree). Son of the camp's leader at the start of the film, he is meek and submissive – but he smolders with resentment over his place in his father's shadow.
- Oki (OH-kee). Son of Sauri, he is a mean-spirited bully who lashes out in a vain attempt to soothe his own emotional wounds. (Apak et al. 1998)

The movie version that was released to the world – and that won a Camera d'Or Award at the Cannes Film Festival in 2001 – shows signs of significant revision from the original script. Critics have noted that the opening scene of the movie is confusing, but the opening scene as written was easier to follow. During the opening credits of the original script version, the voice of the camp leader's spirit sets the scene:

My children and grandchildren ... Listen. I, Kumaglak, an old man, pass this story on to you and your own children for all time ... What began long ago the night I was murdered, when my Name and Soul left my body and an evil spirit set family against family in a circle of revenge.

 With anger and envy in their hearts, people no longer shared
what they had but thought only of themselves.
 And this evil lived on in each generation, feeding on mean-
ness, stronger and hungrier, waiting for someone to fight back
... or for the people to die out.

 The story begins when Atanarjuat is a baby. Inside a *qaggiq* (large
igloo for celebrations), families have come together for a pleasant
evening of entertainment and companionship. Kumaglak, the pop-
ular leader of the camp, is there; he is fifty-five years old, powerful,
and confident. Also there is Tungajuak, a stranger, an evil shaman,
seething with spiritual force and amused by the others around
him. The two men square off in a shaman's battle, spirit to spirit.
Kumaglak chooses a young man to be his helper, and the stranger
chooses Kumaglak's own son to be his. The two men sit on the
floor, facing each other, naked, their legs straight out in front of
them, almost touching. The helpers tie them tightly with cords:
ankles to neck, wrists bound behind the back. As Kumaglak's wife,
Panikpak, sings his favourite hunting song, the two men begin to
shake against the strain of the cords and the spiritual battle that is
developing between them. The stranger's breathing becomes the
growl of a polar bear. Kumaglak's breathing becomes the grunt of a
bull walrus. Suddenly, the cords snap off with a loud crack, and the
two men collapse to the floor.
 Then, slowly, the stranger's inner parka rises by itself and begins
to circle the room, threatening to hit the spectators. Kumaglak's
parka rises as well, following the rival's through the air. The gar-
ments pick up speed and then soar out through the igloo's smoke-
hole.
 The men remain motionless, and the spectators wait anxiously
for the garments to return. At last, however, only one comes back,
and the stranger rises, victorious. Kumaglak is dead.
 The evil shaman then removes the necklace of walrus teeth from
the dead man's body. He gives it to Kumaglak's son, the one who
served as his helper. The spectators gasp as they realize that the
son, Sauri, arranged this contest so that he could become the
leader of the camp. The dead man's wife and her brother pack up
to leave the area, conceding authority to Sauri.
 This scene sets the stage for the rest of the movie's arc. The evil
that has infected the camp turns everything upside down. Sauri is a

proud and successful hunter, although cruel to his neighbours and arrogant in his power. Atanarjuat's family is pushed to the margins of the camp's life.

Twenty years go by, and at last Atanarjuat and his brother, Amajuat, are grown men. They are strong and healthy, and with their help the family has been cared for in better fashion. Sauri's son, Oki, is also grown, and he carries himself with the same evil arrogance that afflicts his father. Tensions deepen between Oki and Atanarjuat as both of them court the same young woman. The woman, Atuat, has been promised to Oki, but she loves Atanarjuat. The issue is resolved – superficially, at least – by a traditional punching contest that Atanarjuat wins.

Five years later, Atanarjuat and Atuat are happily married, and they have a son, Kumaglak, named after the murdered camp leader. Another child is on the way. Atanarjuat's brother, Amajuat, is living nearby with his wife. The brothers are skilled hunters, and there is plenty of food.

But during a hunt, Atanarjuat is seduced by a young woman named Puja, who enjoys twisting the lives of men. Atanarjuat makes love with her and takes her as his second wife. Puja is unable to accept settled life for long, however, and she seduces Amajuat as well – and is thrown out of the camp. When she returns and begs for forgiveness, she betrays the brothers once again. As they doze after an exhausting hunt, she places socks on the outside of their tent to mark the place where they are sleeping. Oki and his friends topple the tent, take aim at the places marked by the socks, and thrust with their spears. Amajuat is killed, but Atanarjuat, completely naked, scrambles out of the tent and sprints out across the frozen ocean. The killers grab their weapons and chase him.

They try their best to catch him, but Atanarjuat is a fast runner. He widens the gap between himself and his pursuers, and finally he comes to a broad lead in the ice. The break is wide, with deadly ice water filling it, but Atanarjuat has no choice. Urged on by a spirit voice, running on frozen and bloody feet, he dashes toward the lead and jumps as hard as he can. He lands in a heap on the other side, picks himself up, and runs toward Sioraq, an island off in the distance. Oki, running as fast as he can, reaches the lead and starts to jump, but then realizes that he cannot make it over. He stops awkwardly and slides into the water. He pulls himself out, screaming in pain and frustration, and vows to chase Atanarjuat forever.

He shouts to his partners to fetch their dog teams so that they can continue the hunt for Atanarjuat.

On the island of Sioraq are Qulitalik and his wife, who fled Igloolik twenty-five years ago after the camp leader's murder. They have lived a peaceful life on Sioraq, and with their adopted daughter, they are a happy family.

Atanarjuat arrives, desperate and bloody. The family carries him to the camp, where he is allowed to rest. When he awakes, he explains his situation to Qulitalik and the women, who promise to take care of him. They hide him in some seaweed, and when Oki and his men arrive, they artfully profess ignorance and invite them to stay for dinner, hoping that their willingness to extend the encounter will attest to their innocence. The men eat their fill and then leave, convinced that this old couple knows nothing. And confident that the ice and wind would claim anyone foolish enough to run off without shoes or clothing, Oki tells his men that it's time to search for Atanarjuat's body.

Back at the camp Oki asks his father's permission to marry Atuat, now that Atanarjuat is presumed to be dead. But without proof that Atanarjuat is dead, Atuat remains off-limits to Oki. Oki explodes with anger and frustration – not at Atanarjuat but at his father. A short while later Oki arranges an "accident" in which his father is killed. Oki takes over as the camp leader.

Meanwhile, Atanarjuat heals slowly and goes through several trials to test his fitness to return to camp. At last, he is ready, and he makes the return journey across the ice.

The people of the camp see a stranger approaching, and they gather together to welcome the newcomer. Gradually, they realize that it is Atanarjuat, healthy and alive. Atanarjuat dismisses Puja, tearing her clothes, and he gives a fine new parka to Atuat.

Then he builds an igloo and plans a feast to celebrate his return. Oki and his sidekicks, cocky with power, accept the invitation. They eat heavily, and then Atanarjuat steps out of the igloo. He dons some antler crampons that he has made and returns with a club in his hands. Oki and his pals try to scramble to their feet, but Atanarjuat has made the igloo's floor slippery; only he can manoeuvre with his crampons. After a struggle, Atanarjuat pins Oki and raises the club for a deadly blow.

But he strikes the ice beside Oki's ear, sparing the life of his rival. He declares that he will let his enemies live and that the killing and

feuding will end now. Oki and his friends are banished from the camp, and harmony returns to the community once more.

VARIATION

The bench referred to in the legend variants – the bench on which Atanarjuat sat while waiting for the bowheads that he had killed to drift in toward shore – is still present at Iksivautaujaak. It lies close to the dirt-and-stone road that wanders along the shoreline. Squat and solid, a rectangular block of reddish stone covered with extravagant streaks of seagull droppings, it seems an unlikely focus for a major cultural legend. But it is a comfortable place to sit, and it is not inconceivable that Atanarjuat would have used this bench as a perch from which to scan for his whales. Nearly everyone on the island knows this stone and its significance, and people pass it every day during the busy season of summer when hunting and fishing camps are set up beyond it along the beach.

The basic skeleton of all the above variants involves two brothers who are attacked by rivals. The older brother is killed, but the younger escapes across the ice, where he recovers. He returns and executes his response to the initial attack. But the *Atanarjuat* screenplay deviates from the oral variants above in several ways, some of which are culturally significant for the Inuit – precisely what the Isuma team hopes will be evident. In particular, three departures from the oral variants stand out as deliberate vehicles for Isuma's message.

The first and most significant divergence involves the ending of the story. The screenplay is the only variant that ends bloodlessly. The other three variants end with Atanarjuat killing some or all of the people who plotted and battled against him – the people who murdered his brother. In fact, the oral variants all show Atanarjuat as thirsty for revenge. In the first variant he kills all his male rivals and brings their widows and children into his own fold – perhaps as family, but the tone suggests that they were more like servants or slaves. In the second variant he clubs the men to death, even chasing after the ones who drop the fight and attempt to flee. And in the third variant, collected by Rasmussen, Atanarjuat kills two men, and the others surrender; Atanarjuat takes the slain men's wives and then kills another man for no apparent reason. "He had, as it were, got into the way of killing."

The final line of this variant attempts to justify the murders: "Thus he avenged the slaying of his brother."

The screenplay takes events right up to the point of murderous revenge – but then it veers away. Instead of avenging death, the screenplay ends with a positive message. Viewers see that evil perpetuates evil, ultimately to total destruction: Tungajuak begets Sauri, and Sauri begets Oki, in a lineage of hatred and greed. But Atanarjuat was strong enough to put an end to the feud, not by exterminating his rivals – that would simply perpetuate the evil – but by demonstrating his ability to murder and then choosing against it. This decision allows the camp to drive away the spirit of the evil shaman that has plagued it, and with this presence gone, the authority of the elders comes back into play. The elder Panikpak banishes the worst of the offenders, but she sends them off with a kind heart. Order has been restored – not through "an eye for an eye" revenge but by turning the other cheek.

This ending did not come from the variants of the legend that are in common circulation. Apak, Kunuk, Cohn, and the others at Isuma decided on a positive ending because they wanted to emphasize the importance of harmony and working together, a vital Inuit value honed over millennia of cooperation in small bands immersed in a harsh environment. Much of Inuit life is communal, and when someone puts himself above this communal web, he also puts himself outside it. That is what happens when the ambitious son takes command at the beginning of the screenplay. But Isuma wanted to stress that such an approach must not succeed in the Arctic. So the producers brought the ending around to a positive note in an effort to emphasize the necessity of placing the group before the individual. Norman Cohn explains it this way: "*Atanarjuat: The Fast Runner* is about how to communicate the right way to behave and live. You learn by being told how to behave through stories. That's what the movie is about. A community in the sixteenth century goes wrong. There's a moral breakdown. They are trapped by evil and dishonesty. Then it recovers itself. There is a restitution of moral authority by restoring the value of community as superior to the value of the individual. That's an Inuit value."

Atanarjuat's moment of truth comes as he is about to strike Oki with the club. But he decides against the satisfaction of his own individual revenge and in favour of the salvation of the community

– salvation that would not be achieved by furthering the blood feud. This shift represents an interesting inversion of the legend's message. The first three variants suggest one message: "Don't behave like this, or the person you are persecuting might kill you." But the screenplay offers a positive message: "Putting aside your own anger can help heal a community." The first warns of revenge; the second urges people to rise above it.

ENVY AND EVIL

The screenplay also creates a new rationale for the bloody conflict in Igloolik. The first variant notes that Atanarjuat and his brother were highly successful hunters, for which they incurred the jealousy of the other hunters. Envy can be a potent force in a small, isolated community – so much so that most people take pains to avoid any appearance of flaunting a special ability. As Kunuk explains:

> In this particular area, Igloolik people were afraid to be a leader, or a great hunter. So every person hides what they can do, not reveal it for the public. Like that guy over there is catching all the seals and the walruses and catching all the food, so we turn to him. Maybe we turn to him in friendship, or we turn to him in hate. Hate is the deadliest harm that could happen to that person, so he has to watch out. He could become a leader if he knew that he could overcome all these threats – or what's going to come after him. I knew in this area, everybody just laid low most of the time. 'Cause if you become a leader, everybody looks at you – whether somebody wants to hurt you back. So if you can handle that, you can do it. That's my understanding, that's how I understood it. Nobody wanted to stand up because someone might go after her or him.

In the first variant Atanarjuat and Amajuat did not bother to hide their hunting skills. In fact, they sat on benches after hunting bowhead and simply waited for their catches to float in with the tide. This behaviour could be seen as offensive by the others; the brothers were certainly doing little to make their hunting abilities seem merely average. A bowhead whale is an impressive catch, yet the brothers were so cocky about their hunting skills and their knowledge of the winds and the tides that they did not even worry about

hauling the whales in themselves. So the first variant positions Atanarjuat and Amajuat as somewhat deserving of their fate – murder is the price of arrogance.

The brothers even took two wives apiece. Having two wives was not unusual in traditional Inuit life, but it meant that the man was so sure of his hunting ability that he was confident he could feed both women. And it certainly would not contribute to an air of "going along to get along." A man who had two wives was making a statement to the entire community about his success as a hunter.

In addition, while the first variant does not go into the demographics of Igloolik at the time, the ratio of men to women can become an issue in a small, isolated community. It is possible that the taking of two wives each by the brothers also put a damper on the social aspirations of some of the men in the community – further fuel for their anger.

The second variant is less clear about the source of the conflict. It simply states that the brothers never got along with the rest of the community, so "it was decided that the two brothers must be killed." No justification for the killing is offered, except to note that the rest of the community seemed to be against this family from the start.

And the third variant supplies even less information, beginning with the attack that killed the older brother.

The screenplay, however, offers a very clear explanation of how the conflict began. Young Sauri, the son of the camp leader, coveted his father's power and wanted it for himself. He ushered in the evil shaman, who challenged the leader to a mortal contest. The leader was killed, and Sauri took over as the camp leader – his power and authority illegitimately gained. He ruled heartlessly, and he treated Atanarjuat's family with scorn. But he who lives by the sword dies by the sword, and Sauri's son falls victim to the evil himself. He kills his father and takes over the leader's position.

So it is the desire for personal gain at the expense of the stability of the community that introduces evil into the camp. The evil is represented by the murderous shaman, but the shaman does not arrive unsummoned; he is a physical manifestation of evil that the scriptwriters could use to show the extent to which evil was in control. The root cause is lust for power – first Sauri's, then Oki's – which upends the community's harmony. And this cause brings

about the parallel move in the end, when Atanarjuat chooses in favour of community stability over his own lust for revenge.

The new rationale offered in the screenplay stems from both a pragmatic need and a philosophical one. The pragmatic need was simple: by positioning the brothers as nice guys, the movie lacked the arrogance and jealousy prevalent in the first oral variant, so another impetus was necessary to explain the violence. But the philosophical need is more complex. It reflects Isuma's desire to show how individual ambition can disrupt the cohesion of a community, and it also carries echoes of the nature of shamanism. Shamanistic power is neither good nor evil; it is simply an ability to function in the spirit realm beyond the reach of ordinary people. Some shamans use their abilities strictly for good, but most are multidimensional, using their skills to suit the demands of the moment as they see fit. At times, certain shamans gained reputations of evil, largely through the selfish use of their powers. By having two shamans, one good and one evil, engage in a contest at the start of the screenplay – and by having the evil shaman win and bring about the death of his rival – Apak shows the uncertain nature of spiritual power in Inuit life. Shamans can be helpful, but they can also destroy. (In fact, there are words in Inuktitut that can kill.) *Atanarjuat* shows such differentiated use of power through the introduction of evil into the community.

INCLUSION

The screenplay, of course, is substantially longer than are the three oral variants presented first in this chapter. Part of this difference is pragmatic; a feature-length movie needs to fill two hours or so, and *Atanarjuat* stretches to three. Also, a movie needs to have more characters, more subplots, and more changes of location than the bare-bones legend allows.

But there are other reasons for the additional detail and complexity. One is that Inuit storytelling is an active event (Wachowich 1999, 4), complete with voice changes, grunts and noises, gestures, and other effects employed by a skilled storyteller. To replicate the degree of animation that a storyteller brings to a tale, Apak and the Isuma team drew on other kinds of embellishments, including the creation of additional characters and their corresponding tensions and textures.

But perhaps the most important reason for the additions lies in a fundamental part of the Isuma philosophy. Kunuk and the others at Isuma strive continually to present aspects of traditional Inuit life to their viewers, and the movie offers an opportunity to add richness through these aspects.

One such aspect involves the naming process. When a child is born, he or she is often given the name of a deceased relative – and the name carries with it the relative's stature and rank. In the screenplay the significance of this tradition is foregrounded. In the end, Atanarjuat and Atuat have a son, to whom they give the name Kumaglak – the name of the original camp leader, who was murdered. The boy has clearly taken on the spirit of the deceased leader: the screenplay notes that "when he speaks ... his is not the voice of a child." The reassertion of order and sanity has allowed the former leader's spirit to return to the camp through his name, bringing the story full-circle.

Another aspect of traditional Inuit life that the scriptwriters bring out is the potency of a public threat. At one point, Oki threatens Amajuat – "If you think you're a better man than me, I – ! I could – kill you!" The threat in the screenplay carries the weight that it would have in traditional life. A public threat put the one who made it in grave danger because the person who was threatened had the right to attack in self-defense – at any time and without further provocation. Oki's inability to control himself adds to the tension of the camp because now Amajuat could kill Oki with impunity. As Rasmussen puts it: "One must never say anything about death in fun, for in such case, that which was not meant in earnest, or at any rate meant only as a threat, may very often become reality" (1929, 106). The thinking behind this prohibition is obvious. In a small, isolated community threats are dangerous; by making the threatener vulnerable, the community can minimize the number of idle threats that get tossed around.

The prohibition against threats points to a deeper value in traditional Inuit society: self-control is important. Another way that this value is revealed is through the ritual of embarrassment songs performed during *qaggiq* festivities; Atanarjuat and Oki bait each other in this way during one scene in the movie. The songs pose a question: can you keep your cool while your rivals are trying to humiliate you through denigrating mockery?

Cheerful duels of song must not be confused with those songs of abuse which, albeit cast in humorous form for greater effect, have nevertheless an entirely different background in the insolence with which the singer here endeavours to present his opponent in a ludicrous light and hold him up to derision. Such songs always originate in some old grudge or unsettled dispute, some incautious criticism, some words or action felt as an insult, and perhaps breaking up an old friendship. The only means then of restoring amicable relations is by vilifying each other in song before the whole community assembled in the [*qaggiq*]. Here, no mercy must be shown; it is indeed considered manly to expose another's weakness with the utmost sharpness and severity; but behind all such castigation there must be a touch of humour, for mere abuse in itself is barren, and cannot bring about any reconciliation. It is legitimate to "be nasty", but one must be amusing at the same time, so as to make the audience laugh; and the one who can thus silence his opponent amid the laughter of the whole assembly, is the victor, and has put an end to the unfriendly feeling. (Rasmussen 1929, 231–2)

This process of pushing the limits in a specifically situated ritual serves both as a test of one's control and – if the control is maintained – as a catharsis that allows normal relations to be resumed. When Oki and Atanarjuat compete in such a ritual, each attempts to cause the other to explode into anger – the ultimate failure. But these two rivals never had normal relations, so the ritual fails to restore balance to the community.

The screenplay points to hosts of other elements of traditional Inuit life as well, including the importance of maintaining a pleasant front for your enemies and the manner in which babies are given specific skills. It also shows such activities as the wolf game – a kind of tag – and various hunting practices as well. The Isuma scriptwriters were eager to introduce their audiences – whether Inuit or Qallunaat, Northern or Southern – to the facets of Inuit society and culture that elevated life above a mere quest for food and survival. The Inuit have an active and thriving culture, and it has persisted for thousands of years. The *Atanarjuat* movie gave the Isuma videomakers a chance to share some of it with viewers

around the world. Even the Inuit actors learned about traditional
Inuit life by working on the video project. Lucy Tulugarjuk, who
plays Puja, explains:

When we were in the *qaggiq* scene, and other scenes, too, it was
amazing, just thinking, "Oh, this is how our ancestors used to
live." And how it must have been hard on them, or – big differ-
ence. And here we say sometimes that we're hungry or, you
know, don't have much to eat. If there's no washing machine,
how are we going to clean our clothes? But this is nothing com-
pared to what the past was before, especially after doing a
scene, like, girls, sometimes we'd have a girl talk, or whatever,
and we'd say, "Oh, how – oh, it was so dirty and nowhere to take
a shower and nowhere to wash your caribou clothing." I'm glad
I'm alive today and not in the past. Well, it was – They were
really strong. I'm so proud of them. 'Cause they survived
through so much tough life, and yet so easy on them. 'Cause
today, it's us who are in the tough life, I guess, 'cause we're
stuck between two worlds. Our, real, well, our ancestor style and
the future style, of Qallunaat, I guess.

6

Streams of Culture

After creating *From Inuk Point of View* and a short documentary entitled *Alert Bay*, Zacharias Kunuk and Norm Cohn set out to produce a three-part series about Inuit life in the 1930s, before extensive contact with Qallunaat. The first of the three videos is *Qaggiq*.

Completed in 1989, *Qaggiq* shows a distinct leap forward in Isuma's development. This video was the first from Igloolik to be distributed in the South and broadcast internationally (Fleming 1996, 30). According to Kunuk, "We showed it in Montreal, in Vancouver, and in Edmonton at the Local Heroes Film Festival. Also, it's been shown in Calgary, Toronto, New York, Los Angeles, Paris, Holland, Japan and Denmark. I was in all those places" (Fleming and Hendrick 1991, 28).

Qaggiq means "gathering place" and usually refers to a large igloo built so that several families can get together for singing, dancing, and food. The video follows the activities of four Inuit families who come together late one winter to celebrate the coming of spring. The families greet each other on the cold, flat tundra, and they talk about building a *qaggiq* together. Meanwhile, one of the families is putting pressure on its eldest son to get married; the mother says to her son, matter-of-factly, "I feel like getting a daughter-in-law sometimes."

The planning for the *qaggiq* continues. The *qaggiq* will have to be large but not overwhelming; because it will require no bed, it can hold all the families in a reasonable amount of space. The men

decide to send a dog team to a nearby camp in the hopes of bring-
ing elders back to participate in a celebration in the *qaggiq*, "they
should be included when we complete the *qaggiq*." The men do all
the talking and planning; the women tend the *qulliq* (stone lamp)
and serve the sugared tea.

The video intertwines two plot lines: the building of the *qaggiq*
and the building marital pressure for the young man. The pressure
does not have to increase by much; the young man abruptly barges
into the other family's igloo and declares: "I want your daughter
for a wife."[1] He is rebuffed by the father, who insists that his daugh-
ter is still too young, but the mother has other thoughts. She turns
to her daughter: "I want you to get a husband!"

At last, it is time for the families to come together in building the
qaggiq. The men plan the work and choose the site, and the young
men cut the snow blocks with a saw and some knives. It takes little
time for snow blocks, roughly two feet wide, four feet long, and ten
to twelve inches thick, to emerge from the deepening pit. The
young men hand the blocks up to their fathers, who put them care-
fully in place and trim the edges with knives. After the first two rows
of blocks are in place, the remainder are cut from within the circle;
the floor lowers into the insulating snow while the ceiling rises
overhead.

The *qaggiq* grows slowly, but at last the final blocks are fitted into
place at the top.[2] The cracks are chinked, and a ventilation hole,
three inches in diameter on the outside but wider on the inside, is
carved near the top. The timing is good; a short while later, two dog
teams arrive, bringing elders and other families. With a *qulliq* blaz-
ing brightly near the entrance, the *qaggiq* is ready for the celebra-
tion. The men perform drum dances and sing *ajaja* songs.

After the drumming, the attention turns to contests of strength
and skill in which the young men attempt to show off their talents.
They put on parkas while suspended upside down from a horizon-
tal pole. They punch each other on the shoulder until one suc-
cumbs to the pain and quits. They pull each other's mouths by the
corners in a test of endurance and control. The contests are fol-
lowed by more drumming and singing, but the weight of signifi-
cance is greater this time. The young girl's father sings:

In the autumn
Training dogs, they sure are fast.

I felt joy, going into a *qaggiq*.
It was a joyful time, getting near the *qaggiq*. My ear would buzz.
Ajaja, Ajaja,
It was a joyful time, hearing the beat of the drum.

Then the young man abruptly grabs the girl by the arm. He guides her firmly and quickly out of the *qaggiq*, and the meaning of this move is clear: he has taken her as his bride. Her father looks bemused; faced with the tacit question of how he'll react to the taking of his daughter over his initial objections, he expresses his new perspective through song:

My dogs here.
You joined the family.
I wasn't thinking,
About a family here.

With this concession, the video ends.

QAGGIQ AS SYMBOL

Kunuk chose two themes for this video, streamlining the collage approach of *From Inuk Point of View* and bringing greater depth to a smaller number of threads. The themes – the building of community through the construction of a *qaggiq* and the interlocking of a community through the web of marriage – carry potent messages that reflect on both the past and the present Inuit worlds.

Qaggiqs are used to bring communities together, even today. In anticipation of the 1999 Return of the Sun Festival in Igloolik, the Inullariit (Elders) Society hired several men to build a *qaggiq* out of ice blocks. The construction took about two weeks, and the structure was not quite ready in time for the celebration in mid-January; the *qaggiq* required more ice blocks than anticipated, and the builders had stripped the nearby lakes of their supply. They had to wait for a few days while the lakes refroze before they could cut more blocks and complete the *qaggiq*. (The festival was held in the gymnasium of the elementary school.)

Once it was completed, the *qaggiq* stood about twelve feet high and about twenty feet in diameter. It was built on a flat tundra field just uphill from the high school. The ice blocks were six

inches thick and ranged from one to four feet in length and one to two feet in width. The lowest layer of wall was made of four-by-two-foot blocks placed on end, forming a kind of close-knit ice fence around the circle. Then two rows of smaller blocks spiralled up from the base to the top. Both the inside and the outside surfaces were smooth because wet snow had been pressed into any gaps and allowed to freeze. (The temperature outside ranged from thirty- five to forty degrees below zero.) But it was the shape and construction, not the frozen seams, that gave the structure its strength; an adult could walk on the top of the *qaggiq* without falling through.

A small entry passage, open at the interior end and hinged with a plywood door at the other, led from the windy world outside to the stillness inside the *qaggiq*. With a single Coleman stove burning, the air was frosty, and breath hovered in ghostly clouds. With three Coleman stoves burning a short while later, the air was still frosty, and breath hovered in ghostly clouds. One night, with three Coleman stoves and two *qulliqs* aflame, the forty or so people who turned out for an evening of casual drum dancing still refused to take off hats and mitts, and children performed the squat "monkey dance" (similar to Russian kick-dancing) to keep themselves warm.

The *qaggiq* was made of ice for durability, and the structure was still standing when I left Igloolik in early April. The walls were translucent, and the glow of any lamps inside could be seen from a distance. At times it was lit with *qulliqs* and at other times with electric lamps tethered to gasoline-powered generators outside. It was built to give the people of the settlement a place to gather for games, drum dances, and other events, and various low-key gatherings were indeed scheduled there throughout the winter. Like the version shown in the Isuma video, the structure served as a locus of celebration.

The *qaggiq* is a rich symbol in Inuit culture. It represents friendship, neighbourliness, relaxation, competition, nutrition for the body and the soul, escape from the pressures of the harsh world outside. Stories are told inside the *qaggiq*, and stories are told about the *qaggiq*; it has always been a centre of communal enjoyment. For example, in previous eras the *qaggiq* was the site of a wife-swapping game in which two male participants leave the gathering and dress up in ludicrous costumes: one male and one female. They then

re-enter the *qaggiq* with sticks and whips and drive all the men out-side. They move frantically and comically, searching among the women for any men who might be hiding, driving them out with merciless blows. Once all the men have gathered outside, the two masked dancers join them – and one of the men in the crowd whis-pers to them the name of a woman inside. The dancers dash back inside, approach the woman who has been selected, and touch her feet with the stick and whip. Laughing, she follows the masked men outside, and she re-enters a moment later with the man who has chosen her. The crowd reacts with laughter, jokes, and approval. This process is repeated until everyone is paired off. After the cele-bration, the participants will go off in these pairs for a night of sex (Rasmussen 1929, 241–2).

As Kunuk chose to show in his video, the *qaggiq* triggers a wide variety of games. Many of the themes surrounding the *qaggiq* centre on the concept of community. The decision to build a *qaggiq* itself is done with the participation of all the community leaders, not just one person. Once the decision has been made, through a process of consensus rather than majority-rule vote, the men of the com-munity gather to begin the process. They work together as a team, even if they have come from different places and have met just a short while before. The young men cut the blocks, following the guidance of the elders who select the best snow and decide how many blocks of various sizes are needed. The older men work on the *qaggiq* itself, shaping and placing the blocks carefully until a sturdy structure emerges. Meanwhile, the women prepare the *qulliqs* that will light and warm the interior of the *qaggiq*. They also mend their family's nicest garments and perhaps polish some *ajaja* songs to sing during the festivities.

And the games and activities themselves reinforce the cohesion of the community. Contests that on the surface might seem to fragment the community by pitting one person against another in fact strengthen it; winning is important, but what matters is partic-ipation, daring to try, risking the good-natured laughter that fol-lows silliness. By standing before the group – whether to beat a drum, model a new *amauti* (woman's parka), try a feat of skill, or take on an opponent in a game of strength or endurance – a per-son counts him or herself, and so is counted by the others, as a member of the group.

PRECONTACT FOLKLIFE

One of Kunuk's goals with the *Qaggiq* video – and with most of his work – is to show how the Inuit lived in the past. Some of his videos show life in a much earlier time, while others are set in a more modern era. In *Qaggiq*, Kunuk presents the folklife and material culture of the Inuit after contact with whalers and missionaries but not too far into the postcontact world.

The most obvious example of precontact life in the video, of course, is the construction of the igloos themselves. Many Inuit today know how to build an igloo, but it is a dwindling art form – and it is done now for reasons of cultural appreciation as much as temporary shelter. By showing the building of the *qaggiq* in his video, Kunuk emphasizes both the importance of this skill and the skill itself; viewers can watch *Qaggiq* and get a sense of how to build an igloo of their own.

The *Qaggiq* video shows other examples of Inuit culture as well, including traditional caribou clothing; sunglasses made by incising a slit into a shaped and decorated piece of bone, ivory, or antler; and dog teams pulling *kamotiqs* (wooden sledges), which are usually piled high with equipment and people.[3]

In addition to the material culture shown in the video, some of the activities reflect the way of life before the extensive arrival of Qallunaat in the North American Arctic. The contests of strength and skill, for example, represent an ancient form of entertainment among the Inuit. As Rasmussen notes:

The Eskimo temperament finds a lively and characteristic
expression in the mode of entertainment chosen as soon as but a
few individuals are gathered together. The natural healthy joy of
life must have an outlet, and this is found in boisterous games as
well as in song and dance. Underlying all the games is the domi-
nant passion of rivalry, always seeking to show who is best in
various forms of activity: the swiftest, the strongest, the cleverest
and most adroit. There are many different kinds of games, often
in the form of gymnastic exercises ... There are ball games, races,
trials of strength, boxing contests, archery etc. (1929, 227)

The contests shown in *Qaggiq* fit with Rasmussen's description. They are bouts of strength, balance, control, and endurance. The

tests inherent in hanging upside down by the knees and donning a parka – or sustaining blows of increasing vigour on the shoulder muscle, or battling a strong opponent in a lip-pulling contest – have long been part of the Inuit repertoire of challenges for the contestants and entertainment for the onlookers. Other forms of these contests are prevalent even today. *From Inuk Point of View* shows contestants facing each other on hands and knees, with a single leather strap encircling both their heads; each contestant tries to pull the strap off the opponent's head before suffering the same fate. It is a contest of strength, quickness, and cunning, and despite the setting – a modern gymnasium, with spectators dressed in Toronto Blue Jays jackets and Edmonton Oilers caps – the atmosphere is very much like the one captured in the contest scene in *Qaggiq.*

Another obvious example of precontact folklife in *Qaggiq* is the drum dancing and the *ajaja* singing. These forms of cultural expression are ancient, as Rasmussen has noted (1929, 228–9), and they serve multiple roles in Inuit society. One role involves participation – and through participation, inclusion. Both drum dancing and *ajaja* singing require talent and experience to do well, but almost anyone can do a passable job after watching and listening a short while. The drum dancing involves holding a large drum, usually made of jet-black polar bear skin, and beating the frame with a short mallet. The challenge is to maintain a steady rhythm while bending forward slightly and dancing a small circular shuffle. The dance ultimately is a test of upper-body strength; the drum is heavy, and sustaining a beat for more than a few minutes can be taxing. *Ajaja* singing often involves making up verses on the fly, calypso-style, and singing them to a loose melody while typically following the rhythm of the drum. The verses, like poetry, tend to echo with significance that ripples out from the concrete description of the words.

One other item representative of precontact life is worthwhile to mention here: the methods by which young men and women are "married." Traditional Inuit culture does not include a formal marriage ritual or any sort of legal bond; even today, "common-law" relationships, in which the participants are referred to as "wife" and "husband" as often as "partner," are not rare. These relationships are not necessarily casual; they often represent sincere motives and lifelong bonds. But the formalities of a church service

and a government certificate are not considered essential. So in
Qaggiq, when the young man presents his request to the girl's par-
ents, his wording is accurate: he seeks permission to take her as his
wife, not permission to marry her. And at the end of the *qaggiq* cere-
mony, when the "groom" guides his "bride" firmly out the door
toward their new life together, the action serves as official notice to
the community of their new relationship.[4]

One of Kunuk's goals in creating *Qaggiq*, of course, was to record
for future generations – and for people in the South and elsewhere
who know little about the Inuit – some of the significant events that
marked the routine of Inuit life. Providing impetus to his motivation
was the realization that such activities as drum dancing and *ajaja*
singing were dwindling in the face of increasing numbers of alter-
nate forms of entertainment. The diminution of this tradition has
been noted on many occasions, including Dewar's observation that
the relative infrequency of traditional song and dance events in
Igloolik can be traced to the shrinking number of elders who seek to
reaffirm their cultural identity through traditional song and dance,
the increasingly difficult access to *ajaja* songs that are often over-
whelmed by modern music, and the changing social conditions that
have led to a "virtual emptying" of the settlement during the Christ-
mas and Easter holidays – times when *qaggiq* celebrations often took
place (Dewar 1990, 413). In this decision, Kunuk reveals his passion
for history, his admiration for his ancestors, and his wish that the
important parts of traditional Inuit culture might persist.

Kunuk's effort involves an intersting twist of fate. Many people
blame television for an erosion of traditional Inuit culture and val-
ues, and certainly the evidence seems to support this contention –
a contention that many Inuit foresaw even before television arrived
in the Arctic (Roth 2005). Kunuk himself brought a television and
video camera to Igloolik before the community allowed broadcast
services to be brought in. But recognizing the inevitability of
change and the power of moving images, he is using video and tele-
vision to reinforce Inuit culture and to undo – or at least mitigate –
the insidious effects that television has brought to the North.

POSTCONTACT FOLKLIFE

Indications of precontact life, some examples of which are described
above, are present throughout the video. But the timeframe is

clearly not precontact; rather, it is a time after the whalers and missionaries arrived in the Arctic but before the Canadian government's relocation effort forced Inuit into permanent settlements. (For more on the relocation, see Tester and Kulchyski 1994.)

This distinction is important in Kunuk's mind. The magic of traditional Inuit life did not end with the arrival of Europeans; the strangers brought changes – radical changes – but they did not and could not diminish the practicality, the patience, the fortitude, and the creativity with which the Inuit faced their world.

However, the impact of contact with Europeans was profound, and it filtered into nearly every aspect of daily life. As Dorothy Eber explains:

"We used to call the whalers the Arctic Postmen, because they brought many things," one survivor of the whaling days told me. The whalers brought new equipment, new concepts, new attitudes, new delights. They brought rifles, ammunition, and wooden boats (replacing bows and arrows and skin boats with sails of intestine); they brought metal objects, wooden objects, tea kettles, ships' biscuits, glass beads, and cloth. They brought new music; the accordion rang out from ships afloat or wintering over. Even today's young people sing O Isaccie! and the slightly ribald lyrics ("Isaccie's little penis is terribly ticklish"), set to the music of O Susannah! They brought wage labour, new diseases, and new genes. The relationship between Inuk and whaler was close and intimate; it is a rare Inuk who has no whaler ancestor. (1989, xvi–xvii)

Clues of the postcontact timeframe are not difficult to spot in *Qaggiq*. Perhaps the video's most significant indication of contact with Europeans is the frequent – but not inaccurately frequent – use of tea as the beverage of choice. In the families' igloos a pot hangs over each *qulliq*, melting snow and ice. When the water is ready, a handful of tea leaves is tossed in and allowed to simmer. One woman, handing a mug to a visitor in the igloo, comments that she has no sugar; the man replies that he likes his tea unsweetened.

Before the Europeans arrived, of course, the Inuit had no tea. But once Europeans brought it over, most Inuit quickly developed a fondness for it, and having a "mug-up" became a popular pastime, warming the body and hydrating the bloodstream. But before

extensive contact, other beverages were the staples. Diamond Jenness notes that the Copper Eskimos drank nothing but water and the broth in which meat or fish had been boiled, often thickened with blood (1922, 106).

The tea in the video was prepared in metal kettles and served in metal cups, items that were furnished for the Inuit by the Hudson's Bay Company (HBC) in exchange for furs. The video also shows suspenders, igloo doors made of wood, metal knives, and machine-made saws with wooden handles, also the kind of goods provided by the HBC.

The pipes and tobacco too are evidence of the postcontact culture that Kunuk conveyed in the *Qaggiq* video. Pipes were carved of stone, bone, or antler, or they were procured from the HBC. Even pipes made by hand of native materials, however, require something in them to burn, and the Arctic climate and soils do not yield tobacco or anything else to smoke. From early postcontact times, tobacco has been a popular substance in the North, even to this day. Smoking is extensive in the Arctic, and lung cancer is the most common cause of cancer death (Inuit Tapiriit Kanatami 2006).

Perhaps the most interesting example of postcontact culture lies in the role of the young girl's mother in the marriage decision. Men and women had distinct roles in traditional Inuit life, but in cases of disagreement the man's word was generally final. For the wife to disagree – and then unilaterally approach the suitor's parents for further discussion and a de facto override of the father's veto – is not in keeping with most descriptions of decision making and power relationships from traditional times. And the husband's reaction, bemused and philosophical, is not typical either. Kunuk explains:

I wanted to show what would happen if you proposed to get married and you get the "no" answer ... When a young man comes in and proposes, out of the blue, for their daughter's hand, how did that look then? That's the message I was trying to do. Trying to get any memory back, how they got married. I just tried to show that, and what if it was a "no"? "No" is more interesting than "yes" ...

In the last scene, what I was trying to do was – everybody's there. The man that said "no" is right by his daughter. The young man has to be brave enough to grab the girl and take her out, stop at the entrance, and then go out. Because if the

man who said "no," if he could speak up now in front of everybody, he could stop it and make a fool of himself. Or just sit down and shut his beak, and accept it. So that there was a message that I tried to do. It was worth it – it was a big hit.

The video's careful indicators of early postcontact life are violated by a few anachronistic glimpses that indicate a videomaking philosophy more than a comment about the timeframe. As the adults are chatting in an igloo early in the video, one of the men reaches for a cup of tea – and his caribou sleeve slides back, revealing a modern wristwatch. In another scene, a plastic jar can be seen in the background. These and a few other small items could be seen as a breakdown in rigour, but they are in fact evidence of Kunuk's philosophy about his work: he strives to create a scene, not an illusion. The video was made in 1989, and Kunuk does not attempt to pretend that it was made in 1930. Rather, when small inconsistencies creep in, he doesn't worry about them. They are real. This video does not show families in the early postcontact Arctic; it shows modern families portraying families in the early postcontact Arctic. At one point, two young children struggle to avoid bursting out laughing when the camera is trained on them, and the longer the camera remains, the more impossible their quest becomes. Eventually, they explode in hysteria and bury their faces in their parkas. Kunuk could have cut them out of the scene – they did, after all, "break character" – but he chose to leave them in. This is how these children reacted to the camera, and their behaviour does not detract from the video.

Fundamentally, the video creates an image of Inuit life that Kunuk and the others at Isuma expect viewers to accept. It is a communication that serves a role in the negotiation of Inuit culture, and with the durability and consistency of recorded media, the video is positioned to influence this negotiation for years to come. The goal is not illusion but persuasion, the presentation of a worldview and a cultural respect that Isuma producers hope will be greeted with sympathetic hearts.

NUNAQPA

Whenever he can, Kunuk likes to help actors learn from elders, give them a rough idea of what to do – "build a *qaggiq*," "hunt seal

pups," and so on – and then turn them loose, following them with his camera. He records their activities and their dialogue as they occur naturally, and then he shapes the raw footage into a coherent video back at the studio.

This was the approach he took when he made his first video as a formal member of Isuma. Entitled *Nunaqpa*, which means "going inland," this fifty-eight minute video was created in 1991. Set as *Qaggiq* was in the 1930s, it follows two Inuit families as they hike inland to hunt for caribou and cache the meat for use during the winter.

The video begins when the sun is setting on a late-summer day. A traditional *ajaja* song is sung, slow and strong. The scene shows the coast of a long bay or strait, glinting water next to stretches of wet tundra. The singing is replaced by the raspy voice of an elder man telling a story about hunting caribou when he was young. The shimmering light of a *qulliq* fills the screen, and then we see the elder's face. He is in a dark tent, and he is wearing a caribou parka. Others – including the suitor and his family from *Qaggiq* – are in the tent, listening to his story.

The choice of topic is not accidental. It is late summer, the time when Inuit in the Igloolik area turned their thoughts toward heading inland, usually to the interior of Baffin Island, to hunt caribou. The caribou, fattened from a season of easy grazing, would be cached to provide food during the long, lean winter ahead, and the hides would be softened and sewn into very warm garments.[5] As the sun sets and the *qulliqs* cause the sealskin tent to glow from within, the talk centres on the hunt. "Tomorrow we ought to start walking inland," says the leader of this family. This declaration inspires a woman to sing an improvised *ajaja* song that is greeted with warm enthusiasm. The people involved in the hunt retire early to rest for the day ahead.

The next day, with drum-dance sounds in the background, the hunting party from the two families prepares the gear. Not everyone will go; the elders and some of the younger children will stay behind. Bundles of skins are tied and fitted with straps that slide over the shoulders – the straps running horizontally, unlike typical backpack straps from the South – and harnesses are forced down over the dogs' heads. Tents are struck and rolled up with the poles inside. The sun is shining, and the day is pleasant; it is a good day to begin the trek inland.

Little is done to prepare food and water for the journey; the hunters will rely on their skills to secure game and find springs along the way. Saddlebags are placed on the dogs' backs, a puppy is situated in one woman's *amauti* hood, and a young child is hoisted onto a man's shoulders. The loads are heavy and awkward – some of them are balanced with a wide strap that runs across the forehead – but they are necessary for survival. With a cheerful "We will show up eventually," the group is off, hiking slowly over the rolling hills.

Once a site is chosen and the camp is set, it is time to search for caribou. The hunters – the leader of the camp and four of the younger men – set out with rifles, leaving the women and children in the camp. At the top of a ridge, they bring out the telescope and search the hills before them. It is not long before they spot some caribou, a small herd of three animals. They work out a plan of attack. The caribou will bolt if spooked, so the leader of the camp goes in one direction while the others circle around. The plan calls for the leader to herd the caribou toward the waiting riflemen.

The caribou are close by. The leader of the hunting party signals for the others to move into position. The caribou climb the hill toward the ridge. Then the herd splits, with two of the animals heading off to the right. The hunters crawl forward, hiding behind the waist-high boulders that line the ridge. They hunker down behind one boulder and hurriedly take their rifles from their sheaths. They kneel behind a boulder and rest the rifles against its top. They line up their sights, and two blasts explode through the air. The hunters return the rifles to the sheaths. "We shot two!" one of them says.

The animals are lying dead on the tundra, and now the butchering begins. With a small knife – the blade is just two inches long but very sharp – the young men begin with an incision along one caribou's belly. Their hands move like those of an expert seamstress, confidently cutting and pulling back the hide. Then they turn their attention to the legs, cutting a circle around each ankle and slitting up the back of the calf and thigh. This incision joins the main one, and then they begin to peel the hide off the meat. The skin removes neatly, with virtually no blood and only a slight tearing sound. It is a straightforward process of removing the caribou's coat and taking it as their own. Once the hide has been removed, the caribou, still otherwise intact, takes on a purple

sheen, its open eyes staring out lifelessly from a skinless face. Then the body itself is opened, and the meat and organs are removed in large pieces. The other hunters finally join these two and help with the butchering.

The haunches of meat are fitted neatly into the chest cavity, forming a heavy, compact packet of meat. The other caribou is dragged over from where it fell, and the process begins again on this animal. The parcels of meat are placed on the ground and covered with a heavy layer of stones; they'll keep there until winter, when the hunters can return by dog team and haul the meat back to the village.

It is a peaceful time, softened by a smoky fire, warm tea, and the satisfaction of completed work. The successful hunters tell each other the story of how they caught the caribou.[6] Then, with their skin coats showing red blood in places, the hunters pack bones, organs, and some of the meat into the two skins, bundle them up, and head back toward their camp. The hunt successful, it is time to rejoin their group. With a slow, strong song in the background, they walk across the tundra and the hills, stopping at times to spot caribou with their telescope. As the hunters continue to walk, the sound of women singing is heard. The scene shifts to the women and children at the camp; the two oldest women are singing a song together. At the end of the song, they shout and lunge at each other, amid great laughter.[7]

Then the talk turns to food. "Aged bird skin makes a good chewing gum," one of the women says. This is relaxed conversation to pass the time until the hunters return. "Adding used blubber to it and chewing it makes it more delicious!" the other adds. They go on to talk about how oil that has dripped behind the *qulliq* can flavour walrus skins; "so delicious!" Leftover soup can also flavour the skin, and "ptarmigan droppings are also delicious when mixed with meat, reddish and delicious!"

At last the hunters trudge into view. They are greeted with cheerful shouts and questions about their success. The women are delighted that caribou have been caught. The bundles are untied with the comment, "let us welcome the food." The skins are unrolled, revealing the glistening layer of fat on the inside. "Oh good! It has fat! Wonderful!" The whole camp is happy.

After a meal and a rest, everyone begins the preparations for the trek home. The tents are struck, the bundles are retied, and the

children are hoisted onto shoulders once again. It is time to head for the winter camp before the weather gets too cold. The tents will be stored until spring, and the winter will be passed in houses made of stone and sod, with sealskin roofs. A light drizzle falls as they make their way back; the tundra saturates and swells with pools through which they must wade.

The old man's voice is heard: "My mother used to tell me to hunt whenever I could, even in bad weather, so I won't ever go hungry, and my family would have food. That's what she used to advise me. Sometimes I used to be successful in my hunts."

Back at the winter camp, the children and elders wait. One woman practises string figures, making a fox and inviting it to share some whale meat. Then the children shout: "They're coming! They are arriving!" The announcement raises excitement in the camp. The hunting party works its way slowly from across the tundra; a drum-dance song is heard. The stream is forded once again. The hikers at last are in the camp; hands are shaken, smiles are exchanged. "I am grateful," says one old woman. "That is joyful!" says another.

And with the reunion, the video is over.

DIRECT VOICES

By recording action that is almost entirely unscripted – but nevertheless shaped through discussions with elders who remember life in the 1930s – Kunuk and the Isuma producers set the stage for the kind of videography that they would pursue throughout the thirteen-part Nunavut series. Their goal was to set aside, for a while, the pursuit of classic dramas that have dramatis personae and story arcs. The characters in *Nunaqpa* have personalities, but they come across through the act of performance, not through preassigned descriptions on paper. The intent is to show how Inuit lived on the land in the 1930s, not to tell a story with a beginning, a middle, and an end.

Nevertheless, the story does follow a kind of natural progression. Like the base camps on Everest, subsets of the group are left behind – first, those who cannot travel are left at the home area when the large party departs, and then the nonhunters are left at the camp when the small hunting party goes off to find the caribou. When the hunters go out with little more than their rifles,

some suspense kicks in – will they be successful in bringing food back for their families? The people left behind do not seem worried; they pass the time telling stories and swapping small talk. But the starkness of the tundra and the approach of winter send a clear message that this is not hunting for sport.

Despite the suspense, the climax is quick and uneventful. The hunters clean and prepare their rifles, and then they shoot two caribou. Unlike films and other media that position the Inuit as struggling to survive in a harsh and unforgiving climate, *Nunaqpa* shows that the gathering and processing of food was a routine part of Inuit life. The Inuit did not spend their lives in constant struggle, the video suggests, because they were smart enough to work out systems and schedules that brought about the desired results.

The lack of scripting lets these messages emerge in ways that are more direct and more credible than any scripted movie could achieve. Viewers watch the Inuit in action, and they are expected to believe what they see on the screen.

In this way, *Nunaqpa* shows a facsimile of life before extensive contact with Qallunaat. Isuma bills the video as a drama, not a documentary, but it nevertheless offers at least a filtered understanding of routine activities as remembered by the elders. It could perhaps more accurately be called a demonstration, a cultural re-enactment that reflects both the *content* – old-time hunting and camping techniques – and the *spirit* of the era that Isuma is trying to convey. Ultimately, the goal is to honour the wisdom and resourcefulness of the elders and ancestors who lived in the era before washing machines, wood-frame houses, and television.

The video also demonstrates the rhythms of Inuit life before the changes wrought by modernity and contact. Life was close to the land, patient, and deliberate, the video asserts. More important, webs of relationships kept communities close and functioning. Division of labour along gender and age lines meant that food would be harvested and children would be raised. Simplicity, knowledge, and planning would improve the chances of a comfortable and pleasant life.

SAPUTI

In 1993 Igloolik Isuma created *Saputi* (*Fish Traps*), the third part of the 1930s trilogy. The video is intended to show the activities of

Inuit families as they attempt to harvest Arctic char, an important staple in the seasonal cycles of procurement and survival. The video shows a flat stretch of Baffin Island tundra that drops sharply, in places, down to a wide river. A few families have camped along the river so that fish traps can be built and the char can be caught and dried. The time is the 1930s: zippers tighten children's skin outfits, stubby pipes provide relaxation and gentle activity, canvas bags hold clothing, and rifles wait for caribou. But outside technology hasn't fully penetrated to the families on the land; the stone weirs, the friction fire-starters, and the skin tents offer reminders that the old technology was retained when it worked.

The men build the traps. They wade into the cold, swift river, soaking their clothes and filling their boots. They lift rocks from the river bottom and stack them in a sinewy line that snakes from bank to bank. Some rocks are big and must be carried with care to avoid the loss of fingers and toes. Footing is treacherous in the noisy, splashing current. As the weir develops, water piles high behind it and spurts between rocks. It is late summer, the time when char head upriver for the winter. Insects fill the air, and lightweight skin clothes make activity easy and fun. It is a good time to be out on the land. But the fish do not arrive, and the video shifts to trace the internal action of the imagination in the form of visions and daydreams.

Kunuk made this video with a set of goals in mind. He wanted to show viewers the kind of life that Inuit have earned on the land for millennia. He wanted to show viewers how resourceful, clever, and wise the Inuit can be. He wanted to venture into the internal life of Inuit on the land; the video shows hallucinations and daydreams as vivid as the fish.

Kunuk considers himself a video storyteller, the latest in an immeasurably long line of Inuit storytellers that dates back thousands of years. That videography perpetuates this lineage is easy to see. For millennia Inuit have shared knowledge, taught children, negotiated and passed along their culture, and conducted myriad social functions through storytelling. Winter nights are long in the Arctic – in Igloolik, one of them lasts for seven weeks – and storytelling has long been a popular way to pass the time. In the *qaggiq* (the large igloo constructed to allow multiple families to gather together) drum dancers would boom out steady rhythms as they danced in a shuffle while turning in a circle. Singers would per-

form *ajaja* songs or face each other and conduct the vocal gym-
nastics of multiharmonic throat singing. Shamans would chant
and gyrate and dredge up the underlying causes of sickness, bad
weather, or famine. And storytellers would share their repertoire
with the gathered listeners, bringing minds back hundreds of years
or far out into the realm of the spirits.

In the steamy, smoky, dark atmosphere of the igloo, where peo-
ple are pressed tightly together and smells of tobacco, sweat, and
blood commingle into oppressive density, the effect of a well-told
tale could be profound. Minds are susceptible, bodies are tired,
and imaginations are ready for fanciful journeys. The storyteller
stands in the centre of the igloo, in the centre of the crowd, and
tells the tale with dramatic flourish, adding sound effects, varied
voices, wild and intense gestures, and swelling vocal intonations to
make the scene come alive in the midst of the listeners.

Video can create many of the same effects. By presenting both
visual and aural stimuli, it can carry people away from their current
circumstances and engage their minds in whatever worlds the
videographer wishes to create. By presenting layers of information
– not just the surface elements of dialogue and setting but also the
more subtle influences of gestures, facial expressions, and tone
of voice; of incidental props in the background and details on
clothing; of proximity between characters and body language that
reveals state of mind – video can excite the viewers' imaginations
with multifaceted shades of meaning, portent, and motive. And
by making use of culturally significant symbols, video can tap into
viewers' previous knowledge and cultural understanding to
explain, suggest, hint, and reveal.

In *Saputi*, Kunuk tells a story of a community working together,
of the fickle nature of the Arctic environment, of the potent effects
of imagination. Many Inuit stories, told in gatherings, centre on
recent activities: a hunt, or a trip, or a brush with death. The teller
recreates the event for his listeners, walking them through actions
of interest. *Saputi* takes the same approach. It walks viewers
through the events surrounding a group's attempt to build a weir
and catch some much-needed fish before winter. As Kunuk notes,
it also attempts to capture something of the inner life of the Inuit:

In *Saputi* I tried to do something else, daydream scenes. That's
what I tried to do. I tried to do a daydreaming scene because

when I was a child I used to daydream a lot, especially after watching a movie. I used to daydream a lot and get dragged behind, got left behind when we were walking out. I am just . daydreaming away. I tried to show how daydreaming – I don't know if I did it. I tried it. And just like daydreaming, it was running and jumping in the river. Just daydreaming. I tried that and then I tried a girl who sees a young man coming toward her. And really walking away. I tried to show pictures of – that person doesn't exist and just disappeared right off the bat. I tried rock monster, which was a hit to the kids. The kids love that. Every time when I was a child, get in water and something moved behind a rock, and I was always dreaming of such a horrible thing.

The story reflects Kunuk's own experience, daydreaming as a child, and it relates the tale of one group's attempt to gather char during the annual migration upstream. Through visual and aural stimulation, through an appeal to the imagination and the memory, through the creation of characters and their situation, Kunuk shares with his viewers a story as vivid and intricate as the ones told orally in the midst of dark and smoky igloos.

One overarching theme in Inuit life, even today, is the centrality of nature. Weather can be fickle, turning even minor activities into life-threatening events. Animals can show up – or not – when hunters are ready. Smart people follow nature's lead, taking what is offered and making do with the circumstances presented.

Saputi demonstrates this philosophy. The Isuma crew got everything ready. The costumes were prepared. The tents were built. The makeup and hairstyles were designed and put into place. The action was outlined. The cameras were cleaned, the batteries were charged, and the fresh tapes were secured. The entire cast and crew were transported to the site.

But the fish failed to show up. The weir remained empty. Many production teams would have declared the project a failure – how can you make a video about fish traps if there aren't any fish? But the absence of fish, from Isuma's point of view, was no calamity. The arrival of fish in a "real life" trap was never certain; if you build it, they might not come. And if the fish chose to show up elsewhere, or to migrate at a slightly different time, the only recourse for the Inuit was to cut their losses and try to find other game. So the lack

of fish in *Saputi* did not destroy the project. Isuma would record whatever happened when fish traps were built at this time, in 1993. The result might be a video about the harvesting of char, or it might be about the hunting of caribou while waiting for char, or it might be about games and daydreams while looking for caribou and waiting for char – but no matter what happened, it would be accurate. Nothing is certain in the Arctic.[8] The Inuit – and anyone else who spends time in the North – must bend to accommodate the setbacks, opportunities, changes, and devilish thwarts that nature and chance put in the way. The Isuma team set out not to make a video about the trapping of fish but to make a video about life at the fish traps. With this goal in mind, one that did not rely on the cooperation of nature, success was assured.

The Inuit philosophy regarding environmentally enforced delays and changes is not the topic of everyday chat in the North; it is too obvious and fundamental to sustain a conversation. But through the shooting of *Saputi*, this philosophy became foregrounded and articulated by the people involved in the project. This articulation extends to the rest of the community as well when the video is aired; people discuss the program and why it turned out the way it did.

In addition, videos such as *Saputi* offer a way that a society can remember its traditional folkways – and through remembering, recreate and perpetuate them to ever-accreting degrees. Success at the traps was important in traditional Inuit life. The stone weirs are tall, wide, and long, and they represent a terrific amount of work. In the grand caloric formula of the North, the *saputis* must generate more energy than they require – or the effort is pointless. To build a long, strong, tall, massive stone trap and have this effort prove fruitless is a serious setback that must be corrected through the immediate and successful hunting of other game to make up the deficit.

The traps also reflect the sizable amount of knowledge about natural cycles and nature's wisdom that has been developed and preserved over the years. The weirs, straining water to ensnare food, are the stone equivalent of a bowhead's baleen. In fact, another fish-trap design calls for the creation of a low rock weir across the mouth of a river; at high tide, the fish wash upstream over the stone wall, but when the tide drops, the wall lets the water through but holds the fish back, making them easy prey for the

fishermen. In this way, the mouth of the river and the mouth of the bowhead function in precisely identical ways.

A knowledge of the seasons is also essential for success at the *saputi*. A woman in the video explains that the fish should be running because the nights have been dark for a while. Whether there is a causal connection between dark nights and the movements of fish is uncertain; it is possible that the fish use the length of the dark periods as a cue to begin their migration. Regardless, the two events coincide; the Inuit took a phenomenon that they could readily detect – the length of darkness at night – and correlated it with one that they could not readily detect – the migration of fish up the rivers. By observing the timing of the two, they developed for themselves a means by which they could know when it was time to move to the *saputi* areas. (Similarly, the twisting into a spiral of a small phototropic plant on the tundra suggested that it was time to go inland to hunt caribou; the observable event was used as a signal to change behaviour.)

This juxtaposition of events carries meaning. Longer nights mean that it's time to build a *saputi*. Twisted Arctic cotton means that it's time to hunt caribou. Without the juxtaposition, meaning is lost. Kunuk and other Inuit videomakers understand juxtaposition; they know that the placement of scenes and images in the linear stream of video frames can produce meaning far beyond the messages inherent in the scenes and images themselves.[9]

It is this knowledge of the fish, of the environment, of the messages imbedded in the world around them, and of survival itself that *Saputi* records. The recordings give the people of Igloolik a means by which they can retain at least the knowledge of these old ways, and this retention can lead to re-creation for those inclined to practise what the ancestors knew how to do. So video also serves as a kind of history – filtered, partial, and subjective, as all histories are – that can influence the folklife of today and lead toward the shaping of life tomorrow.

7

Video as Socio-Political Endeavour

The political, social, and economic agenda that Isuma pursues has its roots in the group's split from the Inuit Broadcasting Corporation (IBC). Both Paul Apak and Zacharias Kunuk worked for the IBC in the Igloolik production centre before leaving, for socio-political reasons, to form Isuma.

Their criticisms of the IBC centre on political and economic control. The IBC is headquartered in Ottawa, and its funding comes from the Department of Canadian Heritage, a branch of the federal government. From there, the chain of authority falls to the production centres but most fully to Iqaluit, which is the hub of the other four (Igloolik, Taloyoak, Rankin Inlet, and Baker Lake). Each production centre has responsibility for portions of the programs that the IBC puts on the air. In Igloolik, for example, Jake Kadluk and the others created material for *Qimaivvik*, a cultural program; *Qaujisaut*, a program that teaches life skills to young people; and others. Segments produced for the *Qimaivvik* program are sent to Baker Lake, where they are added to segments from other centres to form a hosted, magazine-format show. Segments for the other programs go to Iqaluit.

Critics at Isuma point to several problems with this system. First, positioning the IBC headquarters in Ottawa distances the top decision makers from the very people who are supposed to be supported by the IBC's efforts to reinforce Inuit language and culture. (This argument has been made by other groups as well; see Roth

2005.) This geographic separation leads to some very real difficulties. The people in Ottawa, for example, see the interworkings of the federal government's various bureaus far more closely and more often than they see the functionings of the IBC production centres and producers. Proximity to Ottawa makes it difficult for IBC's own leaders to prioritize their tasks with an eye toward the real demands of video production in the North – and much easier to prioritize based on the intricacies of Ottawa politics. Kunuk and Apak found the bureaucracy, with its centralized budgeting and other tentacles of control, too Ottawa-bound; they found too little emphasis on making quality videos and too much emphasis on Southern-based red-tape requirements for compartmentalized budget allocations.

In defence of the IBC, executive director Debbie Brisebois points out that while the organization is indeed headquartered in Ottawa, the "headquarters" consists of four people, counting herself and a receptionist/secretary (1999). The office itself is small and run-down, with second-hand furniture, and it has been broken into several times. She counters the projection of the IBC as a top-heavy, bureaucratic organization anchored in the South.

But to the people of Isuma, the IBC bargain is Faustian in the sense suggested by Faye Ginsburg (1991) and John Palattella (1998); the suggestion is that apparent advances in communication capabilities come at a cost to cultural autonomy. The IBC, in Isuma's view, is a Southern organization, with Southern administrators, Southern trainers, and Southern values. (Kunuk has said that the IBC is like a dog team, with producers being the dogs and the Southern managers sitting on the sled.) Cohn and the others argue that the IBC operates like any other mainstream media organization; it is a colonial enterprise in that it impresses the objectives of a dominant society onto an aboriginal society, and it is insidious in that it does so with a Native face.[1] The "front lines" of the IBC, made up of Inuit producers, make possible the hegemony necessary for further dominance by the South. The IBC looks, on the television screen, like an Inuit organization, and the Inuktitut tumbling out of its soundtracks makes it sound Inuit as well. But it is in fact a white organization based in Ottawa, Cohn says, with the camouflage of an Inuit veneer. As Kunuk puts it: "We were proud to get into television. The IBC was important to us. But it was only a name; it was not the same underneath."

Cohn – Isuma's most vigorous voice on political matters – cites a stream of evidence to support this position. Most of the Inuit working at the IBC were trained in the South, and those who were trained in the North learned their artistic trade in workshops run by trainers brought up from the South. (Ironically, Cohn himself came to Iqaluit from Montreal to train Inuit videomakers at the IBC. After witnessing the political situation first-hand, however, he joined Kunuk and eventually became one of the principals of Isuma.) But the problem goes deeper than the initial training system. With the headquarters in Ottawa, the IBC is set up to discourage Inuit producers from advancing to positions of real power, Cohn says, because few want to leave the Arctic. In addition, by the time Inuit producers are ready for higher positions, many have already left the IBC, frustrated by Ottawa's strict control and the need to put serious, professional equipment requisitions in the form of "wish lists like kids at Christmas." Moving the IBC headquarters to the North would help matters quite a bit, Cohn argues; Isuma is doing quite well despite the hardships imposed by distance from the large population and distribution centres in the South.

In addition, coming out of Ottawa is a stream of imagery that undermines genuine efforts at self-representation. "There is a propaganda machine that shows Inuit media making major strides toward self-representation," Cohn says, "but it is actually managed by southern bureaucrats." This propaganda machine puts out two messages, Cohn argues: that the true Inuit culture was wiped out by contact with Europeans and that contemporary Inuit life is "a victim-laden morass of abuse and social problems in which a dead culture leaves people unable to cope with modern life." There are a dozen Canadian Broadcasting Corporation (CBC) and Telefilm products, he says, that put forth one or both of these views. In reality, most Inuit are finding ways to adjust to a rapidly changing world, and little irony is seen in the image of a dog-team driver with a dog whip in one hand and a general positioning system (GPS) receiver in the other.

To make matters worse, Kunuk adds, the people who hold the key positions in the government – the federal government that supports the IBC and such funding agencies as Telefilm – change jobs frequently, forcing Isuma and others to re-educate a new crop of Arctic-green bureaucrats every few years.

The Isuma producers suggest steps that the IBC could take to reduce the tension between its mandate and its reality. If the IBC brass were headquartered in Iqaluit or one of the other Nunavut communities, for example, they would have a better sense of the challenges, needs, and attitudes prevalent in the North. (Brisebois points out, however, that several positions that once were located in Ottawa have been moved to the Arctic production centres [1999].) And if more of the top officials were Inuit – or at least spoke Inuktitut – they would have a better sense of the audience that the IBC is supposed to serve. In fact, relocating to the Arctic would make it easier for Inuit to work their way up the ranks to the upper levels of administration.

The counter-argument is easy to see, however. If the headquarters were in Nunavut, the IBC would be physically marginalized in the Ottawa power circles; it is difficult to mount a persuasive lobby from a thousand miles away. By putting the IBC's top office in Ottawa, and by filling it with people who have some experience in the world of Ottawa politics, the IBC stands a better chance of being heard by those who make the crucial financial-allocation decisions for the federal government. Still, say the critics, the IBC budget is dwindling – hardly evidence of a successful presence in Ottawa. Moving the headquarters to the North would have more benefits than costs, they argue.

It also must be noted that the IBC is a creation of the Inuit Taparisat, the "Inuit Brotherhood," which functions to promote Inuit culture and involvement in the Canadian political process. The Inuit Taparisat (also spelled "Tapirisat") proposed that the CBC's northern service be reduced to ten or twelve hours a day, thereby freeing four to six hours a day for Inuit programming (Raboy 1990, 344–5). The group also applied for a television network licence and proposed sharing a satellite channel with the CBC. The licence was awarded in July 1981, and the IBC began broadcasting in January 1982 (344–5). The IBC, therefore, was born out of a desire to preserve the Inuktitut language and to promote Inuit culture and perspectives on the Canadian airwaves.

Nevertheless, Cohn argues that another step that would benefit the IBC would be the implementation of local budgeting control so that the Igloolik centre, for example, could decide for itself how to spend the money allocated to it. This shift would allow centres to save money in some areas and apply it to areas of greater need –

while restoring some dignity to the videographers who should be trusted to make sound, professional judgments. The Igloolik IBC has been trying for years to get vehicles that would allow its crew to travel and haul its gear. The requests made in its "wish lists" have been repeatedly denied. The result is that the local producers for the Inuit Broadcasting Corporation – people who hold positions that should garner respect in the community – are forced to borrow or rent all-terrain vehicles (ATVs), boats, and snowmobiles to do their jobs. Julie Ivalu, the director of the IBC production centre in Igloolik, resorted to running bingo games in an effort to raise the funds needed for a snowmobile. The effect on morale, esteem, and reputation is clear; imagine the American Broadcasting Corporation (ABC) news crew in Indianapolis or Houston holding raffles to raise money so that its reporters can use a car to get to news sites. By shifting control of portions of the budget to the local production centres, the producers would be able to set their own priorities and make decisions and adjustments accordingly.[2]

And a third step would be to give the local production centres greater freedom in creating their own full programs rather than feeding small segments to magazine-style shows that are too disjointed to make a cogent point. The power of a single half-hour feature on a particular subject explored by an individual videographer is much greater than anything that can be cobbled together from parts submitted from multiple centres. Because the centres are not coordinated to contribute material on a particular topic so that the pieces can be joined to form a potent whole that addresses an issue affecting all of Nunavut, the magazine format offers little opportunity for rich presentations – while at the same time discouraging creativity and energetic investment in any given project. There is a big difference between being asked to produce an eight-minute segment about something cultural for the next *Qimaivvik* program and being given the freedom to produce a complete show about an issue that is relevant to the producers and the viewers. The former might engender consistency, but the latter engenders passion, enthusiasm, and a heightened sense of self-worth among the professionals being asked to do the job.

Brisebois once again counters Isuma's charges. She notes that the budget is decided upon collectively by the Ottawa administrators and the managers of each of the production centres. Once

fixed costs have been subtracted from the funds provided by the government, the remaining money is directed by the leadership group as a whole (1999).

ISUMA

Compared to the IBC, Igloolik Isuma maintains a much more antagonistic stance toward Ottawa and the South. The problem, as the Isuma producers see it, goes back to initial contact with Europeans, and it has been exacerbated by several downturns since then. The relationship between Inuit and Qallunaat has long been unidirectional, with the outsiders in charge and the Inuit in service to them. The outsiders have changed over time, and now they live in Ottawa and proclaim their right to make decisions about the Inuit a thousand miles to the north.

One of the darkest periods centred on the attempts by Ottawa to corral the Arctic into mainstream Canada. This paternalistic and racist effort took several forms, the two most dramatic being the relocation effort, in which nomadic Inuit families were herded into permanent settlements (Tester and Kulchyski 1994), and the forced education of Inuit children in residential schools. In particular, Cohn argues, the residential schools, where children (Kunuk included) were beaten when they spoke Inuktitut or practised Inuit traditions, destroyed a fundamental part of Inuit culture. In the past, authority among the Inuit was granted on the basis of age, wisdom, and skill; an elder who was known to be a successful hunter could make a suggestion, and the camp would treat it as an order and willingly comply. The compliance was willing because the people in the camp understood that their survival and prosperity depended on following the best advice, and people with experience were in the optimum position to offer this advice. As younger men and women watched and listened, they gained the experience that would eventually bring authority to them.

The residential schools changed all this. Using sometimes brutal methods, they trained a new generation of leaders in their own way, forcing a shift in authority toward levels of formal education and away from age and experience. As a result, many elders with real-world experience do not hold positions of authority today, and young people with classroom learning find themselves with the authority to issue orders – even to those very elders.

"Traditional knowledge is not valued," Cohn says. "People have nothing to do."

"Our elders are not giving orders," Kunuk adds.[3]

Into this vacuum has rushed not only Southern systems of authority but also Southern systems of domination. Cohn, in fact, sees the IBC – and the nascent Nunavut government itself – as another example of the standard postcolonial shuffling. When one system is pushed back, the system that takes it place, he believes, has been shaped and trained by the initial power in the first place. So the new power becomes the new establishment, mirroring the very establishment that it struggled to overthrow, and little is changed. It's still the establishment versus the aboriginals, but now the establishment includes the IBC. "The IBC is not a progressive step by the government," Cohn says.

So as far as Cohn and Kunuk are concerned, Isuma is waging an ideological war against the IBC – and through the IBC, against the colonial government that forced Inuit into strange new communities and harsh residential schools.

"Igloolik Isuma represents something, but it faces a serious struggle," Cohn says. "At the centre is the politics of self-representation."

UNCIVIL WAR

The process of funding *Atanarjuat* underscores the difficulty that independent, indigenous producers often face when trying to create top-quality, professional videos (Wilkin 1998). The project began in 1996, when Paul Apak came up with the idea to create a full-length screenplay, in Inuktitut, based on an Inuit legend. He and the others at Isuma would pull together actors and other participants from Igloolik, going to other Northern communities only if necessary but never drawing from the South. They would rehearse, shoot the scenes, edit the footage, and show the movie, with English and perhaps French subtitles, on CBC or some other major Canadian-centred broadcaster. The movie would also be available on videocassettes and DVDs so that schools, universities, libraries, and other institutions could show it to students and patrons. The Isuma producers had the talent, the expertise in Northern videography, the credentials, and the support of the settlement.

All they needed was the money – $2 million. A large sum but a sum that represented a tight and lean production in the realm of major moviemaking. Isuma applied to Telefilm for the funding.

Telefilm represents half of a fund that wields more than $200 million intended to support the creation of Canadian films and videos. Of the $200 million, $100 million goes to Telefilm, and the other half goes to the so-called Cable Fund (now called the Canadian Television Fund). Each half is then divided again, with $50 million going to support private ventures and the other $50 million going to support public programming at the Canadian Broadcasting Corporation.

Isuma falls into the "private" side, so ostensibly Isuma could apply for part of a $50-million pot. But there's a catch. Each of the four $50-million subfunds is divided again: 65 per cent for programs in English and 35 per cent for programs in French. Like the IBC's productions, Isuma's work is in Inuktitut, quite deliberately and importantly. But 65 per cent added to 35 per cent totals 100 per cent – there is no room in these funds for programs that rely on a language other than French or English. Recognizing that aboriginal groups need access to video-production funds, Telefilm and the Cable Fund each set aside an additional $1 million for use by aboriginal groups. The difference between the aboriginal "envelope," as it is called, and the English and French envelopes is deep, and Isuma charges that it is based on the assumption that aboriginal groups are inherently less professional than are their English- and French-speaking counterparts. The eligibility rules for the aboriginal envelope are more lax than are the requirements for the English and French envelopes; the intention is to make it easier for aboriginal groups to undertake video projects. However, not only is less money available for aboriginal programming in general, but the ceilings are lower as well: projects applying under the English and French envelopes may request up to $1 million apiece, but aboriginal-language projects may request no more than $100,000. This is a lot of money, and many of Isuma's projects have been funded under this envelope; *Nipi*, for example, received $100,000 from the aboriginal-language envelope at Telefilm, and this money was sufficient for Isuma to create the hour-long video in accordance with the group's artistic and professional standards. But for the feature-length *Atanarjuat*, with a full cast, historical sets and

costumes, and all the other necessities of a top-quality movie, $100,000 is far from sufficient. So Isuma applied for funding, through Telefilm, under the $1-million envelope. (The rest of the funding would come from other sources, but a major contribution from Telefilm would be critical to Isuma's access to these sources.) But because the project is not in English or French – and despite the promised subtitles – Telefilm relegated the project to the aboriginal envelope, with its $100,000 cap. Kunuk and Cohn responded with a stream of letters. They pointed out that the aboriginal-language envelope, with its relaxed eligibility requirements, was a fine idea but that aboriginal producers must be able to break out of this envelope eventually and compete against other major Canadian producers for the larger funds. Otherwise, the system would be biased against major aboriginal productions; it would force aboriginal producers into a "funding ghetto" – Cohn's term – from which they could never escape. It would doom them to producing only small, low-budget programs, while producers who made English- and French-language movies would have access to much larger funds.

Another key to the funding web was a broadcast commitment from a network; the value of the air time had to be counted as a certain percentage of the overall project budget. Isuma secured the commitment from the CBC – but with a frustrating catch. The value of the broadcast time was not *allowed* to be counted toward the budget that Telefilm required of Isuma. Kunuk and Cohn wrote more letters, offered arguments, contacted other potential sources of funding, and eventually pieced together a complex and delicate matrix of money and commitments that would make the project possible.

Eventually, Isuma received some initial funding from Telefilm, and Kunuk and Cohn believed that they had a commitment for the rest of the money necessary to produce *Atanarjuat*. Early in 1998 auditions were held in Igloolik for the dozens of speaking roles and walk-ons available. Igloolik residents talented in sewing caribou-skin clothing and sealskin *kamiks* (knee-high boots) were hired to study traditional Inuit designs and make the costumes for the production. Others were hired to help with hair styling and makeup, including the elaborate tattoos that once decorated the hands and faces of Inuit women. Skin tents were made; harpoons,

caribou-antler sunglasses, and other tools were crafted; and the props for the shamans and other characters were created. Isuma even custom-ordered a remote-control walrus head from a special-effects shop in Toronto; the walrus was needed to crash up through the sea ice on cue, something real walruses have difficulty comprehending.[4] Everything seemed to be in order; the taping began in the early spring of 1998.

But taping was halted abruptly in May; Telefilm had exhausted its annual supply of cash before it could issue the rest of the money for the *Atanarjuat* project. Isuma was not alone; filmmakers and videographers throughout Canada were cut off, several in mid-project. No more money was available for 1998, and Isuma had no choice but to lay off the actors and crew, pack up the costumes and sets, and wait until the next application cycle. The mood at Isuma was bitter and smoldering. Lucy Tulugarjuk, who plays Puja in the movie and also was working as the coordinator for the Tariagsuk Video Centre, circulated petitions of support around Igloolik, and in the span of four hours she had collected 177 signatures on one petition and 43 on another. Kunuk and Cohn fired off letters to officials, letters to newspaper editors, faxes and phone calls to everyone they could think of – but their protests were met with bureaucratic apologies and encouragement for next year.

The funding glitch thwarted a major impetus for the movie. *Atanarjuat* was supposed to be part of the inauguration of the Nunavut territory on 1 April 1999. The movie was to be shown nation-wide on or near that day in an effort to heighten awareness of the historic creation of the new territory. With the delay, the movie was not ready in time for the celebration, so the power of the timing was lost.

The delay, says Telefilm, was due to late application materials that knocked the Isuma request out of consideration. Kunuk and Cohn, however, feel that the underlying problem is a racist funding system that tries to use the ideas of affirmative action to keep professional aboriginal producers permanently locked into a small-scale funding system.

"The battle now is to try to produce Canada's first network-level, Inuit-produced, aboriginal-language film. No white people in it. Inuit values and Inuit resolutions," Kunuk said. "But in the system of national – not aboriginal – financing, we have been very eligible

for three years. We met the criteria. But we have been cheated. Discriminated against this year. We are eligible, but they refused even to evaluate the project. Everyone says yes, but the answer is no."

In response to my questions about such frustrations, a spokesman for Telefilm – who would not give his name – explained that Isuma had not filed the necessary paperwork in time and that the fund was exhausted by the time the forms arrived. He went on to say that Telefilm is proud of its commitment to aboriginal productions, and he pointed out that Telefilm even sponsors aboriginal video awards.

I was then referred to Shelley Nowazek in the Telefilm public-relations department. She explained, by e-mail in response to written questions at her request, that there was no "suspension" of funding for *Atanarjuat.* "We did not enter into, nor was there a production funding agreement in place in fiscal 1998/99. We had outstanding development advances totaling $119,770 as at the end of 1998/99. Isuma's production financing proposal in 1998 required Telefilm to come in for $1 million. Telefilm was not prepared to for business reasons, nor were the resources available, to commit $1 million into *Atanarjuat,*" she wrote.

She noted that Telefilm had a $537,000 production funding commitment for the 1999 *Atanarjuat* work. In addition, in response to further questions, she stated that Isuma had received $10,000 for a project titled *Angaguq,* noting that the *Nipi* program had received production funding and that *Angiraq* received development and production funding. But not all proposals can receive support, she said.

"Projects are evaluated in batches of similar type projects, in any category there is more demand than available resources. Unfortunately due to the level of demand on limited funds, we must turn down viable projects each funding period," she wrote.

But Isuma remained frustrated. Cohn pointed out that Isuma received a letter from a Telefilm official explaining that the system would be adjusted to allow for large-scale aboriginal productions but that any changes would come too late to include *Atanarjuat* in the Nunavut festivities. Until changes are made, Cohn argued, Telefilm will continue to have procedural requirements that allow officials to say that they support a project while at the same time denying funding for it. *"The Fast Runner* meets all the objectives in the mandates – Canadian culture, Canadian content, national sig-

nificance, Canadian workers, national heritage – but it can't get the money," Cohn said.

Despite their anger, Kunuk and Cohn had no choice but to begin the funding process once again – and this time, money came through more smoothly. The National Film Board put up some of the money, with commitments in place from other sources as well. Isuma pulled together a team to polish the script and lay the groundwork for renewed taping in the spring of 1999.

TWO QUESTIONS

At the heart of the *Atanarjuat* struggle are two fundamental questions. The first centres on who gets to represent a group. If a southern-Canadian video company wanted to make an English-language movie about the Inuit of Igloolik, the right to compete in the $1-million envelope would have been assumed. But because an Inuit group wanted to do the same project in the Inuit language, the project was shunted to the lower envelope. The message, as Isuma interprets it, is clear: when it comes to video portrayals of indigenous cultures, presentation is more acceptable than self-presentation. In other words, "it is better for us to represent you than it is for you to represent yourself," Cohn says.

The second question lies subtly within the first, and it centres on who gets to teach a group. When one group is attempting to learn about another, who gets to serve as the bridge between the two: one of ours or one of theirs? The funding structure in Canada suggests a preference for the former, which is perhaps intuitively predictable. It is easier to listen to "us" talk about "them" than it is to listen to "them" talk about "them." In creating *Atanarjuat*, the Isuma videomakers attempted to turn this formula around. Quite deliberately, they struggled to shatter the easy approach and replace it with its more direct, more intense, and more potent counterpart. As Kunuk says, "We are in the best position to tell our own stories."

In addition to reinforcing the value of aboriginal perspectives, Isuma also strives to improve the standard of living in Igloolik. As is the case in most Arctic communities, there are few jobs in Igloolik, and most of the jobs that are available are service-oriented government positions: working in the housing office, driving water-delivery trucks, and so on. The high unemployment rate in Arctic communities is generally seen as the offspring of the

relocation effort, which concentrated the Inuit in permanent settlements that could not generate enough wage-paying jobs to sustain the population. "Poverty is political," quotes Cohn. With poverty comes reliance on the government in the form of family-support cheques – and with reliance comes compliance.

The Isuma leaders see their enterprise as a reaction against this stacked system. By offering paying jobs to people – Cohn calls it "the industrial component" of their effort – Isuma can reduce their dependence on the government and give them the freedom to make choices, to make changes:

> Igloolik Isuma is taking goals of self-representation and self-determination and industrializing them. Filmmaking here can create more quality jobs than any other option. *Atanarjuat* had sixty people on the payroll – the payroll budget would be $1.8 million. Isuma was paying children, elders, educated people, people with no schooling, people with computer skills, people with cultural skills, and so on. The new government centre will bring in ten to twenty new jobs, but none for people over sixty, people with no education beyond the tenth grade, people who are unilingual, etc. The IBC in Igloolik has never employed more than five or six people at a time. Igloolik Isuma wants to translate the value of interest in the Arctic into an industrial benefit for the community. People pay a lot of money for information and materials from the Arctic. Igloolik Isuma wants to make sure some of that money ends up in the hands of the Inuit in the community.

Until this dream takes hold on a steady basis, however, reality remains grim. Communities like Igloolik have few hopes for bringing money in from the outside. One path taken by several communities has been the production of art, which is sold through galleries in the South. But prints and carvings were never imagined as a major, long-term source of outside revenue. James Houston, who played a significant role in developing a market for Inuit art, envisioned the sale of artwork as a way for Inuit to bridge the gap between a land-based economy and a wage-based one (1995b). But the sale of artwork alone cannot support a community. Another potential source of revenue, especially with the advent of Nunavut, is the exploitation of oil, diamonds, and other underground assets

in the Canadian Arctic. The extraction of these resources poses challenging environmental and cultural problems, however, and many Inuit are wary that the bulk of the money earned from such operations would vanish to the South.

Isuma wants to offer its art – and its process – as an alternative. "One intended benefit of Igloolik Isuma is to provide a desperately needed source of revenue to the community without causing more problems than it solves," Cohn says. "We want to market Inuit values and information to the outside world from an Inuit point of view and transform the economic reality of the community." Through the variety of jobs surrounding a major movie production – including scriptwriting, costuming, makeup, hairstyling, acting, and a wide variety of logistical positions linked to the production process – Isuma hopes to give people jobs, skills, and a future.

"It's about moral leadership and moral authority and cultural survival," Cohn says. Igloolik Isuma wants to make videos in an Inuit way, and it wants to carry out its work while both maintaining Inuit cultural values and gaining national broadcast exposure at the same time – all while bringing in much-needed jobs for the people of Igloolik.

But Isuma's approach, while it has its freedoms, also offers challenges. The cash flow at Isuma is always rocky; the feasts of grant payments are followed by the famines of between-payment stretches in which artful bookkeeping and persuasive conversations keep creditors barely at bay. The collapse of the *Atanarjuat* project in the spring of 1998 delivered a stunning blow to Isuma's finances. To survive, the group had to assuage a lot of people to whom money was owed – money that was legitimately expected during the *Atanarjuat* taping but that vanished with the tearing open of an envelope from Telefilm. And many of the cast and crew of *Atanarjuat* – people who were owed payments for everything from acting to providing dogs to hauling equipment – were offered a chance to convert the money owed to them into "memberships" in the *Atanarjuat* project. The memberships blended equity investment in the project and assurances of ultimate payment of the debts if possible. Each member received a membership number keyed to his or her account at Isuma. If a person was owed $500, for example, this debt was recorded in the books under the person's membership number, and a certificate was issued to the person that indicated the account. Once *Atanarjuat* was finished and

began to bring in money, the debts were to be paid off equally across the board. When the debts were all paid off, then the memberships would convert to shares in the project and any possible future profits. A person originally owed $1,000 would have twice as many shares as a person owed $500 and would thus receive twice as much of the profits from the movie. The system, devised by Norman Cohn, gave the participants a chance to gamble their debt against greater possible gains in the future. Given that the debts could not be paid off all at once anyway, the participants had little to lose.

One of the financial challenges facing Isuma is that much of its income derives from the production of videos – not their sale or distribution. (*Atanarjuat* is something of an exception.) Once a video is complete, copies are made available for sale, but little else is done to promote the purchase, rental, or viewing of the tapes. Efforts to increase the use of the tapes is not worthwhile for the people of Isuma because even robust sales result in modest sums of money. The large sums necessary to create important videos and keep Isuma afloat come from grants, and grants come from project ideas. A typical Isuma production will routinely receive $100,000 from one or another of the granting institutions. This money pays salaries, buys equipment, and keeps the organization intact until the next project swings into action.

Isuma also faces a fundamental irony of its own. Despite its best efforts to get out from under the control of Ottawa, Isuma still must rely on government-sponsored grants to pay for its productions. Kunuk and the others must come up with ideas that will qualify for the funding process, appeal to the decision makers at Telefilm and the Cable Fund, and ultimately result in a product that enhances Isuma's ability to tap these funding sources in the future. Direct control of the videomaking process lies firmly in local hands at Isuma, but the outfit is still dependent on a Southern-based granting system steeped in southern-Canadian values and worldviews. They fight vigorously against the foibles of this system, but ultimately they must adhere to it or perish.

For all its anti-assimilationist posturing, and for all its cultural condemnation of the IBC as a puppet of white Ottawa, Isuma has critics of its own who charge that the group's principals are really interested in a much more basic goal: the acquisition of large sums of money and the freedom to spend the money any way they

please. To the critics, Isuma's efforts are directed less at cultural preservation and social survival and more at the personal accumulation of power and control. They see Isuma as vying to replace the Igloolik office of the IBC, which would allow Isuma access to the Television Northern Canada (TVNC) airwaves while at the same time collecting grant funds for projects of its own choosing. All sides of this divide insist that no personal animosity exists – the problem is not that individuals in Igloolik can't get along – but the reason for the competing interests is interpreted differently by Isuma and by its critics.

THE LOCUS OF CONTROL

The gulf between Isuma and the IBC points to a possible answer to the question about one inherent effect – and perhaps even motive – of indigenous media. Jake Kadluk at the IBC points out that when he is on the job, he works in a basically Qallunaat manner. When he is on the land, he works in a basically Inuit manner. This differentiation of approach reflects the Southern nature of the IBC; it was created in Ottawa, it operates out of Ottawa, and it bears the structure, culture, and expectations with which it has been infused by Ottawa. So the people at the IBC operate in a Southern way. This is not to say that they become Southern by working at the IBC, as has been suggested by some anthropologists (Weiner 1997). Rather, they rationally adopt the approach that is required of them while they are on the job. As Debbie Brisebois points out, the IBC is a production company with a commitment to fill air time; it is in a deadline-driven business (1999).

Isuma is different. At Isuma people operate in a manner more consistent with their behaviour outside their video work. They work on specific projects, and while deadlines are important, the clock and the calendar do not overly colour the atmosphere. The focus is more on expression and less on delivery. It is important to note that the culture at Isuma resembles the culture in Igloolik to a large extent – but the culture in Igloolik can still be contrasted to the culture on the land, in the outpost camps where families hunt and fish. In town Southern systems often shape and tint the rhythms of everyday life. Kunuk leaves the Isuma building, for example, every day at noon so that he can pick up his children at school, drive them home, and share lunch with them before

returning them to their classes. On the land, schedules are useless. You eat when you're hungry; you sleep when you're tired. The position of the sun doesn't affect such behaviours because the sun is slippery; in June it twirls around the sky without touching the horizon, and in November it skids along the horizon for a brief glide before ducking out of sight once again. In December and half of January, it doesn't rise at all. So in the summer you have no choice but to sleep during "daylight," and in the winter you have no choice but to hunt in the shimmering twilight. Life in Igloolik is no longer so free, and the tyranny of the clock and calendar increasingly holds sway. At Isuma the clock governs some aspects of daily life, and the calendar offers reminders of grant deadlines and promised completion dates, but neither is granted supremacy over the flow of work and living – and if a whale or a polar bear is sighted near town, the office will empty as the producers dash out to join the hunt. At Isuma the race is not necessarily to the swift.

This difference in the locus of control and its inherent influence on corporate culture is critical. The ideal would be a locally situated, independently supported media effort with which the Inuit, in this case, could express their worldviews and their culture without having to conform to any outside ideas of "proper" format, "appropriate" content, or "acceptable" tone. Neither the IBC nor Isuma achieve this ideal, and indeed it may be beyond human grasp. (The fundamental problem is obvious: most media enterprises require large sums of money, and most of the world's money is clutched in a small number of hands.) IBC's approach is to develop a noble mandate and to try, on the ground at least, to produce material that honours it. Isuma's approach is to spurn direct control from Ottawa and to exercise independent judgment as much as possible through the granting system.

A Faustian bargain? Perhaps. Both groups sell a certain portion of their souls for the support that they require to persevere. But the victory is not entirely Pyrrhic either. In terms of cultural awareness, cultural preservation, and cultural celebration, the videographers of Igloolik are at least remaining active.

THE HAND AT THE HELM

The recent Inuit-video boom raises some interesting questions, all centred around one major theme: what does it mean when

Native groups take charge of the documentation of their own cultures? Such documentation was long the domain of anthropologists, folklorists, and other researchers, but increasingly the Native groups so often studied by these scholars are beginning to study themselves. What impact does this trend have on the forms of thought often used to make sense of Native cultures? And what does it mean in political terms within the Native groups themselves?

The question of whether putting video cameras in the hands of indigenous people represents a triumph over Western colonialism or a more insidious form of it produces a complex answer. If we look at the examples available in Igloolik, it is not so much the ownership of the cameras as the ownership of the overarching media system that matters. At the heart of the difference is the locus of control. If full control – not only for video creation but also for dissemination and broadcast – lies in indigenous hands, then new and culturally grounded perspectives can result. But if the cameras are available while the training, budget, editorial decision making, and so on are left in outside hands, then it is essentially impossible to produce materials that lack at least some reflection of the dominant society that remains in control.

In journalism studies the long-outmoded Dominant Paradigm argued that media messages worked as "magic bullets" that could be propelled at a society with predictable effects. In essence, a similar kind of faulty paradigm exists in indigenous media today. Peoples such as the Inuit are given media equipment – the enchanted ammunition – but the training and the control remain centred outside the indigenous society. However much the effort is backed by good intentions, it cannot help but fail because the dominant society remains in ultimate control of the product. The only way to realize the noble intentions is to go beyond even the step that Sol Worth took when he gave the Navajo movie cameras (Worth and Adair 1972). His was an important step, but the giant leap comes when the indigenous people get the technology on their own – and use it to their own ends – without any interference at all from the dominant group. (See Roth 2005.) This is precisely what Zacharias Kunuk tried to do when he flew to Montreal and sold his carvings to get a video outfit, and ever since that time, he has been struggling against the funding and broadcast systems that seem unable to give up control.

8

Netsilik and *Nanook* vs Nunavut

When battle lines are drawn in the negotiation of culture, the strategic hilltops often lie in a group's history. Whoever succeeds in gaining control over this history can shape the stories and manoeuvre the characters to grant credence to his or her own perspective. This is, of course, the "God is on the side of the victors" argument.[1]

Where there is no victor – and hence no vanquished – there is more than the usual room for conflicting interpretations of history, with each combatant offering a particular vision of the past that is at odds with the rivals' contentions. This is the situation in the Arctic, where no conquering war has been fought with armour and armament. Instead, the struggle for control is pressed on a cultural front, with each side attempting to package the past to suit its own viewpoint.

With regard to video, both the North and the South – the Inuit on one side and southern Canadians and their allies on the other – create documentaries and re-enactments that focus on the Inuit and their way of life. The Southern fusillade includes *Nanook of the North* and the widely viewed Netsilik series – not to mention a successful film that used Hawaiian actors to stand for the Inuit and Styrofoam domes to stand for igloos.

Nanook of the North, made in 1922 by Robert Flaherty, has been lavishly admired and bitterly condemned – the former for blazing a new path into documentary filmmaking and the latter for fudging

details in an effort to make life in the Arctic seem more primitive and exotic than realism would admit. Nanook, for example, is shown hunting exclusively with a harpoon, even though the Inuit had been using rifles for many years (Palattella 1998, 50). Another scene shows Nanook arriving at the shore after a long ride in a single-person kayak. First, Nanook climbs out of the small, skin boat. Then another person wriggles out through the opening, having apparently been riding inside the forward part of the craft, cramped between Nanook's legs. Then a person emerges from behind the seat, and then another climbs out, and another, and then a dog, the camera cuts between each emergence bearing witness to the construction of the scene. The disembarkation bears a strong resemblance to a legion of clowns leaping out of a tiny car at the circus. The scene is downright comical and wholly fictitious; the boat would have swamped under all that weight.

Flaherty also attempts to paint Nanook and his kin in "Stone Age savage" colours. When Flaherty shows Nanook a gramophone, the Inuit hunter grins like a stereotypical Eskimo, visibly astonished at the sounds apparently emerging – the film is silent – from the machine. Then, in an effort to make sense of this fantastic and wonderful invention, Nanook picks up a record and bites it, an image that leaves Zacharias Kunuk aghast.

John MacDonald, the director of the Igloolik Research Centre, a government-funded laboratory for physical and social sciences in the Arctic, notes that when elders in Igloolik watch *Nanook*, they howl with laughter. Even beyond the obvious exaggerations and indulgent flairs of hyperbole, the film contains countless small errors in the way things were made and done. Flaherty clearly showed the Inuit in a way that he felt would be engaging in the South, with high regard for – but not an absolute insistence on – accuracy.[2]

In Flaherty's defence, his film stands as an early record of some important Inuit life-ways, and his success at capturing footage of the Inuit with 1920s equipment remains an impressive triumph. But his ignorance of his own subject matter left him vulnerable to error, and his enthusiasm for the rugged environment and harsh challenges of the Arctic left him susceptible to exaggeration.

The Netsilik series – created by Asen Balikci, a professor of anthropology at the University of Montreal – stands as another milestone in the presentation of the Arctic on film. Comprising

nine episodes, the series shows the routines of Inuit life in a variety of circumstances: hunting seals, making shelters, playing games, and so on. The episodes, released in 1969, differ from *Nanook* in that they admit to showing the remembered past; the traditional activities were recreated for the purposes of the filming, even though new technologies had already started to change Inuit life in the wake of continual contact with outsiders (see Balikci 1970).

The Netsilik episodes offer a more accurate portrait of traditional Inuit life than does *Nanook*, and the acknowledgment of the "remembered" aspect of their creation aids in placing the series within a broader framework of material about the Inuit. Among Inuit videographers, however, the objections to both the Netsilik series and *Nanook* lie less with their accuracy and more with their authorship. In a fundamental sense, the work of Inuit videomakers – at the Inuit Broadcasting Corporation (IBC) and at Isuma – functions as a reaction to attempts by non-Inuit to define and position the Inuit culturally and historically. The IBC was formed to bring more Inuit culture to the small screen but not just any portrayal of Inuit culture; the IBC exists to show Inuit appreciations of Inuit culture to its viewers. And Igloolik Isuma's videos – and its Nunavut series in particular – represent an effort to tell the story of Inuit life from an Inuit perspective.

NUNAVUT

In response to *Nanook*, Netsilik, and other Southern depictions of life in the North, Igloolik Isuma created the Nunavut series, thirteen half-hour episodes that show what life on the land was like in the mid-1940s, shortly before permanent settlements changed Inuit life in the Igloolik region forever. The episodes follow five fictitious Igloolik families as they go about their lives even while the Second World War pushes the world's strongest armies into a devastating struggle for survival.

The series was produced with the participation of Telefilm Canada and has aired on the Knowledge Network, Television Northern Canada (TVNC), Saskatchewan Communications Network (SCN), TVOntario, and Kanal 7 Turkey. It has also been shown at International Public Television (INPUT), Sundance, and the Art Gallery of Ontario.

A booklet accompanying the series notes that it was "written, pro-
duced, directed and acted by contemporary Inuit of Igloolik, NWT
[Northwest Territories]." The booklet describes the thirteen epi-
sodes in this way:

SPRING 1945 ... IGLOOLIK
1. Qimuksik (Dog Team)
One family travelling in the immense and beautiful Arctic
spring. Inuaraq teaches his young son how to survive in the old
way: driving the dogs, building the igloo, catching seals at the
open water, running down caribou to feed the family.
2. Avaja (Avaja)
Inuaraq's family finally arrives at Avaja to a warm welcome. But
on the hill above the tents, they now find a wooden church and
a priest. Sharing the fresh cariboo feast, telling stories, Inuit are
interrupted by the bell ringing. Inside the church the sermon is
clear: Paul 4:22, 'Turn away from your old way of life.'

FALL 1945 ... IGLOOLIK
3. Qamaq (Stone House)
Grandmother remembers the old way. In autumn 1945, five
families build a stone house to prepare for the coming winter.
4. Tugaliaq (Ice Blocks)
Even here, news of the terrible world war raging outside makes
people frightened and uneasy. They talk of the danger of the
unknown future, of shamanistic intervention to protect their
culture. The weather turns colder, north wind blowing, Inuaraq
builds his sod house, Qulitalik cuts the ice blocks for the porch.
5. Angiraq (Home)
Akkitiq wakes up to a nice day for seal hunting. The stone
house is warm and comfortable. Men pack up the dog team and
look for seals on the fresh ice, women work at home. Some-
times children's squabbling leads to trouble among families.
spring 1946 ... igloolik
6. Auriaq (Stalking)
It is the season of never-ending days. Two dog teams searching
the spring ice, men and boys hunting day and night. Seals are
everywhere: at the breathing holes, sleeping under the warm
sun. Amachlainuk has a lucky day.

7. Qulangisi (Seal Pups)

Seal pups: springtime delicacy, prized for their soft fur and tender meat. When the pups start coming out on the ice, even small children and grandmothers can hunt. Packed up to travel, the families move slowly over the wet ice, through lakes of fresh melting, hunting on the way. Finding the breathing holes is a joyful game for everyone.

8. Avamuktalik (Fish Swimming Back and Forth)

Inuaraq throws his bones at the river and finds the fish swimming back and forth. Back at the tent Qulitalik sends the young men out with fish spears to try their luck. The walk up the rushing river is exciting but treacherous. Fish are hiding, it's easy to fall in.

SUMMER 1946 ... IGLOOLIK

9. Aiviaq (Walrus)

The distant sound of the 'tookatook,' the first gas engine to arrive in Igloolik, brings a surprise visitor to Qaisut, island of the walrus hunters. The Priest arrives to study Inuit life, to dig in the ancient ruins and to see the hunt. When it's time to go hunting, Inuaraq thinks the Priest will bring bad luck but Qulitalik finally gives in. Out in the open water, cutting up walrus on an ice floe, Inuaraq's prediction almost comes true.

10. Qaisut (Qaisut)

After the walrus hunt everyone is happy. There will be lots to eat for a long time. Children climb the famous cliffs of Qaisut, exploring paths and ruins left by hunters from the ancient times. Good walrus hunting doesn't only attract Inuit; suddenly Grandmother sees a polar bear after the meat. Quickly men and dogs rush to protect the camp.

FALL-WINTER 1946 ... IGLOOLIK

11. Tuktuliaq (Cariboo Hunt)

Inuaraq and Qulitalik take their families over to Qiqiqtaaluk, the Big Island (Baffin Island), for the cariboo hunt. It's an early autumn and the weather is already getting colder. Lakes are frozen and the sea ice will thicken any day now. Abundant cariboo feed Inuit families all winter.

12. Unaaq (Harpoon)

Sitting around the stone house carving a harpoon, Qulitalik starts talking about the year gone past. Everyone joins in with

stories and laughter. Tea is boiling over the seal lamps, children playing on the cariboo skin beds. Grandmother tells the old stories, everybody has a new one. Home is warm and cozy. It is only when the young ones slip out the door to play outside that we hear the winter wind.

13. Quviasuvik (Happy Day)
It's almost a month since the sun disappeared. Back in the stone house everyone wakes up to Christmas Day. For Inuit now, Christmas is a strange mix of ritual, some from the old life and some from the new. But either way, with lots of meat from a good year hunting, and a warm shelter against the blowing cold, this is a joyful time for celebration and stories.

The first two episodes were designed to fit together back-to-back, showing the traditional ways of Inuit life beginning to buckle beneath the pressure of missionary determination. The first episode, *Qimuksik* (*Dog Team*) opens with a dog team pulling a *kamotiq* (sledge) across the packed snow. A guitar strums a gentle country-music tune while a voice sings lyrics in Inuktitut. The driver cracks his long whip alongside the dogs to keep them moving in the right direction. A young man on the dogsled jumps off to give the sled a push, keeping it away from a rock that pokes above the ice. Behind the driver, on the sled, are his wife and two daughters. The actors are the Ammaq family: Samuilie, Micheline, and their children; in keeping with Isuma's pledge to bring employment to Igloolik, the actors are people from the settlement. In the video they are Inuaraq and his family. After driving the sled, Inuaraq uses a saw to cut snow blocks and builds an igloo, while the mother and the girls pack loose snow in the cracks between the blocks. Inuaraq also hunts a seal at the edge of the ice, using rifle and harpoon, and the family gathers to eat the fresh meat of the carcass. After eating, the two daughters play a loose game of tag on the ice; it's a good way to warm up. Then the father and son hunt caribou and help themselves to the meat, although the son complains that the flesh tastes "too male."[3] The two hunters finish skinning the animal, tearing the hide off in a single fatty coat. When they take the animal back to the rest of the family, the mother and the girls enjoy a snack of caribou meat and lice.

Then the *ajaja* song returns – a resonant baritone. The dogs are untangled, and the sled moves again. We see the son tending to a

dog, then the father, son, and older daughter dragging a seal by the harpoon line. Then the son runs to catch up with the sled; he jumps on with ease, then pushes the sled to one side. The family moves on. More images: the dogs lying on the snow; the father with his harpoon; the women sitting on a rocky hillside; a seal on the surface of the water, jolting when hit with a bullet; a seal carcass next to the sled; the dog lines being untangled again.

The video ends.

The second episode picks up at the same point. The family is driving across the ice on the sled; we hear the same country-music song in Inuktitut. After the titles, the family packs up its gear on the *kamotiq.* Inuaraq gives the command to go and wields the long dog whip; he runs toward the animals; the dogs turn away from him and run off in the direction that he intended. The sled pivots on the snow and creaks off across the ice. Inuaraq climbs aboard. When the sled stops, Inuaraq untangles the dog lines, showing his son how to do it and explaining the importance of training the dogs to stay still so that they won't run away when they are off harness.

As the family approaches the Avaja peninsula, the site of a very old Inuit settlement, Inuaraq stares in amazement at the large number of tents in the area – and the wooden Catholic mission. (Avaja received a mission long before formal settlements were established in the area.)

Standing on the peninsula is a Roman Catholic priest in a long, black coat.[4] He watches the sled draw near. The families living in the tents also watch. The priest walks toward the shore. "They're coming to us," a woman on shore yells. The Inuaraq family sits patiently on the *kamotiq,* waiting as the dogs pull them closer to the peninsula.

"A priest," Inuaraq says. "Maybe scary? Will he turn us away from our ways?"

The dogs need no guidance at this point; they head for the cluster of people and tents on the shore. The priest strides confidently down from the church, toward the new arrivals.

"Will we turn away from our ways?" Inuaraq asks again after he and his family have climbed off the sled.

"I'm afraid," his wife replies. The people already on the peninsula watch the family intently but do not yet approach. "It's too bad we came."

After greeting the people on shore, the family is approached by the priest, whose name in English is Father Forehead. The priest welcomes them to Avaja; it is interesting to note that *he* is welcoming *them* to an area that they have visited often, long before he ever arrived. Father Forehead gives Inuaraq some tobacco and invites him to church that evening.

After a caribou feast with the people already camped at Avaja, the church bell rings, and the Inuit gather themselves casually for the hike up the hill to church. When they arrive, Father Forehead leads them into the small wooden church; they duck as they cross through the low doorway.[5] The snow in front of the door has been dug away, and people step down to enter.

Inside, a bronze Christ gleams from a wooden cross. A row of candles, in glass containers of different colours, lights the front of the church, suggestive of stained-glass windows. The people sit on a bench that runs along three walls; some sit on the floor. Father Forehead, wearing a white sash with crosses embroidered on it, instructs the congregation: "Song Number 91."[6] He raises his arms and slowly flaps a beat. He begins to sing, in uncertain Inuktitut, a slow hymn, and the congregation, unsure of the tune, struggles to sing along. Then Father Forehead begins the sermon, telling the story of Moses and the burning bush. For "God," he uses a word that translates as "Earthmaker." The people in the congregation listen, but they begin to nod off in the warm and darkened church. The younger ones sleep, leaning against their parents.

After the burning bush story, Father Forehead reads from Ephesians 4:22: "Turn away from your old ways of life. Turn the other cheek. The temptations are misleading."

Some of the adults are asleep now too.

Verse 23: "Become new with your minds through his spirit. Become new with your minds through his spirit."

Verse 24. "Be born again. Be like the Earthmaker. What was created, be at ease. Be able. Be holy."

Father Forehead leaves a long pause. Then he raises his hands.

What is the message? The road that our Earthmaker takes, follow it! Follow it! Uh – If you catch a seal, give thanks to the Earthmaker. If you catch a caribou, give thanks to the Earthmaker. The Earthmaker loves you, but Satan wants you,

too. If you hunt on Sunday, you'll make Satan happy. The Earthmaker will be angry. Build an igloo on Sunday, you make the Earthmaker sad. Satan is happy. Keep the Earthmaker in your mind and love Him. But Satan also wants you.

Some children begin to fuss. "Come to church on Sunday," the priest concludes. "Think of the Earthmaker. Follow his road."
The hymn singing returns:

I wish I could fly up
Today to Jesus.
In Heaven
He is with the Father.
Jesus, Jesus, Jesus,
In the glory.
Jesus, Jesus, Jesus,
Open the door for me.

The congregation exits into the cold, white day. Father Forehead stands on the snow, watching his flock depart. The singing continues:

I wish I could fly up
To my Father
Where happiness is.
I want to be with you.
Jesus, Jesus, Jesus,
In the glory.
Jesus, Jesus, Jesus.

And the video ends.
The series continues somewhat loosely, showing important Inuit activities as the seasons progress. In *Tugaliaq* (*Ice Blocks*), for example – after an interesting, ad-libbed discussion about how they could use shamanistic powers to fly to Hitler and kill him – Inuaraq and his friends decide to build an ice porch for their *qarmaq* (semi-permanent shelter) and a sod house nearby to hold the additional people who are arriving. The video follows the actions of the men, women, and children – each pursuing his or her own important tasks – as they convert ice, hides, and snow into shelter and space for social

transformations. Mittened hands with steel knives scrape the blocks into complementary shapes and fit them together to build, in essence, a shimmering igloo on the front of the *qarmaq*.[7] The ice walls stand four feet tall, their six-inch thicknesses allowing the sunlight to sparkle through. A block is placed over a gap that will serve as the door.[8] The cracks of the ice walls are filled with snow and small pieces of ice moistened in a bucket of water.

Some children sled down a small hill and wrestle playfully with dogs. The women layer the canvas top of the new sod house with caribou skins, fur side down, and with help from some of the men, they roll another large sheet of canvas over the skins, trapping the caribou insulation between the canvas tarps.

The bright sun is setting slowly, casting long shadows across the snow. The last of the ice blocks are fitted onto the top of the ice porch; one block falls to the ground, causing the five men below to raise their arms quickly to steer it to a safe landing.

The credits begin as the ice-porch construction is finished. A coffin-shaped piece is slid into place at the top, filling the final hole; the structure is strong enough to allow men to crawl onto it. As the scene fades to black, the view encompasses the two new creations: the sod house in the background to the left and the ice porch, bright with the setting sun behind it, in the foreground to the right. With these structures in place, the families look forward to a more comfortable winter.

Another of the Nunavut series, *Qulangisi* (*Seal Pups*), shows two families meeting on the ice to confer about the best place to hunt seals. When they arrive at the right place, each person – man, woman, and child – finds a seal hole and watches, quietly. Some of the hunters are in groups, but most are alone, staring down at the ice with a hook, a harpoon, or a rifle at the ready. Far off in the distance one group of women and children hooks a seal and pulls it out of the hole. The camp leader has traded his telescope for a harpoon, and he waits near a seal's breathing hole. With a sudden movement, he raises the harpoon and hurls it down forcefully into the slushy water. He pulls on the sealskin rope and drags a medium-sized seal out of the hole. It has been impaled in its side, and the harpoon's toggle is firmly anchored in its flesh. The seal claws at the ice, trying to get back to its hole, but the toggle holds. The hunter pulls the seal across the ice until it reaches a dry spot. He then stands on the rope to keep the seal from moving away,

moves the harpoon shaft out of his way, and then hits the seal on the head with two hard blows of his fist. The seal stops moving. The hunter calls to the people at one *kamotiq*, they drive the dog team over to him and lift the seal on board. The hunter describes his success: "It appeared, I got up, speared it. The hole was narrow. I got it in time when it turned."

Other seals are pulled from beneath the ice, and at last the families gather to eat. They open a baby seal with a slit along the belly, and everyone gathers around, young and old, woman and man, and they carve out pieces of the dark meat and eat it with such intensity that the conversation slows to a stop. When the children are finished, they play with the seal's severed flippers in a pool of water, pretending the flippers are seals themselves. The flippers settle to the bottom of the clear water; they are seal pups diving to escape the harpoons and bullets of hunters. The children notice a small shrimp in the water and attempt to catch it with their hands, pointing out to each other that shrimp are tasty. The adults finish the meal with bannock and tea.

WORKING THE COMPASS

The Nunavut series builds to no crescendo; it offers no concluding fanfare. It resolves not to C Major but rather ends in mid-bar, with an indication of time moving forward beyond the final note. The world of the Inuit was circular, the seasons following the stars in a wheel of repetition. Maturity was marked not by what was done but by what was learned, as the opportunities to learn again came back around. Flaherty could not resist the tyranny of the straight line, however, and he seized upon an opportune endpoint for his *Nanook* story; Nanook died of starvation two years after the movie was completed, and Flaherty added this fact to the publicity machine that made his movie popular.

Part of Isuma's mission is to offer an alternative voice to the works of Flaherty, Balikci, and other southerners who try, however earnestly, to portray the life of the Inuit. People from the South, Kunuk notes, are saturated with misconceptions about the Inuit, misconceptions that stem from, and result in, errors in media depictions:

When you are videotaping people and just following them, it's interesting. And you just wanted to show it, out there. How we

live ... Every time I go down South, the people were asking me
if, "Do you still live in igloos?" "Do you still drive dog teams?" I
remember the idea was that when we cry, ice cubes fall off our
eyes. And that's the message I was getting. Why not show it – we
have the technology, we're the same. If anybody invents a new
camera, they can have it – we can have it, too ...

Every time, it seems like every time they're filming Inuit, they're
smiling. They're like they don't know what they're doing. We have
to show them this record is "magic" – it's just somebody recorded
on it. Just, blues and mix, high pitch noises on it – sometimes I like
that. But when I saw Robert Flaherty's movie, you see an Inuk who
sees a record player and puts his teeth on it. Are we that stupid? I
said that to myself, are we that stupid? And they are hammering
English to our heads, we should have a brain though, we do have a
brain. What we try to do is show it with the latest technology. Show it.

Similar to the Netsilik series in some ways and distinct from
Nanook in many ways, the Nunavut episodes reflect an Inuit per-
spective that Kunuk works diligently to present. The killing and
eating of the seal in *Qulangisi*, for example, was presented in a
matter-of-fact manner. *Nanook* positions its hero in a mighty strug-
gle against the overwhelming harshness of an impossible land.
Netsilik shows the Inuit scraping out a grubby survival in a joyless
environment. But Nunavut presents the hunt and the meal in
much the same manner as a Southern videographer might show a
trip to the supermarket and work in the kitchen: this is how we get
food, and this is how we eat it. Audiences unfamiliar with life on
the land might cringe at the thought of blood and entrails forming
a nice meal, especially without the benefit of cooking, but the Inuit
see nothing unusual in it. It is the way that people in the Arctic
have managed for thousands of years.

The Inuit in the Nunavut series do acknowledge the supremacy
of nature, however. They work when conditions are right, and they
pass the time in the igloos and *qarmaqs* when the weather turns
ugly. Even their language reflects an understanding of the fickle-
ness of nature: "If we go through these areas, we could find seals."
The wording is tentative, based on possibilities but not brash pre-
dictions. When animals are plentiful, there is food. When game is
scarce, there is hunger. Humans can hope for the best, but only the
foolish expect it.

The Nunavut videos also focus on the relationship between parents and children. Many Inuit parents dote on their children and allow them a great deal of freedom and authority. One teenager in Igloolik was even allowed to cut short a camping trip because he was homesick for town; at his complaint, the father began packing up the equipment. This kind of relationship is shown at the beginning of the first Nunavut episode, in which the father tries to cheer his young and unhappy daughter. Later, her parents entice her to eat and reward her with fresh caribou lice. She is clearly adored, and her happiness is a prime concern of her parents.

The parent-child relationship is also shown in the manner in which the father, Inuaraq, teaches his son how to be a successful hunter. With two notable exceptions, there is a minimum of verbal instruction.[9] In the Arctic children learn by watching and imitating; Inuaraq goes about his tasks with patient attention to his son's education. Little is said, but the boy is learning, and Inuaraq shows him several facets of life on the land.

Kunuk even employs this method of instruction in his videos. Inside the Catholic mission in the *Avaja* episode, as the priest is droning through his plodding sermon, the congregation nods off. Southern critics might argue that the scene goes on too long, threatening to bring the video's audience to unconsciousness as well. When this point is mentioned to Kunuk, however, he just smiles. He points out that the sermons were indeed long and boring. He acknowledges that he could simply indicate the stifling monotony of the service without dragging his viewers through it – he could, for example, show people yawning, fidgeting, and so on, in addition to the dozing that he does show – but he believes that the best way to get something across is to let viewers experience it. If something was exciting, just show it; it will be exciting. If something was dull, just show it; the audience will feel how wearying it was. Just like a father showing his son how to navigate across the ice, Kunuk shows his audience the scenes directly and allows them to draw from the experience what they can.

Kunuk also shows that the Inuit, while appreciative of their heritage and culture, are not stuck illogically in the past. The scenes in the Nunavut series show the Inuit using metal teapots and stew pots, newspapers on the walls behind sheets of plastic, flannel shirts and suspenders, cans of coffee and other goods on shelves, plywood roofing for the *qarmaq*, wooden rods and two-by-fours,

machine-knitted wool sweaters. Unlike the Inuit depicted in *Nanook* and the Netsilik series, who wear old-fashioned clothing and use old-fashioned implements exclusively, the Inuit in the Nunavut series demonstrate real-world practicality. Plywood makes a good roof. Coffee tastes good and warms the body. Metal teapots boil water much more easily and efficiently than the former method of dropping hot rocks into skin bags. Similarly, the Inuit are aware of the Second World War, and they realize that insanity on such a scale could easily spread to the Arctic. (Interestingly, it was not long after the war that the US Army built the Distant Early Warning stations – the DEW Line – across the North American Arctic to monitor for Soviet missiles coming over the Pole.) The Inuit, as shown in the Nunavut series, are not the often-heralded lost tribe stuck in Stone Age ways. They are as up-to-date as circumstances and their own preferences allow. The Nunavut series strives to show Inuit as multifaceted, rather than as monolithic representations of Southern expectations; it attempts to show various Inuit characters in relation to each other and to their world in ways that emphasize unity in difference (Valaskakis 1994, 61, 71). The media – and video in particular – are capable of creating and reinforcing images and narratives that become implanted in the consciousness of a time, shaping identity through negotiation in ways that surpass the claims of any given group or person. Part of Isuma's deliberate plan is to interject a perspective into these negotiations that can colour the identities that emerge (Valaskakis 1994).

But at the same time, Kunuk chafes against the *illogical* Southern influences that creep into Inuit life. In Igloolik, for instance, the fire siren is blown at ten o'clock each night, indicating that children are required by the town's bylaws to be off the streets unless accompanied by an adult. The curfew strikes Kunuk as artificial and useless, just another attempt at Southern control of Inuit life. In traditional Inuit society, people slept whenever they were tired – and were outside whenever they weren't sleeping. He also sees a threat in the encroachment of Southern holidays: "This Halloween, this is not normal. This Christmas, this is not normal to us. And Remembrance Day? ... Canada Day. These are just holidays that somebody made up – and we have to live with it. And we are trying to handle that well. But, what ... goes on every night [the curfew], that's not normal. But somebody had to think about that,

somebody had to talk about it, somebody had to vote on it, so it goes on. We are trying to hammer it – an Inuk point of view – into everybody's head."

It is in this vein that the second episode functions. Kunuk is aware of the portrayals of the Inuit made by benevolent missionaries who inflicted their views on the people of the Arctic. But the Inuit, who had a vibrant and rich spiritual panoply that embraced shamanism and animism (Merkur 1991), were neither overjoyed nor appalled by the newcomers' religion. They learned about Jesus Christ and added Him to their system without much difficulty, and they foregrounded their Christianity whenever practical circumstances required; when the missionary visited, for example, overtly Christian families received abundant blessings of both a spiritual and material sort. So Kunuk gave himself the challenge of showing how the Inuit viewed the arrival of the missionaries – not as spiritual saviours but as people whose odd ways had to be endured in order to get along.

LOCALITY

In addition to the content, the manner in which the videos were made reflects Isuma's philosophy. The actors are all Igloolik residents, and the dialogue is generally unscripted; the participants were simply instructed to go about the tasks as they normally would. When the task is focused and clear, this approach leads to some powerful moments. When the men are building the ice porch, for example, the individual people form a cohesive team, and each person falls into a comfortable role within this team. Instructions are given, jobs are issued, and the project is carried forward with ease. When the task is less natural and more forced, however, the community (as opposed to professional) side of Isuma's method shows through. When the family approaches the Avaja peninsula, for instance, and the father and mother see the priest standing there, the dialogue becomes quite stilted: "A priest," Inuaraq says. "Maybe scary? Will he turn us away from our ways?" These lines weren't written in advance and polished through successive drafts; they were ad-libbed by Samuilie Ammaq, who was told to react to the presence of the missionary. Isuma could have "corrected" this dialogue with additional takes and some script work, but such a step would betray the organization's mission. The

Isuma producers want to show the world two realities: the Inuit being portrayed as though from the 1940s and the Inuit of today's Igloolik working in a new and public medium. Isuma's process is a large part of its message, and its use of local, untrained Inuit actors is vital to its mission – even if the seams do show occasionally.

But the main point is neither the content of the stories nor the way in which they were told. Rather, it centres on who gets to tell these stories. Even if *Nanook of the North* were error-free and respectfully constructed, even if the Netsilik series mirrored the Nunavut series in every detail, the authorship behind these productions would still set them apart. Isuma insists on the Inuit's right to tell their own stories, and the differences in the products that result serve to reinforce the importance of this authenticity.

9

Video in Politics

In Ingo Hessel's outstanding book about Inuit art, the author notes that "Inuit art is relatively conservative and is rarely political: very few artists deal with present-day social issues" (1998, 71). This is largely true, although some prominent Inuit carvers have created pieces that deal with alcohol, suicide, and other social concerns. For example, Eli Sallualu Qinuajua carved a depiction of the horrors of veneral disease (Seidelman and Turner 1994, 177). Charlie Ugyuk created a carving about alcohol abuse (194) and another one about the dangers of forced Christianity (199). Nevertheless, for video artists, social and political debates are fair game. One Isuma video, for example, demonstrates how video has been used in the Arctic to stake a political stand.

The story centres on the controversial hunt of bowhead whales in the Arctic. Under international law, the hunting of bowheads is illegal. The actions of a few Inuit hunters, however, led to a relatively recent Canadian program that grants Inuit in the Arctic a licence to hunt one bowhead every two years. The licence is given to a different community each time; the first was given to Repulse Bay, and the second, in 1998, was given to Pangnirtung.

The story of the hunt and its controversy is the subject of *Arvik!* (*Bowhead!*). Released early in 1998, it represents an effort to show the Inuit perspective on these hunts.

Arvik! differs from previous Isuma videos in important ways. The most obvious and interesting difference is that the narration in

Arvik! is offered in Inuktitut in one version and in English in another. In the latter version Inuktitut enters only in direct dialogue, such as interviews with people in Igloolik and Repulse Bay, speeches during the court hearing, stories of previous bowhead hunts, and so on. These are subtitled in English on the screen, and everywhere else the words are in English, making this video more accessible to Southern audiences than even *Qaggiq* and *Nunaqpa*, which presented Inuktitut aurally with English subtitles throughout.

The English version of *Arvik!* begins with a voiceover in English; no effort is made to establish Inuktitut as the primary language before switching to English. The voice speaks: "Whales are one of the largest mammals in the world. And there are different kinds. Even though bowheads may be the biggest whales in the Arctic, they feed on the smallest of the food chain ... The Arctic bowheads can grow between forty-five feet to sixty-five feet lengthwise. These huge animals are slightly different from other whales in the world because they have no back fin."

The voice – it's Zacharias Kunuk, taking the role of the authoritative narrator – goes on to explain much about the animal's mating habits, gestation, birthing, geographic range ("all over the Arctic oceans"), and other information.

Then the narrative cuts to information about the whaling industry: "In 1615, Europeans saw many bowhead whales when they sailed into the Arctic waters." Inuit, the voice explains, have always hunted whales for survival, but in the eighteenth century they were no longer alone in their quest. In 1719 Europeans began to harvest the bowhead for profit. They killed huge numbers of the animals, and the industry grew rapidly; in the spring of 1830 the Scottish and the English had more than ninety ships whaling in the Arctic – even though conditions were so difficult that nineteen of them were lost in the ice. The Danish, Dutch, Germans, and Americans, eager to exploit this rich resource as well, joined in the whaling effort with fleets of their own.

The narrative explains the many uses that Europeans found for baleen: springs for carriages, rope handles, combs, chair parts, fishing rods, curtain rods, and corsets. The video also explains that the fat was used for fuel, lubrication, perfume, and other products. In 1818 a single, average-sized bowhead brought in about $10,000 for the baleen and the fat. Whalers spent winters in Pond Bay and

other areas in the Arctic, and they were helped by the Inuit, who gave them food and clothing. Some of the Inuit even hunted bowhead for the Europeans while the latter went back home. An average ship could hold seventeen bowheads. A total of 28,000 bowheads were caught between 1719 and 1911.

Whaling began to decline in 1912 because the whalers decided that there were too few bowhead left to hunt. Only about one thousand bowheads were left in the Arctic oceans. Also, petroleum oil was slashing the demand for bowhead blubber, and plastic was cutting the need for baleen.

After for-profit hunting was abandoned, the numbers of bowhead whales increased slowly. From 1971 to 1994 no one hunted the bowhead at all; in many areas in the Arctic the International Wildlife Commission protected them.

The crux of the *Arvik!* story centres on the hunting of a bowhead whale. On 18 September 1994 a bowhead was caught by Inuit hunters near Igloolik, in violation of Canadian and international law. This act took many governments by surprise, and the reaction was confused. Isuma's purpose in making the video was to offer their own interpretation of the hunt and its aftermath. It is with this goal in mind – not to persuade, necessarily, but to present a viewpoint that insists on respect – that the video presents its case: the whale taken illegally near Igloolik was wounded and would have died anyway, a foolish waste that would benefit no one. The shortage of bowheads was the fault not of the Inuit, who had hunted them for millennia, but of the very Western powers that were now insisting that the Inuit change their ways. The elders, who remembered when bowhead could be caught legally, craved the Muktuk[1] (fat and skin) and wanted to taste it again.[2] And the whales were owned by no one, making suspect any Western laws governing them.

The development of a version with English narration reflects this video's purpose, which is to present the Inuit view of the controversy surrounding the hunting of an endangered species. Presentation of this view to the Inuit themselves is useful; disagreements about the hunt lurk among the Inuit, but the vast majority agree with the video's central argument and benefit from this depiction of their cultural outlook. Yet in the world beyond Arctic Canada, opinions about the hunt are louder and more vigorously stacked on the other side. It is to these people that the English version is

offered – southerners who believe, in advance, that the hunt is wrong and that endangered animals should be protected at all costs, despite culture, history, and subsistence.

So English serves to make these arguments to the very audiences that need to hear them. Even more so than with other Isuma productions, this video goes beyond the retention and reteaching of Inuit culture for and to a new generation of Inuit in the Arctic; instead, it strives to educate people elsewhere about Inuit attitudes. The viewers hear plenty of Inuktitut in the video, but the overall effect in the English version is communication that slides easily into the Southern mind and requires little effort to comprehend.

IMAGERY

Another interesting shift is the use of archival still photographs and sketches to convey the history of the bowhead hunt. The narration plays over still sketches of various kinds of whales in the ocean – swimming, diving, blowing spouts. A pennywhistle, called a "whaler's flute" in the credits, is heard playing a slow, Scottish-sounding melody. (The Scottish, at one time, were active whalers in the Arctic.) Blue whales, sperm whales, humpbacks – the images fade from one to another, until a bowhead whale, with its characteristic curving mouth and mammoth body, fills the screen. In addition, sketches of Arctic whaling scenes and European ports fade in and out gracefully on the screen. As the chronology moves forward, the sketches are replaced in part by archival photographs of the rugged life on board whaling ships.

On the one hand, this technique is a useful way to skirt a logistical challenge: the producers cannot show this part of Inuit history through re-enactments because they are not allowed to hunt a bowhead for the purposes of making the video, and staging a fake re-enactment would violate the reality that Isuma strives for. Whereas *Qaggiq* and *Nunaqpa* show how Inuit once lived by recreating the costumes, technologies, and activities of a previous generation, *Arvik!* has to rely on other avenues. Additionally, the use of sketches and photographs works well with the English narration to make the argument easily accessible to Southern audiences. Viewers from the South have enough experience with history books, photo albums, and museum displays to make this approach familiar; we know how to interpret fixed, two-dimensional images.

Outsiders' impact in the Arctic also takes on a different role in this video. Whereas *Qaggiq* and *Nunaqpa* let contact with whalers and traders seep into the scenes unannounced, through tin cups and weathered rifles, *Arvik!* puts the Qallunaat and their motivations at centre stage throughout the first section of the video. In terms of domestic material culture, the Qallunaat had an important but insidious influence, melting the old ways in the glare of new technologies and demands. In terms of the bowhead whale population, however, the Qallunaat influence was explosive. The whalers from across the ocean and down the coast were insatiable, driven by a quest for profits that would make modern corporations proud. And in their frenzy to kill and export as many whales as they could possibly carry, the whalers paid no heed to the impact that their actions were having on the whale population as a whole. Indeed, with products being developed that would squelch their entire industry, whalers had little reason to worry about conservation; "petroleum would soon negate the need to chase the whale, new industrial products would replace baleen" (Eber 1989, 22). It was only when the decimation of the bowhead whale population made further pursuit unprofitable that whalers left Baffinland for good.

The changes to Inuit life brought and wrought by the whalers were many: rifles, diseases, new foods, new crimes, a market for art and clothing, and an emphasis on the fur of the otherwise unimpressive white fox. But the whalers did more than add new goods and ideas to the North: they also subtracted wealth, resources, and traditions. The near elimination of the bowhead stock is one example, and the video makes it clear that the endangered status of the bowhead whale is the fault of the whalers, the Europeans, the Americans, and the Qallunaat who hungered for factory fuel and corset stays. It is also made clear that the imposition of a ban on Inuit hunting of the bowhead, as a result of the greed of others, is unacceptable.

STYLE

The style of *Arvik!* also differs dramatically from that of *Qaggiq*, *Nunaqpa*, and other Isuma videos. This video takes a much more journalistic approach, with commentaries and microphones and man-on-the-beach interviews. For example, the video shows the whale being hauled to shore amid a light snowstorm and butch-

ered, with many Igloolik-area residents helping themselves to the Muktuk, just as had been done in a previous era. The skin is a dark black and the blubber a nearly white pink. Slabs of the Muktuk measuring about two feet wide and four feet long are cut from the whale, secured with hooks, and dragged onto the rocks. People are shown eating the Muktuk; others cut the slabs of skin into smaller pieces for distribution throughout the community and drag onto the beach pieces of meat the size of a person. Everyone pitches in to get the job done. It is cold work; chunks of ice and snow get in the way.

The narrator explains that the Muktuk is passed out to everyone, and many people taste it for the first time because it has been so long since bowheads were legally available. And the Igloolik Hunters and Trappers Association sends pieces of the Muktuk throughout the Nunavut area "in respect of the elders."

While this butchering and eating is going on, the videomakers interview some of the people at the scene, speaking in Inuktitut; the conversation was translated into English subtitles:

"Now that a bowhead is caught, what are you thinking?" [Elijah Evaluarjuk is asked this question as he eats a piece of Muktuk.]
"I felt odd. Now I'm really glad a bowhead was caught."
"What did you think when you heard about it?"
"I couldn't believe it at first. When I saw the Muktuk then I started to believe it. It's so thick it doesn't seem good to eat."
"Was it your first time tasting it?"
"Absolutely."
"How does it taste?"
"Like a beluga but it's much easier to chew. Rather smooth, it's thick and smoother."

Aipilik Inukshuk, an elder, is also interviewed:

"I was caught by surprise. I was happy. I never expected to taste Muktuk, what a nice surprise."[3]
"Have you often thought it, because there are bowhead whales around here?"
"Thinking we might hunt bowhead whales someday, but it's hopeless, there are laws against hunting them. It's hopeless. I often think when are we going to harvest one? I even think

maybe after I'm gone they'd be finally hunted again. I often think like that."

"Because you're an elder?"

"Yes, I think about it."

Julie Ivalu, the senior producer at the Inuit Broadcasting Corporation in Igloolik, offers this comment: "I sympathize with the government. But the Greenpeace people would think 'this is too much.' That's what I thought."

Others on the cold and muddy beach are interviewed as well: Maurice Arnatsiaq says, "I couldn't really believe it when I heard about it." His wife, Annie Arnatsiaq, adds, "I thought they were just joking around when they invited anyone to come to taste Muktuk. 'Beluga skin,' is what I thought. They're just happy it was really a bowhead they caught. I had to see for myself." Eli Ammaq, an elder, offers this: "I was happy about it. Since the government doesn't own them, why should Inuit leave them alone on purpose?"

Then Simeonie Qaunaq, one of the people who caught the whale, is asked how it happened:

"It came to us when we were on an ice pack, and it had open wounds. A beluga would be bound to die anyways. So I told them it should be killed. There were three of us. When we shot it, it couldn't dive."

"Were you all in one boat?"

"Yes. One boat. We were standing on this ice pack. We started to hunt it and very shortly another boat came. There were two now. Then there were six of us. It was really exciting."

"What was on your mind? Get it out of its misery, because it was wounded and likely to die? Was that it?"

"Yes. If it were a beluga, it would die slowly for sure. I've seen a sick beluga in wintertime, salt water had seeped into its open wounds. It was really skinny. This one was the same. Our people crave the Muktuk, but it would be unable to be eaten. If it were found dead, it would be such a waste. So I decided to kill it to get it out of its misery."

The scene shifts from Qaunaq to a shot of the whale being butchered, the bloody skin and blubber being pulled off the animal. The interview with Qaunaq goes on:

"Nowadays the Government doesn't want people to hunt
bowhead whales. Did you think about that?"

"I wasn't concerned at all. I didn't even think about the
government. We were thinking of the people, the elders. I
thought of them because they crave bowhead blubber. Now
at least it will be eaten. It made me glad about it."

The comments continue. Elder Noah Piugattuk: "I'm very
grateful for this bowhead whale hunt ... I knew they were not to
be hunted, but I became hopeful and began thinking about it. I
began thinking someone should harvest one. So I ordered one
to be harvested." The Muktuk is carved into small pieces and
passed around amid smiles, laughter, and conversation. Elijah
Evaluarjuk again: "I wouldn't mind if they catch one every year
... I don't really like the law. When you're out there, in summer-
time, you see so many bowheads you try not to hit them." Eli
Ammaq again: "I don't want Inuit to be forbidden by the govern-
ment. We don't own the animals. They don't own them either.
But they seem to keep bowheads from being hunted. I don't
agree with this." Others continue to offer their views, all largely
centred on the same themes: the hunting ban is unfortunate;
Inuit, especially the elders, crave the Muktuk; and what right
does the government have to restrict access to a natural resource
in the ocean?

Despite this nod to Southern journalistic traditions, the ques-
tioning in *Arvik!* reflects Inuit values – including respect for elders
– that are not always present elsewhere. The questions asked are
open-ended, gentle, suggestive. At one point, an interviewer asks
the whale hunter, "What was on your mind?" – not a powered
attempt to pin down an answer but an attempt to elicit conversa-
tion, thought, and the sharing of ideas. Then, in an effort to help,
the interviewer offers a lead: "Get it out of its misery, because it was
wounded and likely to die? Was that it?"

The hunter takes the cue: "Yes. If it were a beluga, it would
die slowly for sure ... So I decided to kill it to get it out of its
misery."

The tone of the interviews is one of agreement, consensus, and
mutual approval. The video offers people a chance to share their
views, explain their thinking, and describe their emotions. It is
unhurried, respectful, and supportive of those who share their

views. The argument is made through words more than the actions
of *Qaggiq* and *Nunaqpa*, but the words are Northern in their tone
and arrangement.

SHOWDOWN

The central focus of the *Arvik!* video is not the ocean or the beach.
Instead, it is the courtroom in which Inuit hunters had to defend
their decision to kill a bowhead in violation of Canadian law. In
1995 the three men who killed the whale were charged by the
Canadian Department of Fisheries and Oceans with violating the
law against hunting animals on the endangered-species list. The
video shows people filing into the courtroom, through the blue
metal doors, their parkas still on against the cold. The video
acknowledges that the actions of these men troubled some people
in the community, but it goes on to point out that "they were sup-
ported by many people."

Paul Quassa, the chief negotiator for the Nunavut Land Claim, is
present at the hearing, and he describes the court process as "short
but emotional." He supports the whale hunters, and he maintains
that "all the people of Igloolik" feel similarly. He goes on to address
the court (in Inuktitut, subtitled in English):

> These Fisheries and Oceans Officers were told that Inuit broke
> the law, and they think charging them is the right thing to do
> because it's their job. I don't think they have broken the law.
> We keep saying, this is the Inuit way, they were just following it.
> No one would ever break his own old way. For example, what
> I'm holding here, tells the story from the start. [He holds a
> small object in his hands, difficult for the viewing audience to
> see.] What is "written" here in these ancient carvings, is that
> Inuit always hunted the bowhead whale. This was found right
> near Igloolik. There's a bowhead carved here, and people
> hunting them. [It can now be seen that the object is an ivory
> comb, obviously very old, with an engraving on the flat part
> opposite the teeth.] The very Inuit. It shows exactly how they
> hunted. It's obvious it's always been our way. It is written here.
> We were often told the Inuit way isn't written down. It may not
> be in words, but these pictures show what makes us who we are.

This is what makes us strong, our way. We are being judged today for who we are. When it's like that, whoever follows his old way will never lose.

The scene cuts to a drum-dance celebration at the Ataguttaaluk Elementary School in Igloolik. In the centre of the gymnasium's parquet floor, a man in a white, traditional costume beats a large drum while others sing; children and adults, sitting on chairs and lying on the floor, watch in a loose circle around the room. The event celebrates the bowhead hunt, and central in the festivities is Louis Tapardjuk, the mayor of Igloolik at the time of the bowhead kill. Afterward, he sums up his views:

Across the great seas they came to hunt bowhead whales for profit. After that there were too few whales left. Inuit should have kept hunting bowheads, but it slowed the hunts because the whalers almost finished them off. Those Europeans are more to blame because the whales became extinct. If Inuit kept on hunting up until today, I think we would still be hunting them now. But Europeans hunted too many. Before the Europeans ever came we have evidence that bowheads were always hunted from old stories and old whale bones. Old bones are still around. If Inuit had kept hunting today we ourselves would know how to hunt. We would have the skills and know what to do. But these elders know because they hunted too. They are the ones to be sympathized. It was their right to know what to do and put it to use. But too few bowheads were left for us to learn to hunt them. This is the learning we have lost. It really made us happy a bowhead was caught. "So that was how to do it," is what I thought ... Now it is only by stories that we know about it, how they used to hunt them. I can't even imagine it, hunting for the bowhead myself. People my age are even afraid to get too close to one bowhead. If they had left some for Inuit to hunt, we would be more educated about bowhead hunting. But some of it was lost. It's regretful they even had to make a law against hunting for bowhead whales. Inuit are totally innocent of this. Europeans wanted too much profit, that finished off the hunts. It's pitiful but we cannot turn it back.

The scene now changes to a bowhead whale in the open ocean. Its spouts blast upward noisily, and its black back rises gracefully just a short distance above the waves. The narrator explains that the hunters had to wait more than a year to receive the court ruling. But at last, they learned that the charges had been dropped by the Department of Fisheries and Oceans.

The killing of that one bowhead led to other changes. Two years later the Nunavut wildlife committees and the Canadian government granted permission for Inuit to hunt one bowhead in the Nunavut area every two years.

LOSS OF KNOWLEDGE

The *Arvik!* video celebrates the legal victory, but it also points out that the ban had long-lasting effects. An entire generation of Inuit hunters had grown up without the ability to watch their elders hunt bowhead and so could not learn from them by example. One story told in the video by John Qaunnaq demonstrates the importance of learning from one's elders. He sits by the beach holding a large soapstone carving of a bowhead on his lap; he is finishing the carving with sandpaper as he tells the story:

Before 1970 we caught two bowheads. The first was in here. In a valley called Kangirlukutaak. I killed it with a spear. At first we shot at it, with the only high powered gun we had, a .270. Those 7 mm too, they seemed really high powered. I shot at it I don't know how many times but it didn't help and the skin just spread out. I was with Jackie Nakuqlu. He shot at it for a while but it seemed impossible to kill. I worked at the garage at that time, and our truck was down at the shoreline. We hurried back up to the garage. I cut some steel used to stiffen cement, about ten feet long, soldered it, and honed it with the grinder. It got sharp quickly in 20 minutes. We rushed back and we worked on the whale, until blood spurted out of its nostril. Since we didn't have much experience with a bowhead, we were scolded. We had a twenty-four-foot canoe, and when we got on top of the bowhead the boat stuck to it, and it stayed there. [He gestures with his left hand on the carving of the whale, demonstrating how the canoe rode up the animal's back.] My companion kept the motor running, just pulled it in still running, but my older

brother's boat was an older one, with a smaller front and a five-and-a-half speed motor. We called him over and exchanged boats. His smaller one was easier to handle when we got on top of the bowhead. Then I got out and stood on the whale, spearing it, trying to find the heart. [He points to the middle of the carving.] I sized it up: so this is where the heart should be, using the spear looking for the heart, but not knowing that kind of mammal, it was mostly head, and it was the shoulder I thought was the heart. But I didn't even touch the shoulder. It was really the neck just below the head. I was still looking for the heart when there was an experienced elder who started shouting at us. He was over there on a steep rock, and he shouted, "Where are the flippers?" And I'm on the whale, still floating, I replied, "Here are the flippers!" [He gestures behind him to both sides.] So I backed up a bit. "The flippers are right here." "Go backwards a bit again, back up, just below the shoulder, on the side of the spine, on the left side." When I understood this experienced hunter, I poked with the spear. "Here?" "Little bit further." Still poking. "Here?" "A bit further." [He looks behind him.] Thinking I'm getting close to the rear, I was still on the dry side. "Go at it now, forward, just miss the spine, below the shoulder!" When I poked further down, he started shouting again, "Down, down, down!" [He gestures as though he is stabbing the ground with a spear.] So I poked down. "Down, down, down, you won't go through! Go ahead, go down!" I really did it, down to the heart, as if it would go right through like this. It felt hard and slippery, and I felt it go through. And the whale suddenly stopped. So that's where the heart is. I thought that was the rear part but it died immediately. People like him are still around.

His struggle to kill the whale – a struggle that clearly led to unnecessary suffering for the animal, a violation of traditional Inuit attitudes of respect for one's prey – shows how easily knowledge can be lost; it was only through the shouted advice of an elder on shore that he was able to kill the bowhead with his lance. This erosion of knowledge came about through the decimation of the bowhead population, nearly bringing an end to the hunt; the ban on hunting made this connection between generations even more difficult by preventing elders from sharing their knowledge before they died.

Another example offered in the video focuses on the first legal bowhead whale hunt since the ban took effect. Repulse Bay was the community chosen to host the bowhead hunt that took place in 1996, and the video shows a celebration under way. A band on a stage plays lively music with two guitars, an accordion, and a set of drums, and the crowd is square-dancing energetically. T-shirts are being sold, white with black letters:

BOWHEAD WHALE HUNT '96
REPULSE BAY – NUNAVUT

Between the two lines of type is a sketch of a bowhead whale. The shirts are available only in English, the seller explains; the Inuktitut ones are coming later. The narrator sets the scene: "In August, it is time for the hunt, and more than two dozen men walk down the stony beach toward their boats. They have come to Repulse from all over the region, eager to participate in the first licensed bowhead hunt in decades. Few elders are left in Repulse who remember hunting bowheads before doing so was illegal."

A team of hunters had been chosen to participate in the bowhead hunt.[4] The committee leaders asked who knew how to kill a bowhead, and the hunting team discussed the best way to go about it. Equipment was purchased and shipped in – rifles, floats, and so on – and the formal papers were signed for the hunt. The narrator: "After twenty years of waiting, Inuit are given license to hunt." Hands are shaken, applause is given, pictures of the licence are taken.

Later that same day, the hunt begins. A bowhead has been cited, and the hunters are eager to get out into Repulse Bay inlet to find it. The boats cruise across the water, and a bowhead whale breaks the surface. It blasts water into the air with its lungs and dives calmly. The boats circle around it.

The entire affair has been carefully orchestrated. The position of people in various boats has been worked out in advance by the local wildlife committee, and the location of the media has been arranged. Quickly, a hunter hurls a harpoon at the animal, and the water around it darkens with red. The float attached to the harpoon line bobs nearby, ready to show the location of the whale if it dives. Other hunters throw their harpoons at the whale as it rests at

the surface of the waves, and now three pink floats follow the wounded bowhead through the water.

With the bowhead secured by harpoon toggles to three large floats, the boats cruise slowly alongside, and hunters take aim with their rifles. They shoot the whale repeatedly, but it remains alive despite the powerful rifles used by the hunters.

And then something unexpected happens. The whale dives deeply and does not resurface. The whalers take a lunch break and wait, discussing the whale's behaviour.

"If it had been that kind, it wouldn't have gone so far out – if it were a beluga," says one whaler. "It's taking longer to come up each time. That's how it is. How it will end up, nobody knows. We are still waiting, right where it dived. We're still near it."

"Yes," replies another. "Of course, that other way – It became hopeful. Now it looks hopeless."

When the whale does not reappear for some time, the hunters talk to each other, boat to boat, via radio, and they put a new plan into place. They try a drag line, but it comes up empty. Then they lower into the ocean a Sea Otter, a compact, cylindrical diving machine about three feet long and one foot in diameter. It is painted bright yellow, with black metal tubes forming runners underneath. At the front is a hemisphere of clear plastic that contains a video camera, and protruding from the sides in various places are small propeller tubes. The whale, the hunters surmise, might have become snagged on the ocean floor, and they want to find it quickly. They toss the Sea Otter into the ocean, where it hovers just below the surface for a moment, attached to the boat physically and electronically by a thick cable. They fire up a generator to power the equipment, and they dispatch the Otter downward to do its work – but it sends back grey images of deep-level seawater, flecked with a blizzard of white spots. Technology is not the answer to this problem.

The hopeful crowd waits expectantly on the beach, watching the fleet of small boats milling about the bay, but the frustrating search takes two days. At last, just as the hunters are thinking about going after a different whale, the bloating carcass of their prey lifts off the sea floor and is found.

The meat has spoiled, but the Muktuk is still good, and it is sent to communities throughout Nunavut for people to enjoy. The peo-

ple of Repulse Bay throw a community-wide celebration to honour
the hunt despite its rocky success, and they spend hours dancing to
the lively music of a band in the school gymnasium.

The near disaster of the Repulse Bay hunt demonstrates the ten-
uous hold that a population has on its knowledge. Three floats
were not enough to keep the bowhead on the surface, and some-
one who had hunted bowheads in the past, and who understood
their behaviour and the physics of cold water and deceptive cur-
rents, would have known how to prevent the temporary loss of the
animal. But the ban on bowhead hunting imposed from outside
caused much of this knowledge to evaporate, leaving the modern
hunters frustrated in their attempts to catch a bowhead in a swift
and humane manner.

TRADITION VS THE LAW

An underlying theme in the *Arvik!* video is defiance against the
colonializing efforts of a dominant society. Through the ban on
bowhead hunting, the Canadian government nearly extinguished
Inuit knowledge of how to hunt the whales successfully. The disas-
trous Repulse Bay hunt is evidence of how diminished this knowl-
edge had become. Fortunately, the Inuit were allowed to hunt the
bowhead just in time, when there were still a few elders around
who could offer guidance and advice to the young hunters. By
clinging to their ability to hunt the enormous animals, the Inuit
succeeded in thwarting the effort, however subtle and uninten-
tional, to dismantle this aspect of their culture.

As shown by *Arvik!* the counter to erosive laws is tradition. In par-
ticular, two traditions are foregrounded in this video: the hunting
of bowhead by the Inuit and the importance of fulfilling elders'
wishes.

There is some disagreement regarding how common bowhead-
whale hunting was among the Inuit before the European whalers
arrived with incentives to take up the chase. But the evidence –
both archaeological and oral-historical – supports the position that
the Inuit hunted bowhead long before the European whaling ships
sailed across the Davis Strait. The argument is made, both in
defence of the "illegal" hunt and in the push for a change in the
regulations to allow future hunts, that ancient Inuit tradition
should prevail over recent, externally imposed law.[5]

And the video also emphasizes the importance of carrying out an elder's wishes. A *Nunatsiaq News* article that ran on 23 September 1994 about the illegal bowhead hunt earlier that year explains that it was done because elder Noah Piugattuq, who was ninety-four years old, had said on the community radio station in Igloolik that he hoped to taste bowhead Muktuk one last time before he died. As the final line of the movie indicates, he got his wish. He died a year later.

So the hunters felt obliged to fulfil the request issued by this respected elder, even if it meant breaking Canadian law. Starting when children are born, they learn that age carries significance; it is routine in the Arctic to see an older sibling issue orders to his or her younger siblings, orders that are promptly obeyed. So when Piugattuk broadcast his request – keeping in mind that the Inuit rarely state their orders directly – it was taken seriously.

So with the power of these two traditions behind them, the Inuit hunted the bowhead. As the video shows, they eventually were found innocent of crime, although this decision and the subsequent decision to allow a sanctioned hunt remain controversial. Still, tradition was used effectively as a counter to legal authority.

At the end of the video, the foot-stomping tunes driving the celebration in the gym give way to the slow lament of a pennywhistle. The image of dancing, smiling, flailing celebrants fades into a black-and-white still of an Inuit family during the old whaling days, gaunt and unsmiling in the photographic tradition of the time. In front of this scene appear words: "For their oil and baleen Arctic bowheads earned European and American whalers $350 million in their day." The scene behind the words shifts to a wide Inuit camp, then again to a small skin tent with Inuit adults and children facing the camera with serious expressions. "In today's dollars that comes to more than $100 billion." A snowy waterfront, with buildings and a church in the foreground and a three-masted ship anchored to the edge of the ice. "Soon after tasting bowhead Muktuk for the last time, Noah Piugattuk passed away in 1995 at the age of 95." Two Inuit men, close on their faces. More shots of men, stoic and proud. Shots of men working on small plywood buildings. The credits roll as the images continue to shift behind them.

10

Video as Community

In political struggles over cultural symbols, history, and perspective, the borders are not always external. While the Inuit Broadcasting Corporation (IBC) and Isuma are pressing for opportunities to express the views and situations of the Inuit, another group in Igloolik – created by Isuma – is working on an altogether different front: community videography.

The story of Igloolik's community video centre begins with an image from traditional Inuit belief: the Tariagsuk, the Shadow People. (The word is pronounced ta-RAYG-sook and is sometimes spelled "Tarriaksuk.") They are much like other Inuit, living on the land and functioning in normal ways. The main difference between them and other people is that they cannot be seen directly. You can see only their shadows, their impact on light. Rasmussen explains:

> The Shadow Folk, are quite like ordinary human beings, but there is this peculiar thing about them: that one never sees the beings themselves, only their shadows; they are not dangerous, but always good to human beings, and the shamans are very glad to make use of them as helping spirits. They hunt by running, and can only bring down an animal if they are able to overtake it on foot. These Shadow Folk correspond to the tARajait of the Greenlanders, and Ivaluardjuk related of them as follows:

"It is said that there is this remarkable thing about the Shadow Folk, that one can never catch sight of them, by looking straight at them. The Shadow Folk once had land near Tununeq (Ponds Inlet). One day, an elderly man appeared among them and stayed with them. And the Shadow Folk came and brought food both for him and his dogs. The Shadow Folk themselves had also dogs; one of them was named Sorpâq.

"One day, the Shadow Folk spoke to the old man who was visiting them as follows: 'If you should ever be in fear of Indians, just call Sorpâq. There is nothing on earth it is afraid of.'

"The man remained for some time among the Shadow Folk, and then went home again. He came home, and some time after he had come home, his village was attacked by Indians, and the old man then fell to calling Sorpâq. Sorpâq at once appeared, and began to pursue the Indians. Every time Sorpâq overtook an Indian, it bit him and threw him to the ground, killing him on the spot. Thus Sorpâq saved all the people of the village, who would otherwise have been exterminated by the Indians.

"It is said that these Shadow Folk are just like ordinary human beings, save that one cannot see them; otherwise, they have the same kind of houses and the same kind of weapons, harpoons and bladder harpoons, just like everyone else."
(1929: 210–11)

The image of the Tariagsuk provides a potent symbol for the flickering patterns of electrons that bring people to "life" on a screen. So the name was taken as a title by the video centre in Igloolik: the Tariagsuk Video Centre.

The centre began with Marie-Hélèn Cousineau, a video artist from Montreal. Cousineau had earned a bachelor's degree in art history from Université Laval in Quebec City and a master's degree in art history from Université Québec in Montreal. She founded the Tariagsuk Video Centre in Igloolik in 1991, and the centre quickly launched a women's video group and called it Arnait Ikajurtigiit, which means "women helping each other." Arnait Ikajurtigiit, now called Arnait Video Productions, strives to demonstrate – through consistent and solid example – the importance of women in the Arctic's past and present.

The issue has potent ramifications. In 1997, as the shape of
Nunavut's new government was being carved, an interesting ques-
tion arose: why not mandate that the territorial Legislature be half
female and half male? The plan would have each district create two
lists of candidates for their member of the Legislative Assembly
(MLA) positions – one list of all the male candidates and one list of
all the female candidates. Voters would choose one person from
each list, so each district would send a woman and a man to the
Legislature.

Proponents of the plan argued that gender equity is only fair,
and they noted that while male and female roles have always been
distinct in traditional Inuit life, both roles were equally essential to
the survival of the family. The man hunted and so brought home
the raw materials necessary for food, clothing, blankets, and other
items, and the woman converted these raw materials into usable
goods. Without the woman's active participation in family life, the
man would lack the clothing and sustenance necessary to hunt
effectively – and the family would suffer.

Proponents also saw a chance to catch the world's attention. Vir-
tually none of the democratic governments across the globe man-
date equal participation of men and women in the legislative body.
By passing a referendum mandating gender equity, the Inuit would
show the world that they are able to lead the way on key social
issues, and buoyed by this attention, they could talk with world
leaders about their views on such other important issues as the
environment.

The proposal was voted down in 1997. Opinions about the
defeat varied widely. Several women in Iqaluit – all supporters of
the proposal – told me that Inuit men throughout the nascent ter-
ritory threatened their wives with physical harm if they voted for
the plan. Several men, however, told me that the defeat was due to
practical concerns. What if the best two candidates for a district's
positions were both men or both women?

The failed referendum notwithstanding, the crux of this debate
centres on the role of women in Inuit life – a role that is open to
redefinition in today's Arctic. Under the Canadian Constitution,
men and women are granted power equally. So one central ques-
tion as Nunavut slowly matures is the role that women will play in
the territorial government and society (Minor 2002).

Into this context has emerged the work of Arnait Video Productions, which follows Isuma's example: it shows Inuit women, past and present, in a strong and positive light, demonstrating their value, wisdom, and courage as they enhance the rich complexity of Inuit culture.[1]

In the beginning the women of Arnait met wherever they could, often in each other's homes. When they visited one of the members, they would bring along the camera and the tripod, and they would record the host making bannock, or sewing, or taking part in some other activity. And at each session, the women learned a little bit more about how to make a successful video.

"So we did a few of those classes, and I showed them how to edit," Cousineau says. "I showed them what you do with the machine and how you change something – and you cut, and you add, and this and that."

The project succeeded so completely that it soon became time for the women to be in charge of their own productions. They did the preparation work – choosing topics, lining up interviews, and so on – and they created videos on a variety of topics. One video was about the *amauti*, the woman's parka with the enlarged hood for carrying young children; the women filmed two elders talking about the *amauti*, how the babies were carried, how the beadwork was done, and related topics. These videos were not intended to be shown to audiences; they were working exercises in which the women in Arnait Ikajurtigiit could gain experience with the video equipment and techniques.

Two videos from this period, however, have been shown to audiences in New York, Mexico, and other places throughout the world. One of them is called *Qulliq;* the *qulliq* is the traditional, half-moon-shaped stone lamp that women tended in the igloo or tent. It provided the family's only means of heat and light, and it was used for all the cooking and the melting of ice for drinking water. The video shows the positioning and use of a *qulliq* in an igloo, along with stories about women's work in traditional Inuit life. The other is entitled *Ataguttaaluk Starvation*, and it chronicles the story of Ataguttaaluk and her family, who suffered a horrible crisis of starvation from which only Ataguttaaluk survived. Both videos celebrate women from a traditional/historical perspective: *Qulliq* explores the importance and uses of the *qulliq*, which was ·

tended by women and served as a symbol of a woman's power and
authority within the family, and *Ataguttaaluk Starvation* focuses on a
significant female figure from Igloolik's past.

PAST INTO PRESENT

Much of Isuma's work focuses on the past, showing people of today
the value inherent in the practices, knowledge, and experiences of
elders and their recent ancestors. Much of the IBC's work focuses
on the present, showing viewers the value inherent in both the
quotidian and the extraordinary in Inuit life. Arnait combines the
two approaches in the majority of its works, bringing the past use-
fully into the present to demonstrate the value of women in today's
Inuit society. Five examples illuminate this approach.

Example One

In 1992 the Tariagsuk Video Centre received funding from the
Oral Traditions Program of the Government of the Northwest Ter-
ritories to capture on videotape available knowledge about tradi-
tional health and birthing practices. Cousineau explains:

> We did a series of interviews with midwives and women doctors.
> We did about ten interviews with women, 'cause that's a topic
> that came out, that women were interested in talking about, in
> the survey for the Women's Video Workshop. They were very
> interested in talking about that. So that summer was me and
> Madeline [Ivalu] and Martha [Maktar]. We went to Igloolik
> Point, and we did interviews here. So also we expanded our cir-
> cle of people working with us. And we did a series of hour inter-
> views, they were about an hour. And then we hired somebody,
> like Celina [Uttugak] was doing the translation. And she was
> often working with us in translating and interpreting. Those we
> have also here, we have ten about ten to twelve tapes, and we
> have the translation on paper in English, too.

The project, which in effect was an outgrowth of the original
video survey, was called the Women/Health/Body series. The vid-
eos are straight interviews with women who remember various
aspects of traditional life, including methods of childbirth, heal-

ing, and communication. "Workshop members interviewed nine women elders of Igloolik about their traditional knowledge, skills and personal experience in giving birth and helping sick or wounded people," Cousineau writes. "The grace and honesty of the testimonies, the absence of anger, the beauty of those old women telling amazing stories about the challenges of living on the land by themselves is breathtaking. It is moving and subversive to be in touch with a body of women's knowledge that has been denied legitimacy by recent colonizing institutions" (1994, 38).

Example Two

Buoyed by invitations and funding to show their videos and meet with groups of women in Buffalo and Montreal, the women of Arnait pursued funding from the National Film Board to create a video and an event in celebration of Women's Day. Backed with advice from elders, they went around town recording women's activities: making art, sewing clothes, doing the things that indicated the power, potential, and pride of women in Igloolik. Then they organized a party in the former mission house, and the women they had filmed brought the art, clothing, and other projects that they were working on during the taping sessions. Games were played; prizes were awarded. Food was put on tables to be admired and taken off tables to be eaten. The video was shown to the crowd – and the entire event itself was recorded on videotape, a recording of an event in which a recording of Inuit women's lives was presented. "It was really fun," Cousineau says. "It was really fun. It was a lot of – that activity, there was about seventy women or something. So it was quite successful. [People asked] 'Oh, why don't we do that more often?'"

Example Three

The group then set its sights on an even more ambitious project. The route from Igloolik to Pond Inlet – across Fury and Hecla Strait, then across the width of the fifth-largest island in the world – has been travelled by Inuit for centuries. Most of the people in this area – in Igloolik, Hall Beach, Repulse Bay, and Pond Inlet – came from the same large group of Inuit who lived in a vast area that centred on the top of Melville Peninsula. The people travelled a great

deal in precontact days, and many in these various communities are closely related. The Igloolik-Pond Inlet route was a key link in these migrations.

So the women of the workshop decided to make the journey themselves, by snowmobile, and record it to show future generations what the trip was like. Madeline Ivalu took charge of the project, and Cousineau and Maktar helped with the organization and planning. About fifty people were involved, and five part-time jobs were created to make the idea a reality (Cousineau 1994, 38). Money was secured to pay for gas and supplies. Elders in Igloolik were interviewed, on camera, about the route – what it meant to them, what the trips used to be like, and so on. Then three of the women and their families climbed aboard their snowmobiles and made the trek; on their arrival in Pond Inlet several days later, they interviewed the elders there as well. Then they motored back across the rolling, icy hills and the frozen strait and returned to Igloolik. The resultant video is entitled *Itivimiut*; Cousineau explains the significance of the term: "When you stand on the hill and you see people coming – they're coming from the other side of the mountain – you say *Itivimiut*. Or coming from the other side of the mountain – or they're coming from Pond Inlet."[2] Geographically, Pond Inlet is on the other side of Fury and Hecla Strait – and the other side of Baffin Island – from Igloolik. Conceptually, Pond Inlet is a sister community, the "other side" of a pair with Igloolik. In the trip from one to the other and back again, Cousineau explains in a magazine article, "We recorded other people's travelling experiences and lived our own, which was also one of creation and empowerment" (1994, 38).

At the end of the project, Madeline Ivalu was so satisfied with the results that she proposed a similar journey to Repulse Bay, another sister community equidistant but in the opposite direction, at the base of Melville Peninsula.

Example Four

The women of Arnait were interested in incorporating storytelling – either videos about storytelling or videos *as* storytelling – into their activities. Cousineau had secured another grant for a project that would use videos as portrait tools. The two purposes fitted together nicely. Madeline Ivalu remembered a story about a sea

monster that grabs children, and she agreed to centre the video on herself and the story. Mary Kunuk, the sister of Isuma's Zacharias Kunuk, agreed to draw the monster and the scenes for the story, using a newly acquired computer as her tool set. Susan Avingaq also agreed to be involved and suggested a portrait that centred on her preparing seal skins. So the project became a portrait of two of the women involved in the workshop, and it followed the story of the monster and the story of sealskin preparation as its themes.

The twenty-six-minute tape is called *Piujuq and Angutautuq*. Literally, *piujuq* means "pretty face," and *angutautuq* means "strong young man"; the former is Ivalu's namesake name, and the latter is Avingaq's. To create the videotape, the women worked every weekday afternoon for four weeks or so, drawing scenes, interviewing people, editing the footage, and translating and subtitling the tape. The video shows these two women throughout the preceding decade participating in various community events.

Example Five

The younger women of Arnait, joining after an encouraging radio announcement by Cousineau, tackled two projects. One is called *Mixed Feelings*, and it grapples with the conflicts faced by young Inuit as they struggle to balance the traditional ways of their parents and grandparents with the Southern ways that they see on television, touch in the stores, and hear on the radio.

Mixed Feelings (the title is in English on the video) brings together *ajaja* songs and electric guitars, "old-fashioned" fashions made of caribou furs and newer outfits made of brightly coloured cloth, young mothers with their infants at play, and a teenage artist working in acrylic paints instead of the more "traditional" media of sculpture or printmaking. "I started doing art a long time ago," the young man explains in English, in a gentle voiceover. He continues to paint. "I was just growing up. My parents – my mother – she would tell me to do art and draw something 'cause I think I have the most ideas." The shape he is painting emerges as the muscled arm of a man. The figure continues to develop, becoming a strongman bent in an Atlas pose. He begins to fill in the skin with pigment. "I had a lot to think about when I was growing up. So I did a lot of thinking. And put it down to paper. And from there I kept on doing it. I enjoyed it. And I never bothered leaving it. So that's how it started."

"Do you have any hobbies?" asks a female interviewer, off-camera.

"Yeah. This is my hobby."

"Anything else?"

"Music. Playing guitar. Smoking cigarettes. Listening to music. Make things. Create things. You know. Like songs."

The other early video made by the young members of Arnait Ikajurtigiit is a computer-animation project tackled by Mary Kunuk. Arnait had recently purchased a computer that allowed the videomakers to do their own subtitles and other graphics. Mary Kunuk showed up at the mini-course that Cousineau had created, and the women brought up a southern videomaker to help them learn techniques of artistic video production. Kunuk, inspired by this beginning, joined Arnait with enthusiasm, and she talked with the others about ways that she could put her art skills, honed at Arctic College, to good use. Backed by a Canada Council grant to develop her own animated video, Kunuk and Cousineau created *Aqtuqsi*, a four-minute video about a nightmare that Kunuk had experienced. She had made a print of this nightmare once, and she realized that video's use of time would make it a good medium with which to tell this story more fully.

The video uses both computer animation and footage of real people. It is a highly stylized production that eschews high-tech special effects in favour of eerie simplicity. A young girl stares, as if frozen, at the sky. A jaw's harp plays a disturbing, monotonal beat. The real world of black-and-white gives way abruptly to the dream world of colour.[3] Sound and action do not quite mesh. The girl is flown toward a pond by a pair of disembodied hands clasping her upper arms; she is powerless to resist the attempt to drown her.

When Mary Kunuk made this video of her nightmare, she made some decisions that both linked her project to others that came before it and also made her work distinct. As with the other projects, in different ways she made no attempt to create illusions. The animations are obvious; Kunuk hasn't fussed with extensive shading, accurate perspective, or real-life colouring in an effort to deceive. She does not attempt to make the scenes appear real because they are not real – they came from a nightmare – and Kunuk allows eerie artificiality to reign. In fact, she even goes a step further. She makes the "real," nonanimated scenes artificial and "unreal" through deliberate distortions: stop-action video-

-graphy, the absence of colour, the twitches of a hand-held camera, the mistiming between the video and audio tracks. The beat of the jaw's harp and *ajaja* songs drive the story forward, while the cuts between real images and computer drawings halt it and trip its progress.

The video is unique among Arnait projects in several ways. The subject matter sets it apart; rather than conveying traditional values or demonstrating traditional technologies, Kunuk chose to share a personal, psychological experience, a childhood nightmare in which someone – or something – was trying to drown her in a pond. It carries echoes of traditional belief systems, in which powerful shamans could use their abilities to harm others through the medium of the spirit world, but it does not make this connection obvious. Instead, it is a venture into the expression of a personal experience, a different kind of approach from that taken by most other Inuit artists.

MARIE-HÉLÈN COUSINEAU

Marie-Hélèn Cousineau, who works to some extent with Isuma but focuses her time on the Tariagsuk Video Centre, became interested in videography when she was working toward her master's degree:

Instead of doing a thesis in writing only, I decided to do a video. I created a happening in Montreal, involving artists, and recording the whole thing. And so I did that. And I realized, "Oh, I like to do that." So I wanted to keep doing this. So after that, I kept doing video, and I bought myself a camera. I started to take videotape. I worked with art groups, an art organization in Montreal, like an art gallery. And then the film co-op as the administrator, and doing a catalogue for the film co-op. Doing public relations for them. And that kind of stuff. So I was involved in the non-profit art organization in Montreal. And at the same time I was doing video. And then I met Norman [Cohn], and we did video together. And we went to Israel together, we did video there. I did a video of a group of women there who are involved in the peace movement. And then I realized, "Oh, I like to work with groups of women more." So I did also another project with a friend. We were doing a self-

portrait. And we went to, she was involved, my friend was
involved in theatre. And I was involved in video. So we came up
with a kind of workshop, a one-day workshop, "self-portrait."
And we went to women's shelters, women who have been,
battered women. So we went to different shelters and did a
one-day workshop on self-portrait video. So I was working with
women and then also with arts organizations. And doing my
own video and experimenting with that, and going to video film
festivals, and more into the arts milieu.

Later, she went to Iowa and earned a master of fine arts degree.
But in 1987, while she was working with the film co-op in Montreal,
this group decided to have an Inuit television producer come
south to show his work. Cousineau was in charge of the project –
but she knew nothing about the North. "I had no clue, really." She
called the Inuit Broadcasting Corporation, and she was given the
name of someone in Baker Lake. This person was not interested,
however, and the project fizzled. A year later, she met Cohn, and he
helped her to get in touch with Zacharias Kunuk. At first, when she
called Kunuk, she was told that he was out hunting. "I thought it
was a joke or something. I didn't know anything about the North. It
was like, 'He's gone hunting! My God! Maybe he'll never come
back. Who knows?'" With Cohn's help, however, she finally got in
touch with Kunuk and invited him to Montreal. His presentation
gave Cousineau a clear and exciting sense of what was happening
with video in the North. "It wasn't a dream of my childhood to
come to the North. No, I never thought about that before I met
Zak and Norman. So I came here really because of the video work.
That's what interested me was the video work."

Cousineau moved to Igloolik in 1990 and talked with Cohn,
Kunuk, and others about the role that she could play in the com-
munity. The Isuma team had been discussing the possibility of
forming a community video centre, and the project seemed per-
fect for Cousineau.

Funds were available from the Canada Arts Council for the estab-
lishment of community video-access centres, places that give ordi-
nary people access to video equipment, training, and sometimes
broadcast facilities. Several of these centres exist in Montreal,
Toronto, Regina, Vancouver, Halifax, and other southern cities.
The first one, called Videographé, was established in Montreal.

"They started to, by wanting to teach people to do video," Cousineau says. "It was in the seventies, so there was a big trend in wanting to put this technology in the hands of regular people, just ordinary people, so they could express what they, their concerns, their social concerns were, things like that. And also for artists to experiment with the video medium."

Inspired by the success of these centres, Cousineau approached the Canada Arts Council with a proposal to launch a similar outfit in Igloolik. "They knew what we were talking about because they had the experience of the other centres in mind," Cousineau says. There was also a strong Northern precedent that made the project all the more appealing. Community radio stations have been a powerful communicative force in the Arctic; they are used for everything from personal announcements ("Happy Birthday to Bobby from Paulosee," "I have an outboard motor for sale for three hundred dollars") to community announcements ("There will be a square dance at the Community Hall this evening beginning at seven o'clock"), and they even incorporate community activities themselves ("B Three, B Three – call in if you have a Bingo"). The potency of these stations is easily detected – during the local-information segments, nearly every radio in town is turned on and tuned in. Even the PA system at the Northern Store broadcasts the community station to its shoppers. "So the idea was to eventually to be able to do that with video, with television," Cousineau says.

So, emboldened by the success of other video centres and inspired by the success of community radio in the Arctic, Cousineau applied for an exploration grant from the Canada Council. The council gave $5,000 to get the project started, which was enough for the fledgling centre to buy an editing machine, a monitor, and some other pieces of equipment. Cousineau donated the use of her own video camera and microphone, and Norman Cohn chipped in the use of his monitor.[4] But the "centre" had no space, no place to meet, so it began in Cousineau and Cohn's house.

Cousineau describes the centre's purpose in a magazine article:

In 1991, a local organization, Tariagsuk Video Centre, was incorporated and became the first video access centre in the Arctic directed by a board of Inuit members. The objective was to give Inuit more opportunity to express their culture, lan-

guage and artistic interests through the medium of video/TV and to help counteract the increasing influence of southern television. Tariagsuk also works to discover approaches to video training consistent with, and in support of, Inuit cultural values, and which serve the needs of both individuals and the community. (1994, 34)

Cousineau did all the paperwork to create an official nonprofit organization, and then she tried to figure out how best to shape the centre's activities. She had noticed that many of the activities in Igloolik were segregated by sex: women had sewing circles and other groups, and men had, among other things, Igloolik Isuma Productions, run by Zacharias Kunuk, Norman Cohn, Paul Apak, and other men. So Cousineau visited one of the sewing groups, which met on Saturdays at Susan Avingaq's house. She brought her video camera along and asked for permission to film the group's activities.

"I started to record their activity," Cousineau says. "And then I was wondering, maybe we should do a video group just for women. Maybe I would be more at ease, maybe there is, maybe that would make sense in a way. It would be for women. Or something like that. So I decided to take a portion of the grant, that five-thousand-dollar grant, to do that."

The first task was to test the local interest in her idea, so part of the money went toward the completion of a video survey. Cousineau broadcast an announcement on the community radio station inviting women to attend a video course in which basic camera and interviewing skills would be taught. Two women showed up: Celina Uttugak and Martha Maktar. Together, the three women developed a plan to interview selected women around town, on camera, about the value of having an ongoing women's video workshop in Igloolik. The women were paid to do this work; part of Cousineau's vision was to treat everyone involved as a professional, regardless of her background or training. Maktar learned about the technique of camera work and production, and Uttugak set about organizing the interviews. She chose the women to be interviewed, obtained the permissions, and acted as interpreter. About a dozen women were interviewed on camera, and each agreed that the idea had merit.

"They were all very supportive," Cousineau says. "And they were quite clear about what it could do for women's concerns in this town – teaching, or traditional knowledge, or raising social issues."

Meanwhile, Cousineau made arrangements with the high school to use the video-editing studio there, and the result was a video showing the enthusiasm that women had for the project. Cousineau applied for further grant money and used the video as support for her argument. She contacted the Government of the Northwest Territories Women's Directorate, the Arts Council of the Northwest Territories, and other organizations, and money came in to move the experiment along.

At that time, in the spring of 1991, Cousineau went south for a while and gave birth to her son, Sam. She returned in the fall, and work got under way once again in January of 1992. She went back on the community radio and announced that funding had been secured and that additional equipment had been purchased. (She no longer had to loan her personal camera for the workshop's use.) And Igloolik Isuma had rented two small offices in the Hunters and Trapper's Association building; one served as an office for Kunuk and Cohn, and the other became the editing studio for Isuma and Tariagsuk. The workshop finally had a place to set up its equipment. Cousineau also negotiated the use of space in the Arctic College building for the group to meet.

This time, four women responded to Cousineau's call: Mathilda Hanniliaq, Susan Avingaq, Madeline Ivalu, and Martha Maktar.

"I showed them videos that were made in Mexico and other places by women," Cousineau says, "and I said those women, they want to say something of their reality, and they are using video to express themselves. And it was interesting, 'cause three of those women didn't really speak English. Basically Martha was the interpreter – she was working as an interpreter. So we started like that to meet about two nights a week." Once again, the women, including Cousineau, were paid equal amounts to participate in this activity; "my theory was that people were going to be paid even for learning to use it because ... while they were going to learn to use the video, we were also going to make, produce a video. So they would be paid as producers, even though they were trainees."

The group called itself Arnait Ikajurtigiit, which means "women helping each other." And the participants readily understood the

potential of video; as Cousineau explains, "Even though these women never used video before, the participants were very aware of its possibilities: as a bridge between the generations, a tool for education, to preserve and carry on the culture" (1994, 35).

From there, the Tariagsuk Video Centre and Arnait Ikajurtigiit went on to create dozens of videos about women's health issues, Inuit traditions and legends, and other topics. The centre continues to produce new videos, off and on, as energy and funds allow. *Ningiura*, a drama that incorporates oral histories and traditional knowledge while maintaining a focus on Inuit life today, was Arnait's first to receive funding from Telefilm.

AT OUR PLACE

Meanwhile, more grants and wider interest in the group's work began to produce benefits. In the fall of 1997, "we got Mary, Susan, and Madeline to Montreal and Ottawa to present a video," Cousineau says. While she was in Montreal, Cousineau translated the English subtitles on the group's tapes into French so that Videographé could show them as a compilation of work from the Arctic. She wanted to bring the women down to Montreal for the premiere of the French versions, but the cost was steep; a round-trip airline ticket would have cost about $2,000 – about US$1,400. But with the help of the Inuit Art Foundation, which wanted to bring the women south to a workshop that it was sponsoring, and with further support from the Canada Council, the trip was booked. "So they all came to Montreal, and we did the presentation in Montreal, and we did also a presentation in Ottawa," Cousineau says. "And I think that was great because most of the women there were sculptors, printmakers, drawing – more traditional kinds of art. And those three women, although they had those skills, were there as videomakers. So we did a presentation in Ottawa, where there was about fifty other women from the Arctic, and they were showing their video work. And I thought this was great."

After a few more projects, Cousineau returned to the South to further her own education, and she wondered what would happen to the Tariagsuk Video Centre while she was gone. The answer soon came; the people involved in the centre created a community-oriented program that would air four days a week. Called

Nunatinniit, which means "at our place," the show offers a video version of the community radio service that brings so many benefits to the town. By this time, Isuma and Tariagsuk had built an office building next to the Northern Store and the Catholic church, and on the first floor is a studio from which *Nunatinniit* could be taped and broadcast.

Nunatinniit airs only on channel 24, the Igloolik-only channel owned and operated by Isuma and Tariagsuk. The one-hour program is broadcast at 6:30 in the evening on Tuesdays, Wednesdays, Thursdays, and Fridays. (On Mondays, Tariagsuk runs Bingo Night to raise money for its operations.) In general, the Tuesday and Thursday shows are live; guests are brought in to talk, be interviewed, or moderate a call-in program. (One Thursday, Norman Cohn and I moderated a call-in program about Qallunaat perspectives on Nunavut. The calling was steady, so the show was extended from one hour to two hours and fifteen minutes. As Cohn said on the air, "We're going past our ending time – but we own this channel. We'll stay on as long as people keep calling.")

And even though *Nunatinniit* is not specifically a project of Arnait, falling instead under the Tariagsuk umbrella, women hold most of the key positions. The host of *Nunatinniit* is Neevee Irngaut. She opens each program with a welcome, and then she offers a news update. If necessary, she acts as moderator for discussions, or she might yield the floor completely to the guests or groups coming in. Another active member is Lucy Tulugarjuk, who also plays the evil seductress Puja in the film *Atanarjuat: The Fast Runner.* Tulugarjuk explains that for the taped programs, the *Nunatinniit* crew might record someone doing something interesting and prepare the tape for airing that night. "Sometimes we'd go to their places, like sometimes if a lady is doing something like polar bear skinning, we'd go to their place. Take some shots and interview," she says. They have also taped a carver at work, a volleyball tournament, a hockey tournament, and other events. "We'd shoot just about anything," Tulugarjuk says. "Women's styles. Men's styles. The weather. How elders know what the weather's going to be like. Some stories. If there's Christmas activities, we'd do that. About anything we could think of." The group would plan ahead as much as possible, sometimes settling on topics two weeks in advance.

Nunatinniit and all other Tariagsuk activities were suspended when the work on *Atanarjuat* became serious in 1998. The Isuma

film project inspired the entire building, including the people of the Tariagsuk Video Centre and Arnait Ikajurtigiit, and they all seized the opportunities that the movie project presented. Some auditioned for acting roles. Others signed on to make costumes. There were prop managers, office managers, makeup and hair crews – the list of positions available was substantial, and all the creative energy in the various groups was funnelled into making *Atanarjuat.* "So there was no room to do something else," Cousineau says. "It's like the whole – everybody who had any video skill was involved in this activity. The main activity was really involved in the film."

So for a time, in the early part of 1998, everything else was put on hold as people rallied around the making of a feature-length film. When filming was suspended in late spring, *Nunatinniit*'s usual summer hiatus was close enough, and everything was shut down until the fall. With the coming of October, *Nunatinniit* was fired up once again, and the job of unifying the community through television was taken on anew – although *Nunatinniit* and other Tariagsuk projects once again fell under *Atanarjuat*'s spell when taping began again in the spring of 1999.

At the time of this writing, Arnait Video Productions was beginning work on its first full-length feature. Entitled *Before Tomorrow,* it will tell the story of a woman and her grandson holding onto their dignity through difficult challenges. The script, based on the novel *For Morgendagen* by the Danish writer Jørn Riel, was written by Susan Avingaq, Marie-Hélenè Cousineau, and Madeline Ivalu, all long-time members of Arnait. Ivalu and her grandson Paul-Dylan Ivalu will play the leads, and Mary Qulitalik, Peter-Henry Arnatsiaq, and Tomassie Sivuarapik will play other major roles.

HELPFUL SHADOWS

Rasmussen offers another story about the Tariagsuk. It is a story, appropriately, about an old woman and her granddaughter:

> Some time after [a preceding incident in which the old woman and the girl were visited by a mountain dwarf and his wife], other visitors came to the village. They heard the noise of dogs and the talking of human beings, but could see nothing but

some shadows moving over the snow. They had received a visit
from the tArqajA qjuit.

Then they heard a voice, which came from the wife of the vis-
iting tArqajAq juaq:

"We have come to the house of poor folk who appear to have
nothing to eat. We will give them some meat."

And then the shadow folk built them a new house, and the
old woman and her granddaughter moved in, and they brought
meat into the new house, and said:

"Take this, though it is not very much. All the meat on our
sledge is frozen."

The Shadow Folk were clever hunters, and the man caught
seal, caribou and salmon, and the old woman and her grand-
child lived in abundance.

One day there came other visitors again. This time it was a
party of real human beings, and the Shadow Man wanted them
to go out hunting with him. They went out together, and it
often happened that the Shadow Man vanished from the sight
of his companion, and they had to search for him. The man was
ill at ease about having such a comrade while out hunting, and
when he saw a shadow close beside him, he stabbed that
shadow with a knife. He killed him, and the moment he was
dead he became visible. He was a young and handsome man.

The Shadow Folk mourned deeply at his death, and went
away, though the old woman and her granddaughter did all
they could to make them stay, for they had grown very fond of
them. (Told by Inugpasuguk, in Rasmussen 1929, 213–14)

In tradition, then, the Tariagsuk were helpful people who brought
benefits to those who worked with them. The resonance of this
image fits well with the modern-day Tariagsuk Video Centre. The
centre brings in grant money, provides occasional part-time
employment, and gives the participants a sense of worth and
engagement.

Cicilia Maria Krohling Peruzzo acknowledges the power of com-
munity media but notes, quite rightly, that "practically speaking,
community communication is not able to surmount mass media,
despite its importance and political significance. On the contrary,
it is complementary to them" (1996, 166). The Tariagsuk Video

Centre operates in complement on two planes. On one, it comple-
ments Isuma's works, offering a more populist perspective and
sharing more community-based views and information. On another
plane, it complements the offerings of mainstream Canadian media,
adding a heartfelt Inuit voice to the national dialogue about Cana-
dian cultures.

Madeline Ivalu, one of the stalwarts of the group, emphasizes the
importance of making a record of the challenges and uniqueness
of the traditional Inuit life. "Because nothing is written based on
our culture," she explains through an interpreter, "this storytelling
on video at least it will show it. It doesn't really matter if nobody
really learns from it, as long as they know one of the stories. But I
would like young Inuit to learn about things like the dirty clothes –
the old, used, worn clothes. Before washers. I hope people will
learn from it how things really were back then, when civilization
was civilization."

Light through the Ice

The young man lay prone across the hard-packed snow of the parking lot. He was outside the Parnaivik Building, a modern-looking office building in the heart of Iqaluit. It was the morning of 1 April 1999, the day Nunavut became an official Canadian territory. Iqaluit was the new capital. The man touched the snow with only the tips of his shoes and the knuckles of his hands, the rest of his body tightly horizontal above the ground. Then he pushed with his feet and inched his knuckles forward. He made the same move again, and again, creeping slowly across the parking lot. When he covered fifteen feet or so, he stood up, and the announcer congratulated him. He had just demonstrated an Inuit game, called the Knuckle Walk, which no one else had volunteered to try. He received a Nunavut football jersey and a set of bloody knuckles, crimson and glistening, for his trouble.

The event was part of the celebration surrounding the birth of Nunavut. Festivities began on Tuesday, 30 March, with throat singing at the Unikkaarvik Visitor Centre, and on Wednesday the centre held demonstrations of traditional sewing skills. Wednesday was also the start of the People's Party, activities that could be counted on to be open to the public. There were Inuit games in which participants tried to kick a tiny toy seal suspended improbably high in the air, pull an opponent off the ground, pull a rope off an opponent's head, pull an opponent's lip – all while enduring the same punishment – and engage in other contests of strength, balance,

skill, and stamina. The Tatigiit Dancers demonstrated traditional Inuit dances, and a community feast offered visitors a taste of char, seal, and *muktuk* (whale fat and skin).

At six o'clock the events turned official, with the swearing in of the commissioner of Nunavut and the formal establishment of the Nunavut division of the Royal Canadian Mounted Police. A fashion show was held at the Nunatta Sunakkutaangit Museum, and then the activities quieted down until the interdenominational church service at eleven o'clock that night. The service was held in the gymnasium of the Nakasuk Elementary School and was accessible by ticket only; many were turned away, but I blundered in through the wrong door and quietly took a seat. In addition to the choir, the stage was crowded with reverends, right reverends, very reverends, most reverends, and pastors, representing Anglican, Roman Catholic, and Pentecostal organizations. After a brief welcome, the two hundred or so who made it through the doors rose to sing the first hymn: the Canadian national anthem. The anthem begins "O Canada! our home and native land!" But, of course, for this service the song was sung in Inuktitut: "O Canada! Nangminiq nunavut." It was sung without irony, but the presence of *nunavut* in the opening line seemed fortuitous. The service continued with calls to prayer and acts of worship, and it was punctuated by two other hymns, also in Inuktitut. The service ended at 11:40, giving the worshippers a chance to hike, drive, or ride over to the Sealift Beach for the midnight fireworks that would usher in the Nunavut era.

The weather had turned malicious. Earlier in the week, temperatures had nudged above freezing, causing the igloos created for the celebration to sag and collapse; eventually, they were brusquely bulldozed to make way for tents instead. But Wednesday morning – Nunavut eve – dawned at forty below zero, with a biting wind that cut through clothing and burned skin. The brave revellers who stamped and flapped at the Sealift Beach enjoyed a half-hour fireworks display, close and low in the sky, with the children cheering every colourful blast. The instant the fireworks ended, everyone in the small crowd scampered off to warm vehicles and snug houses.

Nunavut had been born, but the ceremonies and celebrations were far from over. On 1 April, Nunavut Day itself, the People's Party kept the action alive with more games – including the Knuckle Walk – along with tables giving away Nunavut baseball caps, pins, and balloons. Four shirts signed by the members of the

inaugural Legislative Assembly were raffled off, carvers demon-
strated their techniques and sold their wares, and visitors to the
lobby of the Parnaivik Building videoconferenced with counter-
parts in Yellowknife, the capital of the now-reduced Northwest Ter-
ritories. Then, at 11:30 in the morning, an honour guard began
the formal proceedings in a hangar at the airport. The Canadian
prime minister, Jean Chrétien, spoke about partnership and prog-
ress, the new Nunavut premier spoke about challenges and oppor-
tunities, and drum dancing and throat singing gave texture to the
event. After another community feast, the focus shifted to the
Inuksuk High School gymnasium, where the first Nunavut Legisla-
tive Assembly convened.

The gym had been converted into a reasonable facsimile of a
government hall, with black drapes covering the walls and a grey
carpet covering the floor. On the drapes were flags of each of the
Nunavut communities, and suspended from the ceiling were flags
of each of the Canadian provinces and territories – including the
new Nunavut flag, its red inuksuk and yellow-and-white back-
ground, emblazoned with the North Star, offering a strong contrast
to the fussy and British-looking flags that shared its lofty space. The
event began with the dragging in of a *kamotiq* (sledge), covered
with caribou skins and knives, hauled by two people in traditional
caribou dress. The *kamotiq* remained in the centre of the floor
throughout the proceedings.

In came the dignitaries, walking casually to their seats. Most of
the northerners wore traditional-styled clothing made of modern
materials; Prime Minister Chrétien wore a black suit, and the
minister of Indian affairs and northern development, Jane Stew-
art, wore a bright red suit. Prayers were offered, and three *qulliqs*
(stone lamps) were lit. Throat singers sang and drum dancers
danced, and then the business came to the foreground. Rules
were put forth and adopted, including the proposal that the
Assembly function on a consensus basis, rather than the confron-
tational basis that colours most of Canadian politics. The Speaker
of the Assembly was elected, in a formal procedure that had been
worked out in advance, and he read a speech about the impor-
tance of fairness and the responsibility that has been placed in the
hands of the Nunavut Assembly. Then the mace was presented
and placed atop two soapstone carvings, one of a man and one of
a woman, who held it aloft. The mace was designed and built by

several Nunavut artists, including my friend Simata Pitsiulak of Kimmirut. (He has since died; his homebuilt airplane crashed into the tundra.) Stewart offered some comments, and then the premier was elected through another smooth and prearranged process. Premier Paul Okalik spoke gently and thoughtfully about the hardships that lie ahead, and then Prime Minister Chrétien added some thoughts and humorous comments of his own. Then the Assembly took care of some formal business before adjourning until six o'clock that night, when it would tackle additional business without the pomp of these ceremonies.

And so Nunavut became real. Festivities continued for days, with snowmobile races and Inuktitut baseball and performances of *Godspell*; the years of work and suspense and dreams had borne fruit. The American explorer Charles Francis Hall predicted more than a century ago that the Inuit were rapidly becoming extinct (1864, 521). No doubt Mark Twain – whose own erroneously announced death prompted him to comment, "the report of my death is an exaggeration" – would have had something to say about this prediction of the Inuit's demise.

Politically, this achievement is not small. Eighty-five per cent of the people of Nunavut are Inuit; the name of the new territory means "our land" in Inuktitut, the Inuit language. While the leaders of the effort that resulted in the split of the Northwest Territories insist that Nunavut will be a place for all people, the demographics suggest that the Inuit will effectively run the new territory on their own. As a territory, Nunavut is beholden to Ottawa in certain direct ways, but these links were true before the split, when the Inuit occupied the Northwest Territories. In fact, at that time the Inuit were governed by two levels of bureaucracy: the government of the Northwest Territories, far to the west in Yellowknife, and the government of Canada, far to the south in Ottawa. With the split, the Inuit living in Nunavut are free to make many decisions on their own, and the necessary ties to the federal government are now more straightforward.

The shift is significant geographically as well. Nunavut represents one-fifth of Canada's land, a region larger than Alaska and California combined. In fact, Great Britain, France, Germany, and Italy could fit within its borders at once. The region has the potential for great underground wealth – including oil, nickel, gold,

silver, diamonds, and other riches – but the extraction of these resources remains a subject of heated debate.

Iqaluit is a community of 3,500 people and growing. Located on the eastern edge of Nunavut, on the shores of Baffin Island's Frobisher Bay, this community once housed an American Air Force station and so has a substantial runway capable of handling heavy jet traffic. This resource, among others, made Iqaluit an obvious choice for the capital, although several other communities vied for the honour. The territorial government of Nunavut is somewhat decentralized, with departments scattered in various communities throughout the region. Igloolik, for example, is the home of the Department of Culture, Language, Elders, and Youth. The decision to structure the government in this way was made for several reasons. First, no one community could handle the overwhelming influx of people, offices, and infrastructure that a centralized government would bring. And second, the planners decided that the benefits of government bureaus should be shared among many communities, infusing their economies with cash and their towns with material benefits. Igloolik expected to welcome about seventy new territorial employees and their families, a total of about 200 people.

The reality of Nunavut has sparked a building boom in all communities that were chosen to receive government branches. Construction was furious throughout the winter of 1998–99, with communities adding office buildings and housing units to accommodate the anticipated influx.

The Nunavut government has a stated goal of hiring at least half of its workers from the Inuit population. This goal proved impossible in the early stages, so most of the employees are non-Inuit. But the hope prevails that as Inuit youth gain the necessary education and training, increasing numbers of Inuit will qualify for government positions.

A Southam Newspapers article published on 21 June 1997 in the *Montreal Gazette*, however, revealed some attitudes among Canadians that could lead to further difficulties for the Inuit. The survey was conducted by Insight Canada between 31 January and 2 February 1997, and it included responses from 1,201 adult Canadians.[1] According to the results, 51 per cent of the respondents "do not believe First Nations are ready to govern themselves."[2] Thirty-eight

per cent took the opposite stance, believing that the First Nations were ready for self-government. In addition, a "majority" believe that "government enters into land claims because of legal obligations," but 30 per cent "continue to believe the primary motivation for such negotiations is guilt over Canada's past" (Aubry 1997).

These responses suggest that attitudes among Canadians toward Nunavut might not be very supportive. And this conclusion is reflected in *Globe and Mail* editorials that cite negative statistics regarding the Nunavut region and call into question the wisdom of creating the new territory and supplying it with the $1.1 billion kickoff fund stipulated in the agreement.

The Southam article also cited a 1996 poll conducted for the Ministry of Indian Affairs and Northern Development that "showed that almost half of Canadians believe aboriginals have an equal or better standard of living than the average citizen." Forty per cent of the respondents to this survey indicated that "aboriginals have only themselves to blame for their problems" (Aubry 1997).

In the article, the minister of Indian affairs, Jane Stewart, said that the poll "may indicate the need to inform Canadians of the true situation ... It shows that we have some work to do in getting the message out about the success stories that are out there" (Aubry 1997). Her position is backed by information from Igloolik Isuma, which insists in a handout that "aboriginals have Canada's HIGHEST rates of unemployment, infant mortality, overcrowded housing and teenage suicide" (original emphasis).

So as the Inuit forge their future with their new territory, they will have to do so without overly vigorous support from the rest of the Canadian people. Once again, they will have to make good use of the tools available to them to keep their society strong, healthy, and distinctively Inuit.

One of the tools at their disposal is video. Through the efforts of Igloolik Isuma and the Tariagsuk Video Centre – as well as the Inuit Broadcasting Corporation (IBC) and others – Inuit throughout the North will have available to them a steady stream of reminders of their heritage and their unique response, historically and currently, to the special challenges of life in the far North of Canada. The videos created by these groups represent a broad range of approaches. Some are historical re-enactments that convert descriptions offered by elders into action that can be viewed by

future generations, preserving slices of traditional knowledge that otherwise might be forgotten – and with this forgetting, the intelligence, resourcefulness, and determination of Inuit ancestors might evaporate as well. Other videos offer glimpses of life in today's Arctic, with all the trappings and distractions available to the rest of the world, fitted into an overall way of life that remains uniquely Inuit. Some videos take pointed political tacks, arguing, for example, against the insanity of a law prohibiting the Inuit (and everyone else) from hunting bowhead whales in the wake of European and American decimation of the whale's populations. Others take a more domestic approach, reminding viewers of the role and significance of the *qulliq*, for instance.

These videos, while disparate in their styles, goals, and levels of creativity, nevertheless achieve one common end: they tell about the Inuit from the point of view of Inuit producers. They stand as a counter to Southern portrayals of the Inuit, portrayals most commonly remembered in such projects as Robert Flaherty's *Nanook of the North* and Asen Balikci's Netsilik series. These Southern depictions have flaws, but the errors in both detail and assumption are not the primary reason for the response by Inuit producers. Rather, Isuma and Tariagsuk make videos precisely because they reserve the right to tell their own stories. Even if the Southern videos and films were perfectly accurate, the ownership would remain an issue. *Nanook* and its cousins offer viewers a Southern take on Northern life, and however closely they mesh with their Northern counterparts, the important distinction remains. The stories are not the entire issue; who tells the stories also makes a difference.

But the cultural and political struggle between North and South does not assume a unification among the Inuit. Igloolik Isuma is pursuing its own agenda, and this agenda, as perceived by the people who work there, includes the exposure of the Inuit Broadcasting Corporation as a Native mask, behind which operates a Southern, colonial enterprise. It is just as bad – and in many ways worse – to offer television programming that looks and feels Inuit when in fact the approach, training, and profiteering are all oriented to the South, Isuma argues. The IBC, for its part, presses ahead undaunted by Isuma's accusations; the producers at IBC are aware of the Isuma allegations, but they do their best – under trying circumstances – to deliver on their mandate to preserve and enhance Inuit language and culture. The system isn't perfect, they

say, but it is better than abandoning the airwaves to the voracious programming beaming up from southern Canada and the United States. The IBC, at least, represents an attempt to offer the people of the North programming that reflects their own culture, geography, and social views.

CHANGES

It is interesting to note that every Inuit-produced video that I have found – and there have been many – focuses on some aspect of Inuit life. Flaherty and others ventured to the Arctic from elsewhere to create films and videos about this "alien" land, and the Inuit seem content to aim their cameras in the same direction. There was a time when the IBC sent correspondents afield, but budget constraints have forced them to turn once again inward, recording and broadcasting videos about their own way of life. The video groups disagree on some powerful and fundamental points, but they ultimately all show Inuit and the rest of the world how the people of the Arctic live and lived. For the IBC, it is a cause. For Isuma, it is a passion. For Tariagsuk, it is a natural reflex to capture and share with others the world that they recognize as unique.

The Arctic is changing in many ways, even beyond the obvious inauguration of Nunavut, and it is fortunate that videographers are on hand to record the changes. The Inuit world of fifty years ago bears little resemblance to its counterpart of today.

One major shift taking place is the transition from a largely communal, corporate society to a more individualistic one. In traditional Inuit life, for example, behaviour was governed by spiritual taboos and by the authority of the elders. Nothing was written, but much was understood. If a person behaved in an intolerable manner, the elders – taking into account the opinions of the entire community – would determine what should be done. The emphasis was on trying to figure out underlying causes: why did this person commit this offence? Once a cause was detected, steps would be taken to correct it. The system was variable and vulnerable to personal and political power, but it worked for centuries. And whatever havoc a particular person wreaked, it was always done with the knowledge that people were sometimes murdered for causing too much trouble.

Today, each community has a set of bylaws that regulate the behaviour of its people. In Igloolik, for example, there are precise regulations regarding how dogs must be handled. No more than two dogs may live in any house; additional dogs must be kept in pens or on tethers outside the town. Dogs must be restrained at all times. And anyone who mistreats a dog is subject to penalties. Another set of bylaws regulates where outpost-camp shacks may be built, and by whom, and how they must look. This bylaw is not often enforced, but there is talk of taking it more seriously. This talk has prompted a rash of shack building as people attempt to get their cabins built before doing so becomes difficult. And yet another bylaw prompts the fire siren to wail at ten o'clock every school night. Children found outside after this time are supposed to be taken home by the bylaw officer, and repeated offences result in fines to the family.

So communal regulations of behaviour have been replaced by bureaucratic ones. And former social expectations have been replaced by hesitancy. Zacharias Kunuk laments that not long ago, if you saw a whale in the bay, you would hop into the nearest boat and take off in pursuit. Today, you have to make arrangements in advance: "If whales are seen, would it be all right if I go in your boat?" The communal spirit has been supplanted by an individual-istic one.

The irony is that communal understandings prevailed when people often were separated by great distances. The Inuit were nomadic, following game in small groups, spending much of their time outdoors and in corporate space. With the compression of the Inuit into permanent settlements came wooden houses with living rooms and television sets. These houses are much more comfort-able than anything the ancestors used, but the walls are more solid in many ways. Fewer activities are done communally. The hunt is communal, but shopping at the Northern Store is an individual activity. Working on *Nipi*, the video about the new Inuit leaders, Kunuk expressed his dismay over the situation. Many of the new ways seem artificial and unnecessary, he said. They just aren't needed by the people.

Change is inevitable, as demonstrated by the Igloolik IBC's shiny new snowmobile with heated handlebars and room for two, and it is to be feared and lamented in the Arctic to no greater extent than

elsewhere. Few Inuit want to go back to the days of skin tents and igloos, to the days before hot showers and cable television. One important milestone occurred recently and should be noted. For several years, the number of families wintering over at the outpost camps had been dwindling, and during the winter of 1997–98 only two families spent the dark months out on the land. But in the winter of 1998–99 the last of the families moved into town, leaving the land empty of human life except for the hunting and fishing parties that ventured out for a few days at a time. It is perhaps the first winter in four thousand years that no one called an outpost camp around Igloolik home.

THE POSITION OF VIDEO

The *qarmaq* (semi-permanent shelter) is low to the ground, more like a small, snow-covered hill than a place of residence and a centre of family life. Outside, little can be seen: two small igloos, one in mid-construction, a couple of *kamotiqs* (sledges) cluttered with boxes and caribou hides, a stray dog with pale blue eyes and a hungry attitude. A small igloo serves as the entrance to the *qarmaq*, keeping the cold outside and providing space for storage. There is little sound beyond the sweep of wind and the crunch of footsteps in the snow.

Crawl on the belly through the low opening to the entrance igloo, then crouch-walk through a Tyvek-curtained doorway into the *qarmaq*. The world inside contrasts sharply with the white and empty land outdoors. The *qarmaq* is large; eighteen people are seated on boxes or at the edge of the sleeping platform, and there is plenty of room to move. The platform, about twelve inches off the floor, could sleep a dozen people comfortably, an aisle down the middle separating the bed into two pie-wedges. The ceiling at its mid-point rises six feet above the floor, sloping down rapidly toward the low rock walls. The floor is of flat stones, and the roof is plywood, but all that can be seen of the ceiling is a thick layer of caribou hides that trap heat. Two Coleman stoves whoosh and flicker, converting ice to teawater in dented metal kettles. Two *qulliqs*, one on each side, cast gentle yellow light into the dark air. A plastic-covered window over the door would let in the blue glare of daylight, but a polar bear skin covers it, keeping the atmosphere inside warm and shadowy and close.

The people are mostly young – twenties and thirties – and two elder men sit in places of respect. This is part of the cast of *Atanarjuat: The Fast Runner*. Rehearsals will begin in earnest in just a few weeks, but now is the time to get the *qarmaq* ready for filming and the voices ready for song. An *ajaja* song in the script carries important meaning, and the actors sing it through, squeaking and rasping in neglected disharmony. Most of the actors look at their scripts, unsure of the words; since the suspension of filming a year earlier, little has been done to keep the material fresh.

They sip coffee, tea, Pepsi. They snack on Humpty Dumpty cheese-flavoured Doodles and chips of frozen flesh hacked off a large char that lies to one side. And they sing the *ajaja* again, stronger this time, the melody spreading by consensus through the cast. It is beginning to sound better, and the singers are gaining confidence. Zacharias Kunuk points out a part that often goes awry, and he sings it through for them properly. He walks the singers through another section as well, and then the group takes it from the beginning. The voices are blending now, the harmonies bouncing off the melody with resonance. They sing it again, and again.

One of the elders is Abraham Ullajuruluk, quick with a smile, sporting purple-framed eyeglasses and a baseball cap littered with lacquered pins. He knows the song well and leads the others along. Later, he explains that he wants the younger generation to learn how the Inuit used to live. He was born in Arctic Bay in 1936, and he had aged many years before he learned of the existence of the Qallunaat. As a child, he knew nothing about how people lived in the South; he knew nothing about their homes. His house was an igloo lined with sealskins warmed by a *qulliq*; he had not seen a Coleman stove. He is here, teaching the song and taking a part in the cast, because he feels it is important that young people learn about that life and remember it. He recognizes that today bears little resemblance to yesterday, and he feels that videos can help to bridge the gap between them. He shakes his head. "I never imagined I'd be wearing clothes made of Qallunaat materials," he says through a translator, gesturing to his jacket, pants, and boots. "I never imagined it."

The other elder is Paulossie Qulitalik, who spent most of the late afternoon building one of the igloos outside. He is strong and wiry, and his gaze commands respect. He is wet from his work; he takes a moment with his coffee before speaking. *Atanajuat* is a legend, he

points out, but it really happened. The world Isuma is portraying in this and its other videos is not some hypothetical dreamland; he needs only remember his own childhood to recall the life they are recreating.

When he watches movies from the South, he sees a lot of aspects of Qallunaat culture that he does not believe. His role in *Atanarjuat* – and at Isuma – is to make sure that the material being produced is accurate. He wants people to see these videos and know that they are true, that they show the world as it really was not very long ago.

As the elders speak for the benefit of my tape recorder, the others in the *qarmaq* fall silent, listening respectfully, learning from these two old men who have earned positions of honour. No one makes a sound. When the elders are finished speaking, the younger Inuit regard their words for a moment, and then the rehearsal resumes. A short while later, people crawl out of the *qarmaq*, blink in the sudden glare of the sun on snow, and hop on their snowmobiles for the fast zip back to town. Tomorrow, they will gather again to further shape the movie that they are making together.

THE CENTRAL QUESTION

This book focuses on one example that provides a small piece of the answer to an overarching question: what happens when Native people who traditionally have been the subjects of anthropological scrutiny take over the scrutiny themselves?

The direct answer to this question cuts to the heart of a common, if unreflective, assumption, which holds that giving the people in question greater ability and authority to tell their own stories will result in an expression of culture that is more pure, more honest, and more accurate than anything that can be created from outside the culture. In fact, the push toward increasingly "insider" presentations does not lead to increasingly unfiltered presentations. Rather, the result is something like Hitchcock's vertigo effect, with the focus moving in while the frame zooms out. At first, such depictions as *Nanook of the North* are dismissed because they fail to escape the gravitational pull of the "colonial gaze," as John Palattella put it (1998, 50). Flaherty, as mentioned previously, showed Nanook hunting with a harpoon, even though the Inuit had been using rifles for years (ibid.). He also showed Nanook's entire family climbing out of a single kayak – a feat not only unheard of among

the Inuit but also in direct violation of the laws of buoyancy – and he had Nanook actually try to bite a phonograph record while grinning eagerly and expressing wonder at the technological achievements of the southerners. These blunders, coupled with similar distortions projected by other Arctic researchers and adventurers, seem to suggest that outsiders cannot be trusted to offer an unadulterated account of Inuit life; by extension, they cannot be trusted to offer a true account of any life outside their own immediate spheres. But two facts stymie this argument. The first is that however flawed it might seem from a late-twentieth-century viewpoint, *Nanook of the North* was an outstanding accomplishment that required determination, vision, and a sincere desire to tell the world, with affection, about the people of the North American Arctic. It cannot be dismissed simply as an example of colonial marauding. Taken in its proper context, it represents an honest attempt to present the North to the South, a goal not too far removed from that of this very book.

The other complication is revealed through a look at the result as it has worked out in Igloolik. The Inuit are becoming masters of videography, but this mastery has not brought about unfiltered expressions of Inuit culture. The filters are still there; only the perspective has changed. Rather than presenting Inuit life as filtered through the mind of a Southern filmmaker, the videos coming out of Igloolik present Inuit life as filtered through the quite distinct political circumstances and aspiration of the IBC, Igloolik Isuma, and the Tariagsuk Video Centre. The IBC, based in Ottawa and funded by the Canadian government, strives to preserve and strengthen Inuit language and culture. The producers at Igloolik Isuma – reacting to the Southern control of the IBC, which they see as an insidious form of colonialism – seek to offer the world a "more Inuit" view of Arctic life, in both product and process. The producers at the Tariagsuk Video Centre work to present their views, priorities, and insights on Inuit life and culture, primarily for an Inuit audience.

So passing the camera to the Inuit did not result in a single, culturally pure form of self-expression. The three groups in Igloolik, as is undoubtedly the case elsewhere in the Arctic and with other media, speak with multiple voices and are not content to let the others speak for them. So the Inuit-Qallunaat divide represented by *Nanook* and the Netsilik series dissolves into an IBC-Isuma-

Tariagsuk divide represented by the distinct groups in Igloolik. And the breakdown continues from there: even within these groups, each producer has his or her own way of creating videos and expressing Inuit culture. Some are content to work alongside each other, but none of them has sacrificed his or her own sense of the "right" approach to that of anyone else. The collapse from a world-scale division to a personal one takes just three steps in Igloolik, but if the Arctic held more videographers – and if this study embraced a greater geographic area – finer shades of division would certainly surface: Arctic Alaska vs Arctic Canada, western Canadian Arctic vs eastern Canadian Arctic, Northwest Territories vs Nunavut, Nunavut vs Nunavik, Igloolik vs Cape Dorset, the IBC vs Isuma, producer vs producer. The framework offered in Igloolik suggests a larger conceptual framework that could be filled with additional data.

The end, of course, is a miasma of individuals, each pursuing the creation of art within the bounds of social and cultural parameters. Each producer responds to his or her own set of agendas, interpretations, alliances, and worldviews. And in so doing, these videographers usher in two additional sets of questions. The first centres on folklore: How do these producers handle cultural symbols? How do they shape their videos into narratives, into material objects, and into ways of living? How do the video groups themselves conduct both art and business in ways that reflect the cultures at their cores? How do the videos interact with the folklore that they record? ·

As discussed in this book, the cultural symbols that infuse Inuit life are used in powerful ways through video. Each frame can encompass a wealth of symbols: the tin teakettle showing adaptation, the *qaggiq* showing community, the positioning of people in a group showing respect and honour, the pipe showing bonds of indebtedness and gratitude, the *amauti* showing tradition and caring for the young. Videographers in Igloolik use these symbols purposefully, and the symbols resonate among their Inuit audiences. The meaning extends beyond direct links, through juxtaposition, to deeper realms of understanding. The family hunting baby seals makes differential use of available technology; the best weapons are used by the best hunters, and the group works together, playfully, to acquire the finest food that can be extracted from the ocean in that season. The hunters tease and banter,

freeze and exert. The messages are interconnected and strong: These people care about each other. They share in both the struggle and the reward. This is no commune; the social hierarchy is clear and respected with an easy grace. The hunting journey is part food- gathering, part family outing, part adventure, part educational opportunity. The elders' knowledge of the land and the sea increases the odds of success, and the physical effort of the younger hunters further enhances the likelihood of triumphant feasting.

Folklorists study expressions of culture, and ballads formed the original core of the field. Narratives soon became central as well, and in more recent years material culture and folklife have taken their place as subjects worthy of the folklorist's attention. These facets of folklore add to the study of Inuit video by allowing the videos – and the processes by which they are made – to be seen as part of the larger realm of folklore.

As narrative, video holds memories of the past, embracing the events of recent years and of distant time. The Inuit Broadcasting Corporation prefers the former, showing its audiences the modern Arctic. Isuma takes the latter approach in most of its videos, giving viewers a sense of what life was like for the Inuit ancestors of generations past. In both cases, the Inuktitut language is recorded and preserved, giving Inuit children greater access to the language spoken by their elders. And in the work of all three video groups in Igloolik, elements of Inuit culture such as clothing, tool making and use, kinship systems, terms of respect, hunting and butchering practices, and sewing techniques are available to anyone, Inuit or Qallunaat, who wants to learn more about the people of the Arctic.

Video is more than visual narrative, however. It also exists in the physical realm, and its construction requires the manipulation of physical objects. Costumes are made. Makeup is applied. Props are secured. Sets are built. Once all these material elements are brought together, an activity ensues that is recorded – sometimes repeatedly – onto videotape, which is then manipulated further in the studio to produce a final program. Videos are built, just as houses and guitars and ceramic jugs are built. In this regard, video can be seen as representative of material culture, so it can be read in the same way that one might read a sculpture. When Isuma created *Qulangisi*, for example, the producers needed a dogsled, so they looked around town and chose the one that best suited their

needs. They also needed caribou clothing and sealskin boots for the entire family, as well as harpoons, sealhide ropes, antler sunglasses, whips, and the dogteam itself. These props formed the raw materials with which the producers created their art. They also worked with actors, translating abstract ideas into specific instructions so that the image seen through the viewfinder matched the producers' vision. Through this process, a piece of physical art was created; it was art that requires the assistance of machinery to be appreciated, but it is physical art nevertheless.

And Inuit video functions, in Igloolik at least, as a form of folklife. When the taping of *Atanarjuat* began once again in the early spring of 1999, many Iglulingmuit were involved. Some people sewed costumes. Others queried elders about the old-time hairstyles. Others learned about tattoo patterns for hands and faces. Still others built igloos and *qaggiqs* to set the scenes. As had happened previously with major video productions in town, the routine of life in Igloolik changed focus and pace. Familiar people filled familiar jobs. It was a changed way of life for dozens of people in Igloolik, and the new patterns mirrored previous ones from the creation of earlier videos.

Igloolik's video groups do more than create works of art that reflect Inuit culture through content. They also embrace an Inuit approach to work – to different degrees – that reflects Inuit culture through creation. The Inuit Broadcasting Corporation has adopted a Southern model, establishing systems of deadlines and production expectations that colour the entire process of videography. Igloolik Isuma strives for a more Northern approach, subordinating deadlines and schedules to a variable and opportunistic system that takes advantage of favourable conditions and refuses to struggle against unfavourable turns. And the Tariagsuk Video Centre follows a Northern approach with an amateur bent, doing projects only when circumstances, energy, interest, and funding coincide.

The Inuit use video, a new technology, to record and preserve older ones. In *Qulliq*, for example, videography commits to a semidurable medium the knowledge that otherwise exists in the minds of Inuit elders; with knowledge of how to start and tend to a stone lamp "captured" on tape, this information will be preserved even after the people who know it have died. But the process of making *Qulliq* takes the preservation of knowledge beyond the merely cap-

tured. When the women who made the movie began to shift from idea to production, they increased their own understanding of how the *qulliq* works and of the role that it played in Inuit life. Similarly, when videos call for sealskin tents or walrus-hide kayaks, the people who make them learn anew both the technology and the symbolism of the objects they create. In this way, videos not only bind knowledge to a strip of videotape – they also provide opportunities for the people involved to reacquaint themselves with important aspects of their heritage.

Videos, like museums, freeze culture into tableaus that can be examined and compared. And like museums, if successful, videos freeze attitudes and approaches, visions and viewpoints, into fixed messages that go beyond mere preservation to persistent prescription. Videos capture specific variants of legends, of clothing styles, of hunting techniques, and they show future viewers "the way it was done." By virtue of their relative permanence, especially compared to the ever-changing body of oral literature, videos offer variants that do not change from viewer to viewer, from year to year, from place to place. The viewers' interpretations and reactions certainly do change, but the video itself remains immutable. In this way, videos become archived reality, offering viewers a resource against which to test the accuracy of subsequent variants. Whether intentioned or not, this effect of videos is undoubtedly strong among their viewers, and it is an effect that is worthy of additional research.[3]

THE WORLD SCREEN

Isuma and the other Inuit video groups are, of course, part of a larger worldwide indigenous-media movement, and they are leading the way in many facets of Native videography. Other Inuit producers – including Bobby Kenuajuak, creator of *My Village in Nunavik*, and Elisapie Isaac, producer of *If the Weather Permits* – are also taking part in the surge of interest in Inuit video. Isuma even formed its own distribution company, Isuma Distribution International, to give remote audiences access to important films.

And during my fieldwork in the Arctic, Zacharias Kunuk and Norman Cohn urged me to spend time in the Australian Outback as well, so afterward I took a summer to visit videographers and others at the Central Australian Aboriginal Media Association

(CAAMA) in Alice Springs and the Warlpiri Media Association in Yuendumu. The situation there is eerily similar to the situation in the Arctic. Responding to encroachment by English programming beamed to the Outback by the Australian Broadcasting Corporation, several groups – including CAAMA, the Warlpiri Media Association, and others – formed enterprises designed to offer Aboriginal-language programming that presented Aboriginal perspectives to viewers in the Outback and in the cities of Australia.

CAAMA has several divisions: video, radio, music production, and the retail sale of Aboriginal merchandise. Like its counterparts in the Arctic, it relies on government grants to survive and produce, although it struggles continuously with mechanisms of financial independence. It produces videos for Aboriginal consumption and for National Geographic and others worldwide, and it produces music CDs featuring Native sounds and country-and-western twang. And it takes very seriously its charge to support Aboriginal cultures and languages.

In Yuendumu, a tiny community farther off in the bush, grants support a local radio station that links to others for weekly broadcasts throughout much of the Outback. The Warlpiri Media Association also creates videos about Aboriginal life and records CDs, primarily of heavy-metal Aboriginal rock. The producers at the Warlpiri Media Association chafe at the power and size of CAAMA, playing something of the Isuma role against the IBC. But the primary goals are securing funding and creating art.

Similar organizations of varying sizes are active throughout the globe. Terence Turner has written extensively about video work with the Kayapo (1991a, 1991b, 1992a, 1992b, 2001), for example, and other examples can be found in Stephen Riggins (1992) and Pilar Riaño (1994), among many other sources.

When indigenous people take over the creation, negotiation, and dissemination of the mediated facets of their cultures – a task previously left to anthropologists, folklorists, and other researchers – several things occur. The most profound, perhaps, is that the sought after pure transmission of culture retreats like a rainbow, always just out of reach. The shift of video technology and access into Inuit hands resulted not in an unadulterated expression of "the" Inuit worldview but in a range of expressions differentiated among several Inuit video groups. These groups clash because they

operate differently and hold distinctly different opinions about the role of Native video in the larger sphere of world media.

The pursuit of Inuit video also challenges some inertia-bound sentiments about folklore that have kept the mass media, and especially the electronic media, tucked away in an unsavoury place within the field. But video carries a two-tiered connection to folklore: it serves as a conduit for stories, artefacts, rituals, and other elements of folklore, and the creation of video functions as a form of folk art itself.

In the Arctic, Cape Dorset is the unrivalled leader in sculpture and printmaking, and Pangnirtung is a potent site for prints and tapestries. Another community is ready to join this list of Inuit art centres. There are some carvers in Igloolik – Jake Kadluk and Zacharias Kunuk, for example, both do outstanding work in stone, and others produce good pieces of ivory and antler – and the sewing and skin work done there is impressive. But in one small brown building, videographers for the IBC produce art on a steady basis, and just down the road, the artists at Isuma and the Tariagsuk Video Centre create works that have been seen the world over. The products of their efforts are as creative, insightful, and attractive as the other arts of the North, and in several important ways the videos carry messages, meanings, and memories in a far more direct and exciting form than can be accomplished with any other media.

It is time for Igloolik to take its place among the famous art-producing centres of the Arctic.

Glossary

aglu: a dome-shaped den in the snow over a seal hole. Seals raise their pups in them.

ajaja: an ancient Inuit song form, in which the rhythm and mood are set with the repeated refrain of "ajaja" (ah-YAH-yah). The verses of these songs are sometimes improvised on the spot, sometimes worked out carefully in advance.

amauti: a woman's parka with a large hood in which an infant can be carried.

APTN: Aboriginal Peoples Television Network.

Avaja: a peninsula near Igloolik Island, at the end of a cluster of islands to the east of Melville Peninsula. It was once the site of a semi-permanent Inuit camp, and it was the site of an early Catholic mission.

Igloolik: a small village of about 1,100 people, located on Igloolik Island between Melville Peninsula of the Canadian mainland and Baffin Island, in the part of the Northwest Territories that became Nunavut on 1 April 1999.

Igloolik Point: a rounded bulge of land on the south side of Igloolik Island. The point is a traditional place for Inuit camps during the summer, and it is still used today for this purpose.

Iglulingmiut: the people of Igloolik and the surrounding area.

Ikiq: strait of water between two bodies of land; specifically used to refer to Fury and Hecla Strait northeast of Igloolik.

inuksuk: a tall cairn of stone resembling a person, used as a land-mark for navigation, a site of spiritual rituals, or an aid in hunting caribou. The word means "taking the place of a human" or "acting like a human."

Inuktitut: the language of the Inuit. *Inuk* means "person," and *Inuktitut* means "behaving like a person"; highly refined language is a uniquely human characteristic. The word also refers to "behaving like an Inuk" – in other words, doing things the Inuit way.

kamiks: knee-high boots, often made of sealskin to be waterproof or of dog or caribou to be warm.

kamotiq: a sledge, made of wood, antler, and metal, that is pulled behind a snowmobile or dogteam. Sometimes pulled behind an all-terrain vehicle (ATV).

lead: an open, water-filled crack in the sea ice. Pronounced "leed."

muktuk: the fat and skin of a whale. Sometimes spelled with a capital M when referring to the fat and skin of a bowhead whale. The Inuit eat mainly beluga and narwhal *muktuk*; it is tough to chew, and it tastes faintly like butter or cheese.

qaggiq: a large igloo built as the site for communal gatherings and celebrations.

qajaq: a small boat used for hunting. "Kayak" in English. See also *qayaq*.

Qallunaak: a "non-Inuk" person. The term is usually reserved for white people. The plural is Qallunaat (KHAD-loon-at).

Qallunaatitut: the English language. Also used to refer to Qallunaat behaviour.

qarmaq: a small, semi-permanent shelter, usually set up at an outpost camp. Originally made of bones, stones, skins, and sod, they are often made of plywood today. Their interior layout is similar to that of an igloo.

qayaq: a kayak; the English word is derived from the Inuktitut.

qulliq: a stone lamp, usually shaped like a half-moon and filled with blubber; the blubber, often seal fat, is pounded to allow it to melt readily, and the wick, which runs along the straight edge, is made of willow or moss.

Siuraq: a small island near Igloolik, called Tern Island on English maps.

TVNC: Television Northern Canada. A television network designed to provide programming to northern communities.

ulu: a half-moon-shaped knife, typically used by women for a vast variety of purposes: flensing skins, cutting strips for ropes, removing hair from a hide, etc.

umiaq: a "women's boat" (as distinct from the hunting-oriented *qayaq*); the term is often used to refer to any open, family-sized boat.

Notes

CHAPTER ONE

1 For an excellent overview of the history of Inuit art, see Hessel (1998) and Swinton (1972).

2 The Inuit of today were preceded in the Arctic by several earlier groups. Generally, various Palaeo-Eskimo groups lived in parts of the Canadian Arctic, and they were followed by a distinct group that became known as the Dorset culture. The Dorset people persisted until about A.D. 1000, and then they gave way to the Thule culture. Current Inuit peoples descended from the Thule (McGhee 1997).

3 Accounts of the nomadic way of life of the Inuit can be found in many books, including Stefansson (1913), Rasmussen (see several entries in the References), and Hall (1864).

4 During my stay in the Arctic, archaeologist Susan Rowley unearthed a tiny *qulliq* (stone lamp) perhaps two inches long. It seems reasonable to speculate that pressure to lighten the load inspired some Inuit to make their tools absolutely as small as possible.

5 Similar shifts in part transformed storytelling into journalism; see Hamilton (1996).

6 Maria Protz explores various facets of selected grassroots efforts (1994). In the same volume, Rodríguez describes the role of video in identity deconstruction (1994), and Ruíz discusses native video productions in Bolivia (1994).

7 For more on this effort, see Meadows (1992).

8 For more on Inuit literature, see Kennedy (1993) and McGrath (1984) as a starting point.

9 I deliberately resisted too much participation in the videography process because I wanted to make sure that I did not alter the process that I was trying to observe. I participated extensively in the life of the community, but I tried to limit my videography work to observation as much as possible.

10 In this effort, I take a somewhat different tack from that demonstrated in Linda Dégh's book *American Folklore and the Mass Media* (1994). Dégh's emphasis there is on folklore as transmitted via the mass media, while I focus more broadly to include mass media (video) as folklore. Dégh hints that the media can be more than a mere vehicle for folklore, but then she falls back to a position in which she holds that the media are conduits – at times, powerful conduits – of folklore (25). Without ignoring the folklore in the media that I describe, I attempt to show how video can stand as a form of folklore itself. I also take a somewhat different tack from the one offered by Edmund Carpenter. He presents television as folklore, but he concentrates more on the audience side of the process, noting that "television extends the dream world" (1972, 61). In this book, I offer a similar slant but more from the creation side.

11 These stages are reinforced in the chapter breakdown offered in Roth's recent book (2005). Roth highlights several key milestones in the development of Native broadcasting in the Canadian North, positioning this development within a larger context of social struggle, colonialism and anticolonialism, identity negotiation, and cultural presentation and representation.

12 CAAMA, the Central Australian Aboriginal Media Association, operates a television station called Imparja that covers a large portion of the Australian continent. But with the exception of a charming children's show and a smattering of other options, the station airs primarily non-Native programming.

13 Not limiting herself to video, Roth also has examined the role of indigenous radio programming. In particular, she has examined the role of a Mohawk phone-in community radio service during and after a historic confrontation in 1990 (1993).

14 Roth's work suggests an even more active role, tilting the balance suggested by "in equal measure" in favour of Native agency, but the general messages are compatible: Native groups in Canada have achieved unprecedented levels of media access and control through their own efforts, understanding, and political acumen.

CHAPTER TWO

1 One critic writing for the *Montreal Gazette* called him the best filmmaker in Canada (Radz 1998).

2 Much to the annoyance of many in Canadian politics, there was a humorous movement afoot for a while to name the western portion "Bob."

3 Such concerns are re-emerging today, with global warming opening the polar regions to travel, shipping, and other enterprises. Canada recently launched a concerted effort to send officials and Mounties into the remote Arctic regions to reassert its sovereignty over these areas.

CHAPTER THREE

1 *Inuktitut* roughly means "what people do" or even "that which makes people human" – an indication of the centrality of communication to the human experience.

2 An *aglu* is a small dome that seals carve under the ocean ice. *Aglus* provide the seal protection from marine predators, a resting spot, a nest for the pups, and access to fresh air through a breathing hole.

3 This has not always been the case. In addition to Bauman's efforts to focus attention on process and away from the product-gaze of the past, Toelken also urged folklorists to attend to folklore as an active enterprise: "Up to the 1970s, it was common for most folklorists, and most folklore textbooks, to pay more attention to the items of folklore than to the live processes by and through which folklore is produced. This led at least one folklorist to lament that folklore scholarship tended to 'dehumanize' folklore" (1996, xi).

4 I would not rush to stand against such considerations – I suspect that a case could be made for them – but for the purposes of clarifying my point here, I will highlight the differences that make an Inuit video more likely to be considered folklore than would a product from the American Broadcasting Associatoin (ABC).

5 It is conceivable that a videomaker might adjust things "on the fly" in response to reactions from onlookers, actors, and other people present at the time, but these people rarely constitute a significant portion of the intended audience.

6 Hymes has noted that competence is not the struggle to create a perfect communication in an imperfect world. He acknowledges that a performer necessarily takes into account the context – the narrative event – and modifies the performance accordingly. Performances vary, then,

because circumstances vary. To me, competence addresses a performer's ability to achieve the desired effect rather than his or her ability to deliver a performance "perfectly" or without the tarnish of the erratic world.

7 Titon notes that not all folklorists see multiple versions and variants as necessary to folklore, and he seeks to mitigate the debate by noting, interestingly, that "when text is understood as a representation of a process, rather than as an item ... this problem disappears" (2003, 95).

8 One question that follows is "what is a type?" Dégh seems to offer two possibilities: a "personal analytical construct" based on an understanding of several variants, or the "most complete variant" of those available (1994, 14). I tend to side with the former definition.

9 Citing Friedman (1961), Bauman notes that "there is also ample evidence to show that rote memorization and insistence on word-for-word fidelity to a fixed text do play a part in the performance system of certain communities" (1975, 303). But of course, such nonverbal elements as gesture, tone of voice, facial expression, and others make each iteration of an item of folklore a new version or variant in its own right, even if the words are delivered without variation.

10 Books disrupt this process too, but they require a starkly different dynamic. The master must be literate to write a book, for example, while the use of a camcorder requires only a simple understanding of the machine's functions. If the master is not literate, an interviewer, facilitator, or amanuensis (Brumble 1990) must intercede, altering the nature of both the process and the product. And of course, books require literacy among the readers, while videos can be apprehended by almost everyone.

11 See further Goffman's exploration of frames and how they are negotiated (1986). These frames, as Goffman mentions, are often the point of particular aspects of communication; people sometimes engage in strategies not for their surface goals but to facilitate the alteration of the shared frames in order to suit the communicator. All three video groups described in this group take part in such negotiations, presenting Inuit material not only to educate viewers about the Inuit but also to shift the frame to foreground discussions of Inuit culture in a world that rarely pays any attention.

12 This perspective can be traced back to Immanuel Kant, and Edmund Carpenter embraces it vigorously, arguing that such media as television create a separate reality (1972). Kunuk, Qulitalik, and others would disagree, noting that their videos of ancestral Inuit life are not self-con-

tained realities but accurate reflections of the reality that existed in the Arctic's recent past. The videos shape reality, they insist, but do not go so far as to create their own.

CHAPTER FOUR

1 A wrestler in the World Wrestling Federation professional-wrestling circuit called himself "The Undertaker" and dressed the part.
2 Henry Glassie points out in *The Spirit of Folk Art* that true folk art is not simply bad, unsophisticated, or immature renditions of "high" art but rather art that adheres to a different aesthetic (1989). It is this different aesthetic, from an Inuit perspective, that Kunuk wanted to pursue.
3 The community of Iqaluit was called "Frobisher Bay" by the British; it was named after Martin Frobisher, the first European to sail into the area. The community has regained its original name of "Iqaluit," but the bay itself retains the name "Frobisher Bay."
4 As this last image is shown, the soundtrack plays a bouncy, acoustic rendition of "The Cover of the Rolling Stone."

CHAPTER FIVE

1 The spelling of the brothers' names varies.
2 Walrus meat is often used to make *igunak*, a delicacy in the Arctic. The walrus is butchered, and the meat is bound tightly in the hide. Then the package is buried on the beach for up to six months. The meat, which has aged in a relatively oxygen-free atmosphere, looks and smells something like blue cheese.
3 Igloolik Island is rising slowly in a "rebound" effect that began when the last glaciers receded. The effect is similar to a mattress returning to shape after a weight has been removed.
4 The diet of the mother – and sometimes a special object that the baby would be made to wear for the first few weeks after birth – are both cited as the source of Atanarjuat's remarkable foot speed. In an interview conducted on 24 September 1991, with Louis Tapardjuk and George Qulaut, Zachariasie Panippakuttuk offered this explanation: "I have heard a legend about Aamajjuaq and Atanaarjuat who were the two brothers. It is said that both had different *pigusiq* [amulet]. The older brother Aamarjuaq was said to have a *pigusiq* of a walrus fore limb so that he will be strong, as for the younger brother Atanaarjuat he had *pigusiq* of caribou muscles so that he can be a fast runner. But I know for certain

that these held truth as it is said that Aamarjuaq was a strong person while Atanaarjuat was a fast runner. The legend itself has a lot of truth in it" (Panippakuttuk 1991).

5 The names of the brothers are switched in this variant, but the story remains similar.

CHAPTER SIX

1 This video is in Inuktitut but offers English subtitles. The quotations presented here are from Isuma's subtitles.

2 The art of building an igloo is difficult to master, and the physics involved in getting the walls to slope overhead without tumbling inward eludes most casual observers. For a worthwhile description of the process, see Freuchen (1961).

3 Many items of traditional, precontact culture are still actively used today.

4 This approach to marriage is documented in Hall's book *Life with the Esquimaux*: "When a young man thinks well of a young woman, he proposes to take her for his wife. If both are agreed, and the parents of the girl consent, they become one. There is no wedding ceremony at all, nor are there any rejoicings or festivities. The parties simply come together, and live in their own tupic [tent, today spelled *tupiq*] or igloo" (1864, 520).

5 It is widely believed in the Arctic that no other material, synthetic or natural, can equal the heat-trapping power of caribou hide. Stories abound of people frozen to death in the latest high-tech garments, while the caribou-clad Inuit survived.

6 Among the Inuit, the term is "catch," rather than "kill." Killing has murderous overtones, whereas the game animals submit willingly to the hunt in order to help feed the people who rely on them.

7 The song follows the pattern of an antilegend and ends, somewhat akin to the "Golden Arm" story, with the singers grabbing someone nearby to make them jump.

8 Charles Francis Hall observed this "you take what you can get" attitude more than a century ago. In *Life with the Esquimaux* he notes the frequent use of the maxim "It can't be helped" (1864). When a woman accidentally smothered her baby because she rolled on top of it during the night, she was mournful but pragmatic: "It can't be helped."

9 Edmund Carpenter notes that "oral languages tended to be polysynthetic, composed of great, tight conglomerates, like twisted knots, within which images were juxtaposed, inseparably fused" (1960, 1620).

CHAPTER SEVEN

1 Roth and Valaskakis have noted that the early formation of broadcasting systems in the Canadian North was advanced without regard to Northern Native views and opinions (1989, 222). While representing an effort to integrate regional differences within the overarching sense of Canadian identity and bring the North "into the mainstream of Canadian life," the early phases of the movement "reinforced conditions of overriding non-native authority, restricted information flow and promoted cultural replacement in native communities" (221–2). Only by triggering organized resistance by Native groups concerned about the effect of Southern programming on cultural values and Native languages did the technological march begin to incorporate Northern Native views.

2 When he was executive director of the Igloolik IBC, Kunuk tried to set aside some of the Igloolik money to create a "Producer's Pot," a fund that would support special video projects beyond the regular weekly programming. One of the projects that Kunuk wanted to develop with this fund was a scripted video entitled *You Should Be Home by Ten*. It was a response to the evening curfew, and it featured a demon that came out every night at ten o'clock and terrorized children. He developed the script and even found an actor to play the part of the demon. The Igloolik budget was so tight, however, that he could never get enough money to create the "Producer's Pot" fund, and the project was never developed.

3 Along these lines, Armes notes that colonialism restructures classes; instead of being based on age and experience, they're based on literacy – a literacy that demands a degree of assimilation (1987, 16).

4 The head contained compressed-air tanks and rubber bladders. It would be sunk into the ocean, under the ice, and moved into position. At the push of a remote-control button, the bladders would fill with air, and the head would shoot upward. It would crash through the ice on cue, as needed. Once the filming was halted, however, the head was shipped back to Toronto for some fine-tuning to make its movements more realistic. Ultimately, this scene was cut from the script.

CHAPTER EIGHT

1 Richard Bauman explores a similar vein (1986, 5).

2 At the end of the Kino Video version of the film, an interview with Frances Flaherty, the widow of the filmmaker, was added. Interestingly, she

insists that the power of the film stems from its complete accuracy and realism. She notes that the slightest hint of artificiality would have ruined the film's potency.

3 In the fall, when the caribou are mating, the male caribou eats nothing but the urine of the female. This diet imparts a distinctive flavour to the meat.

4 The priest is played by Norman Cohn, the only non-Inuk member of Isuma.

5 The church in this episode is the actual church that still stands on the Avaja peninsula.

6 He uses the English "ninety-one." The traditional Inuit counting system went up to ten and then had words for a few additional numbers – fifteen and twenty, for example – but traditional Inuit life did not call for the ability to discuss numbers much higher than this. Today, all numbers are spoken using the English words.

7 Ice was used because it lasts longer than do snow blocks.

8 This is an interesting departure from igloo building with snow, in which the round wall is built without any openings. The windows and door are cut out of the snow once the structure is complete.

9 The first exception involves a lesson about ravens. "Look, the raven is coming back," the father explains to his son. "Hear the call. Listen." They stand side by side, silhouetted against the sun. They listen. The call comes faintly. The raven pushes through the air. "'Qaa, qaa' because we didn't approach it," the father says. "Now, when he's going there, 'katuk, katuk, katuk,' that's how it sounds, telling us there are caribou nearby." He gestures across the valley with his forefinger, tracing the path he is describing. In the valley, some caribou, white and light brown, trot across the ground. "Because if you catch a caribou, he wants to eat the eyes. They love to eat eyes. Look up there. He's waiting for us to kill." "Oh." "Perched. So if you catch a caribou, immediately eat the eyes. Oh, how I love you!"

The second exception involves the testing of ice for firmness. The father raises the harpoon and pokes it firmly into the snow covering the ice. "Check it here, like this," he explains to his son. He pokes some more. "See if it's dangerous as you go," he says. He hands the pole to the boy. "Poke it. Be careful," the father says as they walk closer to the shore. The boy jams the rod down with every step. The father points. "There's the thin part, near the edge. Try to make it go through the ice." The boy walks ahead a pace and thrusts the harpoon down through the snow. The ice below does not give way. He jabs again and again, only to find

solidity below. "Poke it hard and walk down," the father says. "Be careful." The son proceeds forward, testing the ice with vigour. "If you can go to the edge then you'll be able to catch a seal," the father says as he steps slowly behind his son. The boy takes several confident steps without prodding the ice with the rod. All seems firm. He tests the ice again. "Go farther," the father says. "Is it safe?" It is safe, and the father approaches behind the boy. "I saw a seal on the other side," the boy says. The ice remains firm. "Other side?" "Yes. On the other side." The father takes the harpoon. "Hmmm!" he says.

CHAPTER NINE

1 A capital "M" is sometimes used to indicate bowhead Muktuk, with a lower-case letter indicating the blubber of other, smaller whales.
2 This point is reinforced in *When the Whalers Were Up North:* "To this day elders recall the taste of the maktaaq, the whale's skin. Eaten raw or boiled, the bowhead maktaaq was a delicacy to Inuit surpassing all others" (Eber 1989, 16). "The only part of the big whale we ever ate was the maktaaq. It was very much softer and better than the white whale maktaaq" (Anirnik, quoted in ibid., 93). And "The maktaaq was the best I've ever had. It's the best of all the whales" (Sandy Santiana, quoted in ibid., 158).
3 By this he means bowhead Muktuk; the skin and blubber of belugas and narwhals are commonly available after the midsummer hunt each year.
4 A bowhead researcher mentioned to me that the selection process was a source of great frustration. Many experienced hunters were not chosen, and the inexperience of the chosen team was one reason for the disappointing results.
5 Interesting arguments regarding this point can also be found in Glassie (1982).

CHAPTER TEN

1 Arnait Ikajurtigiit is, of course, not alone in this effort. Among projects put forth within recent decades has been *Isumavut,* an exhibit of Inuit women's art at the Canadian Museum of Civilization in Gatineau, Quebec, in 1995 (subsequently a travelling exhibit). In addition, books by Wachowich (1999) as well as Leroux, Jackson, and Freeman (1994) and others have highlighted the contribution of Inuit women to the realms of art and society.

2 *Itivik* means the other side of a mountain or peninsula, and *-miut* means "people of," so the full term literally means "people of the other side."
3 This is an interesting use of the *Wizard of Oz* technique.
4 Two monitors are needed to edit videotape properly: one to show the images being played and another one, simultaneously, to show the material being recorded onto the master tape.

CHAPTER ELEVEN

1 The results, according to the article, are "considered accurate within 2.9 percentage points, 19 times out of 20."
2 Technically, the Inuit are not among the First Nations of Canada, but this distinction is often overlooked in the casual use of the term.
3 This area of research offers rich opportunities because without it we cannot be sure that producers are having the effect that they desire. But such a study exceeds the boundaries of my current project and so must be left to the future.

References

Abrahams, Roger D. 1983. "Interpreting Folklore Ethnographically and Sociologically." In Richard M. Dorson, ed., *Handbook of American Folklore*, 345–50. Bloomington: Indiana University Press.

Alioff, Maurie. 2006. "Falling Forward into an Icy Wind." *New York Times*, 19 November, late edition, sec. 2, col. 5, 20.

Apak, Paul, Norman Cohn, Zacharias Kunuk, Hervé Paniaq, and Paulossie Qulitalik. 1998. *Atanajuat: The Fast Runner*. Igloolik, NWT: Igloolik Isuma Productions.

Armes, Roy. 1987. *Third World Film Making and the West*. Berkeley: University of California Press.

Aubry, Jack. 1997. "Too much spent on aboriginals, most Canadians say in survey: First Nations not ready for self-rule, respondents indicate." *Montreal Gazette*, 21 June.

Balikci, Asen. 1970. *The Netsilik Eskimo*. Garden City: Natural History Press.

Bauman, Richard. 1975. "Verbal Art as Performance." *American Anthropologist* 77, no. 2: 290–311.

– 1986. *Story, Performance, and Event: Contextual Studies of Oral Narrative*. Cambridge, UK: Cambridge University Press.

Ben-Amos, Dan. 1972. "Toward a Definition of Folklore in Context." In Americo Paredes and Richard Bauman, eds, *Toward New Perspectives in Folklore*, 3–15. Austin: University of Texas Press.

Benedetti, Joan M. 1987. "Who Are the Folk in Folk Art? Inside and Outside the Cultural Context." *Art Documentation* 6, no. 1: 3–8.

Brisebois, Debbie. 1999. Personal interview, Ottawa, 3 April.

Brumble, H. David, III. 1990. *American Indian Autobiography*. Berkeley: University of California Press.

Brunvand, Jan Harold. 1984. *The Choking Doberman and Other "New" Urban Legends*. New York: W.W. Norton.

– 1986. *The Study of American Folklore*. New York: W.W. Norton.

Carpenter, Edmund. 1960. "The New Languages." In Edmund Carpenter and Marshall McLuhan, eds, *Explorations in Communication*, 162–79. Boston: Beacon Press.

– 1972. *Oh, What a Blow that Phantom Gave Me!* New York: Holt, Rinehart, and Winston.

Cerny, Charlene. 1989. "Foreword." In Henry Glassie, ed., *The Spirit of Folk Art*, 7–10. New York: Harry N. Abrams.

Cohn, Norman. 2002. "The Art of Community-Based Filmmaking." *Brick* 70 (Winter): 21–3.

Coomaraswamy, Ananda K. 1956. *Christian and Oriental Philosophy of Art*. New York: Dover.

Cousineau, Marie-Hélène. 1994. "Inuit Women's Video/Des femmes inuits vidéastes." *Parallelogramme* 19, no. 4: 34–9.

Dégh, Linda. 1994. *American Folklore and the Mass Media*. Bloomington: Indiana University Press.

Dewar, K. Patricia. 1990. "A Historical and Interpretive Study of Inuit Drum Dance in the Canadian Central Arctic: The Meaning Expressed in Dance, Culture, and Performance." PhD thesis, Department of Physical Education and Sport Studies, University of Alberta, Edmonton.

Dolby-Stahl, Sandra. 1985. "A Literary Folkloristic Methodology for the Study of Meaning in Personal Narrative." *Journal of Folklore Research* 22, no. 1: 45–69.

Dundes, Alan. 1965. "What Is Folklore?" In Alan Dundes, ed., *The Study of Folklore*, 1–3. Englewood Cliffs, NJ: Prentice-Hall.

Eber, Dorothy Harley. 1989. *When the Whalers Were Up North*. Montreal and Kingston: McGill-Queen's University Press.

Evans, Michael. 2004. "The Promises and Pitfalls of Ethnographic Research in International Communication Studies." In Mehdi Semati, ed., *New Frontiers in International Communication Theory*, 201–26. Lanham, MD: Rowman and Littlefield.

Farquharson, Vanessa. 2006. "Identifying with an Endless Landscape." *National Post*, 29 September, Toronto edition, PM6.

Felperin, Leslie. 2006. "The Journals of Knud Rasmussen." *Variety* online. http://www.variety.com/review/VE1117931535.html?categoryid= 31&cs=1.

Fischer, Martha. 2006. "TIFF Review: The Journals of Knud Rasmussen." http://www.cinematical.com/2006/09/09/tiff-review-the-journals-of-knud-rasmussen.

Fleming, Kathleen. 1996. "Igloolik Video: An Organic Response from a Culturally Sound Community." *Inuit Art Quarterly* 11, no. 1: 26–34

– and Stephen Hendrick. 1991. "Zacharias Kunuk: Video Maker and Inuit Historian." *Inuit Art Quarterly* 6, no. 2: 24–9.

Freuchen, Peter. 1961. *Book of the Eskimo.* Cleveland: World Publishing.

Friedman, Albert. 1961. "The Formulaic Improvisation Theory of Ballad Tradition: A Counterstatement." *Journal of American Folklore* 74: 113–15.

Gale, Peggy, and Lisa Steele, eds. 1996. *Video re/View: The (Best) Source for Critical Writings on Canadian Artists' Video.* Toronto: Art Metropole and V Tape.

Ginsburg, Faye. 1991. "Indigenous Media: Faustian Contract or Global Village?" *Cultural Anthropology* 6, no. 1: 95–114.

– 1993. "Aboriginal Media and the Australian Imaginary." *Public Culture* 5: 557–78.

– 1994. "Culture/Media: A (Mild) Polemic." *Anthropology Today* 10, no. 2: 5–15.

Glassie, Henry. 1982. *Passing the Time in Balleymenone.* Reprint, Bloomington: Indiana University Press, 1995.

– 1989. *The Spirit of Folk Art.* New York: Harry N. Abrams.

– 1992. "The Idea of Folk Art." In John Michael Vlach and Simon J. Bronner, eds, *Folk Art and Art Worlds,* 269–74. Logan: Utah State University Press.

– 1999. *The Potter's Art.* Bloomington: Material Culture/Indiana University Press.

Goffman, Erving. 1986. *Frame Analysis: An Essay on the Organization of Experience.* Boston: Northeastern University Press.

Gramsci, Antonio. 1971. *Selections from the Prison Notebooks.* Ed. Quinton Hoare and Geoffrey Nowell Smith. New York: International Publishers.

Hall, Charles Francis. 1864. *Life with the Esquimaux.* Reprint, Edmonton: M.G. Hurtig, 1970.

Hamilton, Candy. 1996. "Recruiting Native Journalists: The New Storytellers." *Winds of Change.* 32–6.

Hays, Matthew. 2006. "Through Inuit Eyes: Natives and Explorers
 Collide in The Journals of Knud Rasmussen." *Montreal Mirror.*
 http://www.montrealmirror.com/2006/ 092806/film1.html.

Hernandez, Eugene. 2006. "'The Journals of Knud Rasmussen' to
 Kick-off Toronto's 2006 Festival." *IndieWire.* http://
 www.indiewire.com/ots/2006/03/the_journals_of.html.

Hessel, Ingo. 1998. *Inuit Art: An Introduction.* New York: Harry N.
 Abrams.

Hillis, Aaron. 2006. "Watching What We Eat." *Premiere: The Movie
 Magazine.* http://www.premiere.com/filmfestivals/3173/
 new-york-film-festival-update-4.html.

Houston, James. 1995a. *Confessions of an Igloo Dweller.* Toronto:
 McClelland and Stewart.

– 1995b. Personal interview, Connecticut, 15 May.

Hymes, Dell. 1975. "Folklore's Nature and the Sun's Myth." *Journal of
 American Folklore* 88: 345–69.

Igloolik Isuma Productions. 2005. *Igloolik Video by Artist.* Igloolik,
 Nunavut: Igloolik Isuma Productions. Available from http://
 www.isuma.ca.

Inuit Tapiriit Kanatami. 2006. Website. http://www.itk.ca/health/
 cancer-types-lung.php.

Jenness, Diamond. 1922. *Report of the Canadian Arctic Expedition,
 1913–18.* Vol. 12, *The Life of the Copper Eskimos (Southern Party,
 1913–16).* Ottawa: F.A. Acland.

Kennedy, Michael. 1993. "Inuit Literature in English: A Chronological
 Survey." *Canadian Journal of Native Studies* 13, no. 1: 31–41.

Kirkland, Bruce. 2006. "Journals No Match for Other Inuit Epic." *London
 Free Press* (Ontario), 29 September, final edition, C5.

Kupaaq, Michel. 1990. Interview conducted as part of oral-history project
 organized by Inuit elders in cooperation with the Igloolik Research
 Centre, Igloolik, NWT. Interviewed by Therese Ukaliannuk. Translated
 from Inuktitut to English by Louis Tapardjuk. Tape no. IE128. 6
 March.*

– 1991. Interview conducted as part of oral-history project organized by
 Inuit elders in cooperation with the Igloolik Research Centre, Igloolik,
 NWT. Interviewed by Louis Tapardjuk. Translated from Inuktitut to
 English by Louis Tapardjuk. Tape no. IE195. 24 July.*

Leroux, Odette, Marion E. Jackson, and Minnie Aodla Freeman, eds.
 1994. *Inuit Women Artists.* Vancouver: Douglas and McIntyre.

Lord, Albert B. 1971. *The Singer of Tales.* New York: Atheneum.

McGhee, Robert. 1997. *Ancient People of the Arctic.* Vancouver: University of British Columbia Press.

McGrath, Robin. 1984. *Canadian Inuit Literature: The Development of a Tradition.* Ottawa: National Museums of Canada.

Meadows, Michael. 1992. "Broadcasting in Aboriginal Australia: One Mob, One Voice, One Land." In Stephen Harold Riggins, ed., *Ethnic Minority Media: An International Perspective,* 82-101. Newbury Park: Sage.

Merkur, Daniel. 1991. *Powers Which We Do Not Know: The Gods and Spirits of the Inuit.* Moscow, ID: University of Idaho Press.

Minor, Tina. 2002. "Political Participation of Inuit Women in the Government of Nunavut." *Wicazo Sa Review* (Spring): 65–90.

Neale, Stacey. 1999a. "Rankin Inlet Ceramics." Part 1, "A Study in Development and Influence." *Inuit Art Quarterly* 14, no. 1: 4–22.

– 1999b. "Rankin Inlet Ceramics." Part 2, "The Quest for Authenticity and Market Share." *Inuit Art Quarterly* 14, no. 2: 6–17.

Palattella, John. 1998. "Pictures of Us: Are Native Videomakers Putting Anthropologists out of Business?" *Lingua Franca* (July-August): 50–7.

Paniaq, Hervé. 1990. Interview conducted as part of oral-history project organized by Inuit elders in cooperation with the Igloolik Research Centre, Igloolik, NWT. Interviewed by Louis Tapardjuk. Translated from Inuktitut to English by Louis Tapardjuk. Tape no. IE141. 24 March.*

Panippakuttuk, Zachariasie. 1991. Interview conducted as part of oral-history project organized by Inuit elders in cooperation with the Igloolik Research Centre, Igloolik, NWT. Interviewed by Louis Tapardjuk and George Qulaut. Translated from Inuktitut to English by Louis Tapardjuk. Tape no. IE200. 24 September.*

Peruzzo, Cicilia Maria Krohling. 1996. "Participation in Community Communication." In Jan Servaes, Thomas L. Jacobson, and Shirley A. White, eds, *Participatory Communication for Social Change,* 162–79. Thousand Oaks, CA: Sage.

Pigott, Marguerite. 2006. "The Journals of Knud Rasmussen." *Canada's Top Ten.* http://www.topten.ca/thejournals ofknudrasmussen.asp.

Protz, Maria. 1994. "Understanding Women's Grassroots Experiences in Producing and Manipulating Media." In Pilar Riaño, ed., *Women in Grassroots Communication: Furthering Social Change,* 102–20. Thousand Oaks, CA: Sage.

Raboy, Marc. 1990. *Missed Opportunities: The Story of Canada's Broadcasting Policy.* Montreal and Kingston: McGill-Queen's University Press.

– 1992. "Canadian Broadcasting, Canadian Nationhood: Two Concepts, Two Solitudes, and Great Expectations." In Helen Holmes and David Taras, eds, *Seeing Ourselves: Media Power and Policy in Canada*, 156–73. Toronto: Harcourt Brace Jovanovich.

Radz, Matt. 1998. "Canada's best filmmaker? He might be working 250 km north of the Arctic Circle." *Montreal Gazette*, 17 October, D1, D3.

Rasmussen, Knud. 1908. *The People of the Polar North*. London: Kegan Paul.

– 1921a. *Eskimo Folk-Tales*. London and Copenhagen: Gyldendal.

– 1921b. *Greenland by the Polar Sea*. London: Heinemann.

– 1927. *Across Arctic America*. New York: G.P. Putnam's Sons.

– 1929. *Intellectual Culture of the Iglulik Eskimos: Report of the Fifth Thule Expedition, Vol. 7, No. 1*. Copenhagen: Gyldendalske Boghandel, Nordisk Forlag.

– 1930a. *Iglulik and Caribou Eskimo Texts: Report of the Fifth Thule Expedition, Vol. 7, No. 3*. Copenhagen: Gyldendalske Boghandel, Nordisk Forlag.

– 1930b. *Intellectual Culture of the Caribou Eskimos: Report of the Fifth Thule Expedition, Vol. 7, No. 2*. Copenhagen: Gyldendalske Boghandel, Nordisk Forlag.

– 1931. *The Netsilik Eskimos: Social Life and Spiritual Culture: Report of the Fifth Thule Expedition, Vol. 8, Nos 1–2*. Copenhagen: Gyldendalske Boghandel, Nordisk Forlag.

– 1932. *Intellectual Culture of the Copper Eskimos: Report of the Fifth Thule Expedition, Vol. 9*. Copenhagen: Gyldendalske Boghandel, Nordisk Forlag.

– 1967. *Kagssagsuk: The Legend of the Orphan Boy*. Copenhagen: Lyngby Art Society.

Riaño, Pilar, ed. 1994. *Women in Grassroots Communication: Furthering Social Change*. Thousand Oaks, CA: Sage.

Riggins, Stephen Harold, ed. 1992. *Ethnic Minority Media: An International Perspective*. Newbury Park: Sage.

Rodríguez, Clemencia. 1994. "A Process of Identity Deconstruction: Latin American Women Producing Video Stories." In Pilar Riaño, ed, *Women in Grassroots Communication: Furthering Social Change*, 149–60. Thousand Oaks, CA: Sage.

Roth, Lorna. 1993. "Mohawk Airwaves and Cultural Challenges: Some Reflections on the Politics of Recognition and Cultural Appropriation after the Summer of 1990." *Canadian Journal of Communication* 18: 315–31.

– 1998. "The Delicate Acts of 'Colour Balancing': Multiculturalism and Canadian Television Broadcasting Policies and Practices. *Canadian Journal of Communication* 23, no. 4: 487–506.

– 2000. "Bypassing of Borders and Building of Bridges: Steps in the Construction of the Aboriginal Peoples Television Network in Canada." *Gazette: International Journal for Communication Studies* 62, nos 3–4: 251–69.

– 2005. *Something New in the Air: The Story of First Peoples Television Broadcasting in Canada.* Montreal and Kingston: McGill-Queen's University Press.

– and Gail Guthrie Valaskakis. 1989. "Aboriginal Broadcasting in Canada: A Case Study in Democratization." In Marc Raboy and Peter A. Bruck, eds, *Communication For and Against Democracy*, 221–34. Montreal: Black Rose Books.

Ruíz, Carmen. 1994. "Losing Fear: Video and Radio Productions of Native Aymara Women in Bolivia." In Pilar Riaño, ed, *Women in Grassroots Communication: Furthering Social Change*, 161–178. Thousand Oaks, CA: Sage.

Seidelman, Harold, and James Turner. 1994. *The Inuit Imagination: Arctic Myth and Sculpture.* New York: Thames and Hudson.

Stefansson, Vilhjalmur. 1913. *My Life with the Eskimo.* Reprint, New York: Macmillan, 1927.

Sutherland, David. 1994. "The Sad Tale of the Rankin Inlet Ceramic Experiment, 1963–1975." *Inuit Art Quarterly* 9, no. 2: 52–5.

Swinton, George. 1972. *Sculpture of the Inuit.* Toronto: McClelland and Stewart.

Taylor, William E., and George Swinton. 1967. "Prehistoric Dorset Art." *The Beaver* (Autumn): 32–47.

Tester, Frank James, and Peter Kulchyski. 1994. *Tammarniit (Mistakes): Inuit Relocation in the Eastern Arctic, 1939–63.* Vancouver: University of British Columbia Press.

Titon, Jeff Todd. 2003. "Text." In Burt Feintuch, ed., *Eight Words for the Study of Expressive Culture*, 69–98. Urbana: University of Illinois Press.

Toelken, Barre. 1996. *The Dynamics of Folklore.* Logan: Utah State University Press.

Turner, Terence. 1991a. "Representing, Resisting, Rethinking: Historical Transformation of Kayapo Culture and Anthropological Consciousness." In George J. Stocking, ed., *The History of Anthropology*, 285–313. Madison: University of Wisconsin Press.

232

232



- 1991b. "The Social Dynamics and Personal Politics of Video Making in an Indigenous Community." *Visual Anthropology Review* 7, no. 2: 68–76.
- 1992a. "Defiant Images: The Kayapo Appropriation of Video." *Anthropology Today* 8, no. 6: 5–16.
- 1992b. "The Kayapo on Television." *Visual Anthropology Review* 8, no. 1: 107–12.
- 2001. *The Yanomami and the Ethics of Anthropological Practice.* Ithaca: Cornell University Latin American Studies Program.

Uhlich, Keith. 2006. "The Journals of Knud Rasmussen." *Slant Magazine* online. http://www.slantmagazine.com/film/film_review.asp?ID=2564.

Valaskakis, Gail. 1992. "Communication, Culture, and Technology: Satellites and Northern Native Broadcasting in Canada." In Stephen Harold Riggins, ed., *Ethnic Minority Media: An International Perspective,* 63–81. Newbury Park: Sage.

- 1994. "Rights and Warriors: First Nations, Media and Identity." *Ariel: A Review of International English Literature* 25, no. 1: 60–72.

Wachowich, Nancy. 1999. *Saqiyuq.* Montreal and Kingston: McGill-Queen's University Press.

Walls, Robert E., and George H. Schoemaker. 1989. *The Old Traditional Way of Life: Essays in Honor of Warren E. Roberts.* Bloomington, IN: Trickster Press.

Weiner, James F. 1997. "Televisualist Anthropology: Representation, Aesthetics, Politics." *Current Anthropology* 38, no. 2: 197–235.

Wilkin, Dwane. 1998. "Telefilm Canada stiff-arms Igloolik's movie-makers." *Nunatsiaq News,* 28 May.

Wilson, William. 1976. "The Paradox of Mormon Folklore." *Brigham Young University Studies* 17: 40–58.

Worth, Sol. 1981. *Studying Visual Communication.* Philadelphia: University of Pennsylvania Press.

- and John Adair. 1972. *Through Navajo Eyes: An Exploration in Film Communication and Anthropology.* Reprint, Albuquerque: University of New Mexico Press, 1997.

* The original audio tapes of interviews conducted as part of the oral-history project in Igloolik, along with their derived transcripts and translations, are held in the archives of the Inullariit Society, Igloolik Research Centre, Igloolik, NWT, Canada. Copies have been deposited at the Northwest Territories Archives, Prince of Wales Northern Heritage Centre, Yellowknife, NWT, Canada.

Index